Imprisoned Art, Complex Patronage

Publication of this book was made possible by the generous support of
The Caryll and William Mingst/The Mildred E. and Harvey S. Mudd Publications Fund
at the Autry National Center of the American West.

Imprisoned Art,
Complex Patronage

Plains Drawings by Howling Wolf and Zotom
at the Autry National Center

Joyce M. Szabo

SAR
PRESS

School for Advanced Research Press
Santa Fe

School for Advanced Research Press
Post Office Box 2188
Santa Fe, New Mexico 87504-2188
www.sarpress.sarweb.org

General Editor: James F. Brooks
Managing Editor: Lisa Pacheco
Editorial Assistant: Ellen Goldberg
Designer and Production Manager: Cynthia Dyer
Manuscript Editor: Jane Kepp
Proofreader: Kate Whelan
Indexer: Catherine Fox
Printer: Four Color Imports

Library of Congress Cataloging-in-Publication Data
Szabo, Joyce M.
 Imprisoned art, complex patronage : Plains drawings by Howling Wolf and Zotom at the Autry
National Center / Joyce M. Szabo. — 1st ed.
 p. cm.
 Includes bibliographical references and index.
 ISBN 978-1-934691-45-8 (alk. paper) — ISBN 978-1-934691-46-5 (alk. paper) 1. Howling Wolf,
1849–1927—Themes, motives. 2. Zotom, 1853–1913—Themes, motives. 3. Fényes, Eva Scott,
d. 1930—Art patronage. 4. Cheyenne art—Florida—Saint Augustine. 5. Kiowa art—Florida—Saint
Augustine. 6. Indian ledger drawings—Florida—Saint Augustine. 7. Prisoners as artists—Florida—Saint
Augustine. I. Autry National Center. II. Title. III. Title: Plains drawings by Howling Wolf and Zotom at
the Autry National Center.
 E99.C53.S89 20
 741.089'97078—dc22

 2010052202

Library of Congress Catalog Card Number 2010052202
International Standard Book Number 978-1-934691-45-8 cloth; 978-1-934691-46-5 paper
First edition 2011.
All Braun Research Library Collection images courtesy Autry National Center. Principal photography
by Schenck and Schenck Photography.
Cover: Howling Wolf, Plate 44. "Indian 'Officer' and brave." Braun Research Library Collection,
Autry National Center, Los Angeles, California, 4100.G.2.13.

Contents

Illustrations

Plates

Figures

Foreword

Steven M. Karr

The Southwest Museum of the American Indian, part of the Autry National Center of the American West since 2003, is Los Angeles's oldest museum. Founded by Charles Fletcher Lummis in 1907, the Southwest Museum is an institution dedicated to the study of America's Indigenous peoples. Over the course of more than a century, it has assembled one of the nation's largest and most important collections of Native American art and artifacts, representing cultures throughout North, Middle, and South America.

The Southwest Museum's stellar collection is enhanced by archival materials housed in the Braun Research Library, today administered by the Autry Institute. The Braun's more than 55,000 bound volumes and serial publications, 150,000 historic photographs, and numerous anthropological papers, manuscripts, and field notes help document centuries of Native American culture, as well as much of the museum's ethnographic and archaeological collections. Major collections at the Braun include the papers of Charles Fletcher Lummis, George Wharton James, and notable early anthropologists such as Frank Hamilton Cushing, George Bird Grinnell, and Frederick Webb Hodge.

Included in the Braun's impressive manuscript collections are original artists' works on paper, among them the historic watercolors of California's adobes and missions painted by southern California artist and art patron Eva Scott Fényes. A long-time friend of Charles Lummis, Fényes shared with the founder of the Southwest Museum a deep appreciation for American Indian culture and art. In part because of this shared appreciation, the library also holds two books containing impressive ledger-style drawings created by two Native Americans—Zotom, a Kiowa, and Howling Wolf, a Southern Cheyenne—who were imprisoned by the United States military at Fort Marion, Florida, in the late 1870s.

These ledger-style drawings are the subject of Joyce Szabo's important study. The books, which were donated to the Southwest Museum by Eva Scott Fényes's granddaughter, Leonora Curtin Paloheimo, have given Szabo the extraordinary opportunity of providing readers with a nuanced understanding not only of evolving trends in representational art among Great Plains cultures but also of the complex relationship between these two Indian artists and the artist-patron who recognized the value and uniqueness of their work.

Valuable stories about American Indian art and its early advocates are not always told. When they are, institutions such as the Southwest Museum and the School for Advanced Research must seek assistance from funding organizations committed to these important topics. For this reason the Autry National Center is deeply indebted to the Paloheimo Foundation for backing this long-term project. Through the legacy established by the Fényes-Curtin-Paloheimo women beginning well over a century ago, the foundation continues its generous support of the Southwest Museum of the American Indian and the Braun Research Library. We are very grateful to this book's author, Joyce Szabo, of the University of New Mexico, for her stalwart dedication. Special thanks are also offered to the School for Advanced Research Press for immediately recognizing the merit of this study and participating enthusiastically in its publication.

Steven M. Karr is Director and Ahmanson Curator of the Southwest Museum of the American Indian, Autry National Center, Los Angeles, California.

Acknowledgments

As is always the case, many people assisted me throughout the long period of bringing this book to fruition. Steven M. Karr, Director and Ahmanson Curator at the Southwest Museum of the American Indian, and Kim Walters, director of the Braun Research Library, both at the Autry National Center, were particularly supportive, as were the Southwest Museum's former senior curator, Steven L. Grafe, and its former executive director, Duane King. Bunny Huffman, of Acequia Madre House in Santa Fe, and Carmella Padilla were also very helpful, and Paul Halme, of the Paloheimo Foundation, was encouraging from the beginning of the project. James F. Brooks, president of the School for Advanced Research on the Human Experience, in Santa Fe, Lisa Pacheco, managing editor, and the entire staff at SAR Press were a pleasure to work with as the manuscript underwent its final transformation into the current volume.

My late mother, Oleattie Szabo, and my father, Eugene, as well as my brother and sister-in-law, Lynn and Juliann, have always encouraged me in whatever I have undertaken. I recognize how fortunate I have been to have them as my champions. Colleagues who have studied ledger drawings have also been extremely generous with their time, assistance, and sound advice. Among countless people who have helped me throughout the years in which I have been privileged to investigate Plains Indian drawings, three stand out in particular: J. J. Brody, my original dissertation adviser; the late Karen Daniels Petersen; and Janet Catherine Berlo. Jerry Brody was drawn in by the power of the original Howling Wolf drawings that formed the core of my dissertation and first book, and the current volume was strengthened tremendously by the close reading that Janet Berlo offered of an earlier draft. Years ago, Karen Petersen shared her knowledge

and counsel openly with a then young doctoral student seeking to enter this field of study. Although I have not seen her in years, my memories of her remain strong.

I dedicate this book to two major influences in my life who have passed away since I began the volume: my mother, Oleattie M. Szabo, and Karen Daniels Petersen.

Introduction

Two small books of vivid drawings, one filled with images by the Southern Cheyenne warrior-artist Howling Wolf and the other with images by Zotom, a Kiowa man, came to the Southwest Museum of the American Indian in December 1986. Gifts from Leonora Curtin Paloheimo, the books had been commissioned directly from the artists in 1877 by Paloheimo's grandmother Eva Scott Muse Fényes (1849–1930). At the time Fényes commissioned the books, Zotom and Howling Wolf were imprisoned at Fort Marion, in Saint Augustine, Florida. Like some of the other Southern Plains Indian prisoners held there between mid-1875 and mid-1878, the two men created many drawings for diverse reasons. Some of the prisoners' books of drawings, including the two that Fényes collected, were sold to people who visited the sixteenth-century Spanish fort where the Plains people were being held.

At Eva Scott Fényes's death, the books came to her daughter, Leonora Muse Curtin (1879–1972), and subsequently they passed to Leonora Curtin Paloheimo (1903–1999). More than one hundred years after their creation, the books became part of the Southwest Museum's collections. Unlike most of the museum's other holdings of Native American art, these two books originated in a specific commission provided by a young woman who continued to be a patron of the arts for the remainder of her life.

Eva Fényes maintained homes in both California and Santa Fe, New Mexico, from the late 1880s until her death in 1930. She met and in both places had contact with the writer, photographer, and preservationist Charles Lummis. Together the two worked to record the extant missions of California as part of an effort to save them and other important sites in the greater Southwest from destruction. Fényes was a painter who worked mainly in watercolor, and many of her remaining paintings attest to her devotion to the preservation project.

Figure 1.
Charles Frederic Ulrich, Eva Scott Fényes, *1882. Oil on canvas, 36 by 24 inches. Courtesy of the Fényes Collections, Pasadena Museum of History,* 2000.019.1012.

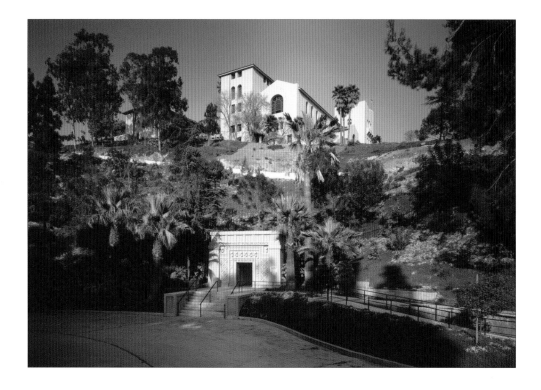

Figure 2.
The Southwest Museum and its tunnel entrance. Photograph by Lawrence Reynolds, about 1986. Braun Research Library Collection, Autry National Center, Los Angeles, California (hereafter BRL), CT.20.

Fényes also supported the development of the museum that Lummis founded in Los Angeles in 1907, and in her later years it became her particular focus. The Southwest Museum, as it was first known, was initially to be a museum of history, science, and art, but by the mid-1920s its scope had shifted to the indigenous peoples of the Americas. Subsequently, the Southwest Museum of the American Indian developed one of the world's largest and most important collections of Native American material. Southwestern works predominated, but the collections also included significant holdings from other regions, including the Great Plains, the Northwest Coast, the Columbia Plateau, the Great Basin, Mesoamerica, and South America. Some Spanish colonial materials, as well as pieces from California dating to both the Mexican and post-Mexican periods, also form parts of the Southwest Museum's holdings.

To support the study of its collections, the Southwest Museum developed a significant library. In the late 1970s it was renamed the Braun Research Library, in honor of the donors who provided funding for a new building for the library. The two books of drawings that Eva Scott Fényes commissioned from the men at Fort Marion are curated in the Braun Research Library collections.

In 2003 the Southwest Museum, the oldest museum in Los Angeles, merged with what had been the Autry Museum of Western Heritage and the Women of the West Museum to become the Autry National Center of the American West, also in Los Angeles. The Braun Research Library and the Autry Library are now parts of the Autry Institute within the Autry National Center.

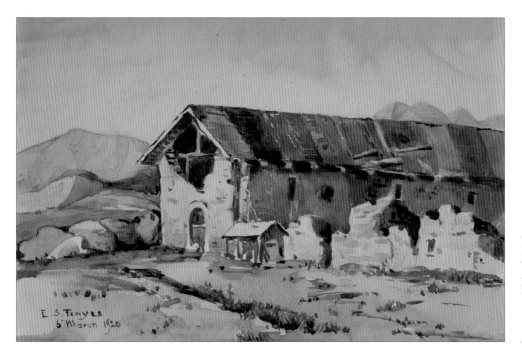

Figure 3.
Eva Scott Fényes, The Church of
Mission San Fernando Rey de
España, *Mission Hills, California,
1920. Watercolor on paper, 7.5 by
11.5 inches. Gift of Mrs. Eva S.
Fényes, BRL, FEN.17.*

Throughout the years since the Southwest Museum's inception, the drawing books
by Zotom and Howling Wolf have remained safely in the library. As is the case for most
Plains Indian drawing books from the latter part of the nineteenth century, whether cre-
ated on the Great Plains or in a Florida prison, the individual pages have been separated
from the books' covers as a conservation measure. The original order of the pages in the
books has been maintained, however, and the covers have been carefully preserved.

In 1969 Dorothy Dunn, who developed an art program known as the Studio at
the Santa Fe Indian School in the 1930s and is famous for promoting Native American
painting, wrote a brief introduction for a volume titled *1877: Plains Indian Sketch Books of
Zo-Tom and Howling Wolf.* The publication reproduced the two drawing books that Eva
Scott had commissioned in 1877. With the generous support of the Paloheimo Foun-
dation, the Autry National Center of the American West decided to republish these
books in the present volume, with better-quality images and an overview of the studies
such drawings have received since 1969. In the following chapters I investigate the draw-
ings themselves in greater depth than has been done previously, examine the reasons for
their creation, and explore some of the multiple messages they carry.

Since Dunn's 1969 publication, the study of what has become known as Plains Indian
ledger art—because of the artists' frequent use of accountants' ledgers as sources of
paper—and of Fort Marion drawings in particular has burgeoned. My examination of the
two drawing books by Zotom and Howling Wolf takes into account the knowledge
about these drawings, their origins, and the issues surrounding their commission that has
accrued since 1969, as well as what they tell us visually about their creators and their

collector. Thanks to the Autry National Center's support, I have been able to augment the complete reproduction of each page with photographs of details of the drawings, allowing the images to be seen as effectively as possible without one's having to handle the fragile drawings themselves.[1]

I also include, for comparison, some drawings by Howling Wolf and Zotom from other collections. This is particularly important when the artist rendered the same subject at different times during his captivity. The art world has long been accustomed to viewing reproductions and studies of, for example, European medieval manuscripts in this fashion. By giving nineteenth-century Plains drawings the same treatment afforded to many other art forms, we can better grasp the creativity of the artists and the reasons behind the specific information they included. The drawings themselves, I hope, can begin to take the place they so richly deserve within the larger history of art.

Imprisoned Art, Complex Patronage

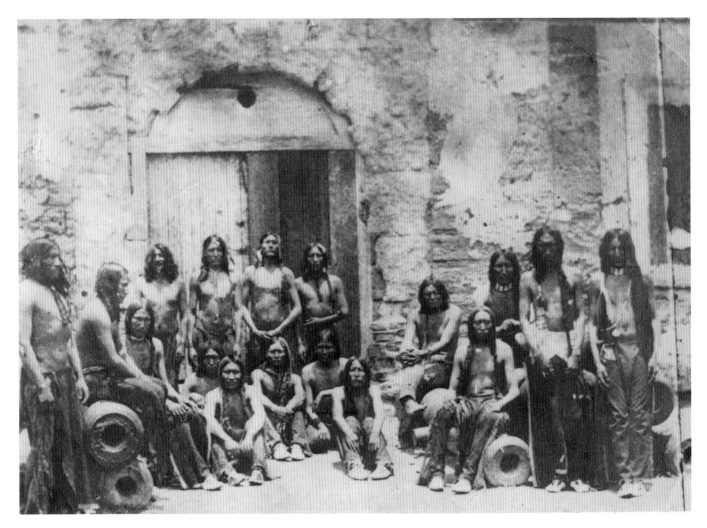

Figure 4.
*"The young men, Prisoners, taken to
Florida," Saint Augustine, Florida,
1875. Yale Collection of Western
Americana, Beinecke Rare Book and
Manuscript Library, 1004474.*

The Southern Plains Wars,
Fort Marion, and Representational Art

Drawings by Zotom and Howling Wolf, the one a Kiowa Indian and the other a South-
ern Cheyenne, are histories of a place and time of creation—Fort Marion, Florida,
in the 1870s. These two men were among seventy-two Southern Plains Indian warriors
and chiefs selected for incarceration at Fort Marion, in Saint Augustine, at the end of
the Southern Plains wars. Among the Cheyenne prisoners was a woman who had fought
as a warrior; the wife and young daughter of one of the Comanche men also went to
Florida, but not as prisoners. During their three years in exile, Zotom, Howling Wolf,
and many of the other younger men made pictures narrating incidents of life on the
Great Plains, their journey to Florida, and life at Fort Marion.

 The drawings explored in this book also have a history subsequent to their creation,
a history connected to the patron of the drawings and her ownership of them. Other
audiences who have seen and studied Zotom's and Howling Wolf's drawings are part of
the works' continuing histories, too. Plains Indian drawings and paintings, including
works created by men imprisoned at Fort Marion, were visual narratives, intended to tell
stories. Those stories still live, for history is, simply put, composed of stories about the
past. As long as drawings such as these from Fort Marion exist, they will continue to tell
their stories.

 For the people exiled to Florida, incarceration was only the latest of many difficul-
ties they had faced. Increasingly throughout the 1860s and 1870s, tension filled the Great
Plains. Encounters between Native and non-Native people and among Native peoples
themselves brought troops of the United States Army to the region in large numbers.
Forts were established at strategic places, and the army worked to maintain peace. Its
main concern, however, was the safety of the growing number of non-Native settlers
moving into and across the plains. Native peoples of both the northern and southern
plains fought to protect themselves and to retain their land and way of life.

One of the most horrific events of the decades before the Fort Marion confinement was the Sand Creek Massacre of 1864, in which Colorado volunteer militia under the command of Colonel John M. Chivington attacked the village of the Cheyenne chief Black Kettle, even though the chief flew a United States flag over his lodge. The militia mutilated the bodies of men, women, and children and paraded through downtown Denver waving spoils of their attack for all to see. Such devastation required revenge. Even chiefs who had previously followed Black Kettle's peaceful ways now turned their attention to war. The younger warriors, eager to prove their bravery, readily joined forces.

Other fights broke out between the Kiowas and their enemies, most important among them the Utes. Sometimes Ute and Apache warriors served as scouts for the US Army, as was the case during an attack on some Kiowas led by Kit Carson in November 1864, about the time of the Sand Creek Massacre. Referred to by Kiowas as the battle of Red Bluffs, a reference to the fight's location in the Texas Panhandle, and by non-Native sources as the first battle of Adobe Walls, after the ruins of a nearby trading post, the encounter was a victory for the Kiowa forces that is recorded in Kiowa historical accounts, or calendars.[1]

In November 1868, just four years after Sand Creek, the Cheyenne chief Black Kettle was attacked again when George Armstrong Custer led his forces against him at the battle of Washita. Black Kettle and his wife, as well as the Arapaho chief Little Robe, were among the many casualties at Washita, despite the fact that Black Kettle again flew a US flag over his tipi, along with a white flag of peace. Some Kiowas had been in Black Kettle's village, and they, too, felt the outrage. This event was so significant that some Kiowa calendars recorded Black Kettle's death even though he was a Cheyenne chief, not a Kiowa.[2] Again, retaliation followed. Sand Creek and Washita were major factors in the escalation of war on the southern plains.

Numerous treaties between the United States and Plains Indian tribes were signed throughout the 1850s, 1860s, and first half of the 1870s, but most of them failed. One of the most famous was the Medicine Lodge Treaty of 1868, as the Cheyenne people referred to it, or the Treaty of Timber Hill Creek, as it was known to the Kiowas.[3] Various Southern Plains peoples were involved in the negotiations for the treaty. Among its provisions were promises that the US government would make annuity payments to the Kiowa, Cheyenne, Arapaho, Comanche, and Plains Apache people if they ceded their land and accepted smaller reservations. The majority of the southern Great Plains would then be open to the development of railroads and to increased non-Native settlement. The Native signers were to retain hunting rights to at least part of the ceded land, and whiskey peddlers were to be kept off the reservations. The Southern Plains people were also to remain at peace. Annual payments of goods did not come, however, and the whiskey peddlers did not stop their activities. When the Southern Plains people attempted to hunt outside the official reservations established for them, battles ensued.

Similar problems arose on the northern plains, but during the mid-1870s it was the southern plains, predominantly present-day Colorado, Oklahoma, and northern Texas, that became particular battlegrounds. The Red River war raged from 1874 to mid-1875. Its name comes from the Red River in the Texas Panhandle, the general location of its major battles, but another name for the conflict, the Buffalo war, may be more apt. Non-Native hunters had already slaughtered hundreds of thousands of buffalo on the northern plains, shipping the hides east, and by 1873 they had turned their attention to the region south of the Arkansas River. This was territory to which the Medicine Lodge Treaty had guaranteed hunting rights to the Southern Plains peoples as long as buffalo ranged there. With the large-scale hunting of buffalo by Euroamericans, both hunting rights and the buffalo themselves were in danger of being lost.

The army did nothing to uphold the treaty's promises. Cheyenne, Arapaho, Kiowa, and Comanche people joined forces to prevent the loss of the animal that was their main source of food and the source of much else in their lives, both physically and ritually. Non-Native hunters fueled anger in both the north and the south, and warriors attacked them in war parties small and large. Among the casualties on the Kiowa side during one such skirmish in 1874 was Chief Lone Wolf's son, who died during a raid in Texas.[4]

The Buffalo war began in earnest with the battle of Adobe Walls in Texas in late June 1874, when approximately two hundred Indians led by the Comanche chief Quannah Parker, with supposedly bullet-proof protection provided by the Comanche spiritual leader Isatai, attacked a much smaller group of buffalo hunters at the trading post known as Adobe Walls. Despite the odds in their favor, the Native forces were badly beaten by the twenty-eight men and one woman inside the post.[5]

Following Adobe Walls, the army mounted a full-scale war against the Southern Plains peoples. The plan "called for enrollment and protection of innocent and friendly Indians at their reservations and pursuit and destruction of hostile Indians without regard for reservation or departmental boundaries."[6] Other encounters of the war included a September 1874 attack by Kiowas and Comanches on a wagon train escorted by Captain Wyllis Lyman on its way to meet Colonel Nelson Miles with supplies. The Indians fired on the teamsters and their army support and finally laid siege to them. The battle lasted several days and left two teamsters and thirteen or more Kiowa and Comanche warriors dead.[7]

The battle of Palo Duro Canyon in the Texas Panhandle, also in September 1874, is often seen as the turning point of the Red River war. While under the command of Colonel Ranald S. MacKenzie, the army was attacked by a Native force estimated at 250 warriors, who attempted unsuccessfully to stampede the cavalry's horses. Early the next morning, the army came across a sleeping village of Comanche, Kiowa, and Cheyenne warriors on the canyon floor. Mamanti, or Owl Prophet, led the Kiowa forces, again under a promise of bullet-proof protection.[8] Loss of life was not extensive at Palo Duro Canyon, but loss of Indian property was. Mackenzie's forces burned the village and stole nearly fifteen hundred horses. The soldiers kept some of them but killed more than a thousand.[9]

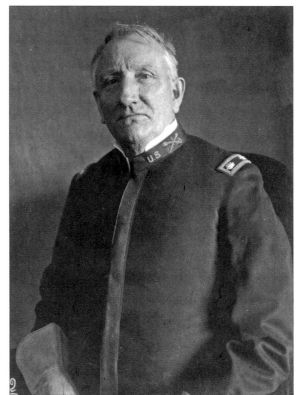

Figure 5.
Richard Henry Pratt. Yale Collection of Western Americana, Beinecke Rare Book and Manuscript Library, 3728657.

The end of the Red River war brought military and government leaders to the decision to send some of the so-called worst offenders in the recent battles to a distant prison. The chiefs and warriors who were actually imprisoned, however, were not necessarily the ringleaders the government sought to incarcerate. Some of the Kiowa war leaders negotiated to remain free, at least one of them by instructing his entire band of Kiowas to surrender at Fort Sill, Indian Territory.[10] The commander at the fort where the Cheyenne and Arapaho people surrendered was drunk at the time he selected the prisoners for exile.[11]

Saint Augustine, Florida, the site of the sixteenth-century Spanish Castillo de San Marcos—by the nineteenth century called Fort Marion—was selected as the prison location because it housed a readily available fortification far distant from the warriors' homeland. By exiling leaders and active warriors so far from their homes and families, government officials hoped to remove them from contact with the rest of their communities and thus promote more peaceful adjustments to the enforced reservation system.[12] No length of internment was set in advance. The officials who conceived of the hostage plan could have had no premonition of what the Florida period would be like for the seventy-one men and one woman sent into exile.

Richard Henry Pratt (1840–1926), who would later found Carlisle Indian School in Pennsylvania, was in charge of the prisoners at Fort Marion.[13] A volunteer who

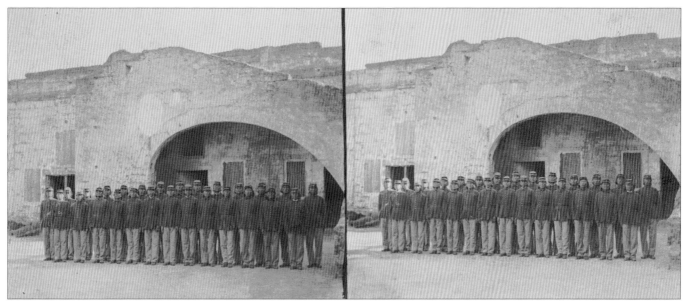

Figure 6. *"Kiowa, Comanchee, and Caddoe Indians, confined in Fort Marion, St. Augustine, Florida." Stereograph, about 1875. O. Pierre Havens, photographer. Photographic Study Collection, National Cowboy & Western Heritage Museum, Oklahoma City, Oklahoma, 2005.043.2.*

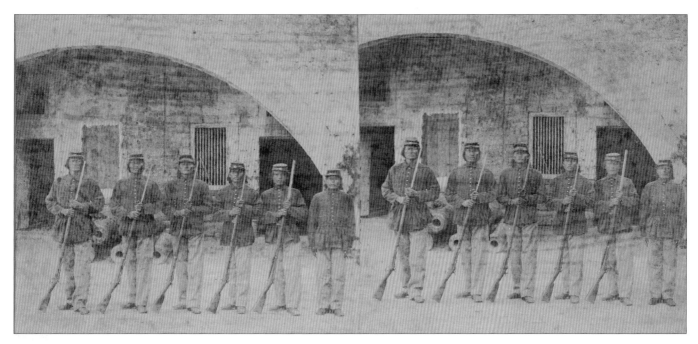

Figure 7. *"Indian Guard, Confined in Fort Marion, St. Augustine, Florida." Stereograph, about 1875. O. Pierre Havens, photographer. National Cowboy & Western Heritage Museum, Oklahoma City, Oklahoma, 2003.161.*

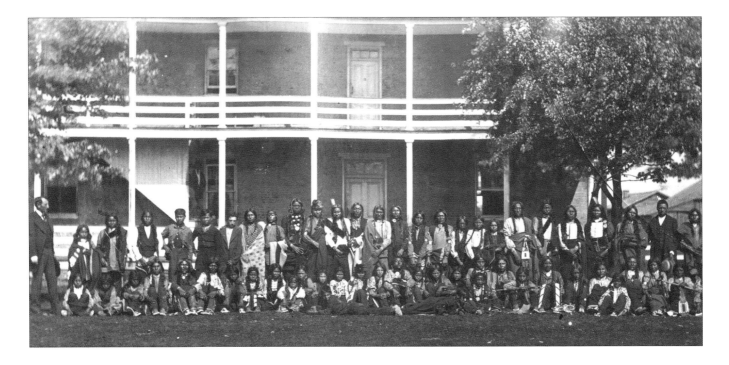

Figure 8.
"First Students at Carlisle, 1879."
J. N. Choate, photographer. Courtesy Cumberland County Historical Society, Carlisle, Pennsylvania.

had served in the Union Army during the Civil War, Pratt was mustered out after the war but returned to the army two years later. He began serving on the Great Plains in early 1867, at first as an officer in the Tenth Cavalry, a unit of white officers and black soldiers who were known as the Buffalo Soldiers. Subsequently, Pratt worked with Native scouts from various tribes during the Plains Indian wars. Because of his experience with Native men from different cultures, Pratt was placed in charge of the Fort Marion inmates.

Pratt was with the chiefs and warriors as they were assembled at Fort Sill for their journey to Florida. Initially chained in wagons, the prisoners traveled to Caddo, Indian Territory, where they boarded a train that would take them to Fort Leavenworth, in present-day Kansas. They subsequently passed through cities including Saint Louis, Indianapolis, Nashville, and Macon. Not only the train itself but also the cities and the large crowds that gathered to see the prisoners as they traveled greatly affected the Indians. Pratt recorded that only one man, the Kiowa chief Lone Wolf, had ever been on a train before, and the speed of the train was terrifying to the prisoners.[14]

During the journey, the Kiowa chief Lean Bear attempted suicide by stabbing himself multiple times. He was left in Nashville until he recovered enough to be taken to Saint Augustine, but he ultimately died at Fort Marion because, according to Pratt, he refused to eat.[15] Another chief, the Cheyenne Grey Beard, tried to escape as the train approached the border between Georgia and Florida. When he failed to stop, guards shot him. As he lay dying, the chief was surrounded by Cheyenne men. Pratt wrote that "among other things, Grey Beard said he had wanted to die ever since being chained and

taken from home. He told Manimic [Eagle Head, another Cheyenne chief] what to tell his wife and daughter and soon died."[16]

Oheltoint, or Charley Buffalo, a Kiowa prisoner, later recalled both events in his account of the trip to Saint Augustine:

That evening the train started again, and we left Bear Hungry [Lean Bear] behind. I was worried that night on the train until the interpreter, George Fox, said we would return home someday; after that I felt better. The train stopped again a short while later. A Cheyenne chief [Grey Beard] jumped from a train window and some soldiers shot at him. Lieutenant Pratt hollered, "There he is! Don't shoot!" But he was already dead.[17]

Arriving in Florida, the remaining prisoners were transferred to a steamboat, which took them from Jacksonville to Toci, and then back to a final train to Saint Augustine. Wagons carried them to the fort. Oheltoint recalled, "We left the train and got on a boat.… When we finally reached Fort Marion, we saw a big house with no top and the ocean. We wanted to make tipis and camp by the ocean, but Lieutenant Pratt said that tipis were in our past. He was a good man, anyway, and we liked him. Lieutenant Pratt stayed at Fort Marion with us."[18]

Richard Pratt was a complex person who is often written about as the villain in the story of Native education. In charge of the Fort Marion prisoners, he required them to adhere to military procedures, including marching, exercising, and participating in daily inspections. Although the prisoners were able to maintain some customs from their own cultures on the plains, Pratt had the men's hair shorn and had them dress in military uniforms. Because of the men's fears of the military, arising from their past experiences on battlefields and from the death of Grey Beard during the journey, Pratt had the strong army presence removed from the fort as soon as possible. The men began to police themselves. They formed their own guard unit, complete with buglers, one of whom was Zotom. Making Medicine, a Southern Cheyenne prisoner, was made sergeant of the guard.[19]

Pratt recognized the mood of the prisoners, who had been taken so far from their homes and families and now found themselves in a strange place where water seemed endless and the environment absolutely foreign.[20] He soon sought ways for the men to be as active as possible in their enforced exile. He also wanted to demonstrate to his superiors the men's work ethic, part of which was their ability to earn money. Men worked in local industries and interacted with visitors to Saint Augustine and Fort Marion. Some of the younger men began learning to read and write English; women from Saint Augustine and long-term visitors to the city volunteered as teachers.

Fort Marion faced Anastasia Island, and Pratt took the prisoners there and to nearby Matanzas Inlet from time to time during their captivity, for the day and to camp.[21] Such outings gave them not only new experiences but also the sense of a life at least marginally closer to that from which they had come. Although they slept in army wall tents rather

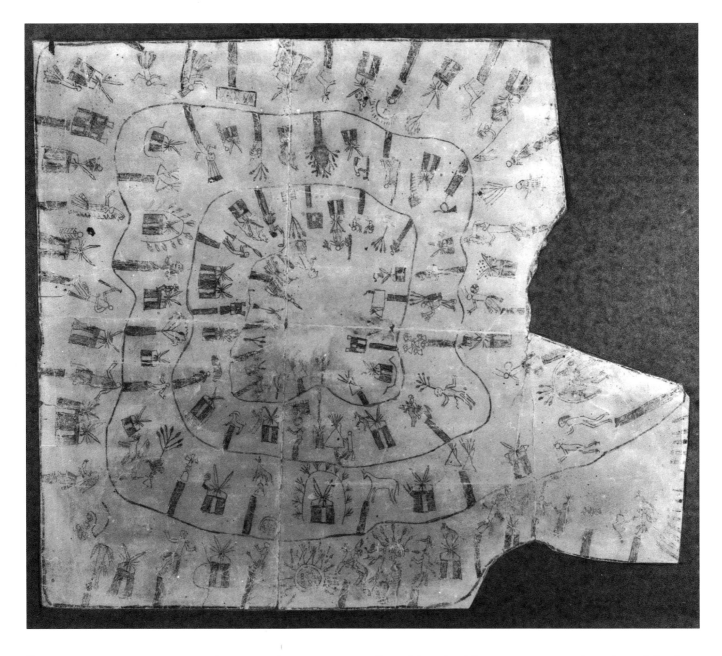

Figure 9.
Kiowa calendar, 1892. Pencil on paper. Courtesy Phoebe A. Hearst Museum of Anthropology, University of California–Berkeley, 2-4933.

than tipis, the open air was, Pratt felt, a healthier environment than that of the fort. There, the prisoners' quarters consisted of the dank cells of the interior, lower level of the old structure and some additional space constructed on the ramparts.[22]

The imprisonment lasted for three years, during which time several more men died.[23] When the prisoners were released from Fort Marion in mid-1878, Pratt traveled with them to Hampton Institute, in Hampton, Virginia, a school that had been established for freed black slaves following the Civil War. Seventeen of the former prisoners, who

wanted to stay in the East for further education, remained at Hampton.[24] Pratt lobbied for a separate school for Native students and achieved his goal when Carlisle Indian School opened in Pennsylvania in 1879. Ten of the former Fort Marion prisoners entered Carlisle.

There, Pratt followed many of the same practices he had instituted in Saint Augustine, but the curriculum was more formal, including both academic and industrial education. This was to be the procedure for off-reservation boarding schools into the early years of the twentieth century. For the most part, students were not to focus on their homes or cultural practices but were to work toward full assimilation. Pratt wanted all Native people to become US citizens, and he felt that assimilation was the best means of achieving this goal.[25] Not until the early years of the twentieth century did a newly appointed US commissioner of Indian affairs, Francis E. Leupp, officially recognize the failure of this kind of system and reinstitute a focus that included Native arts.[26] Pratt was vehemently opposed to these changes and resigned over the altered direction of the curriculum at Carlisle.[27] He continued to lobby against what he felt were negative practices—those diametrically opposed to the assimilationist policy he wholeheartedly endorsed.[28]

Initially, students at Hampton and Carlisle did make drawings, some closely resembling those created at Fort Marion.[29] At Hampton, drawings were sent to people who gave donations to the school. Pratt apparently did not encourage drawing at Carlisle in the same way he had in Florida. He had wanted to get the Fort Marion prisoners "out of the curio class" in Florida, meaning that he knew the public saw the inmates themselves as curios. Yet, early during the Indians' confinement, Pratt encouraged the creation of tourist spectacles in Florida by staging dances and a "buffalo" hunt—with a steer as the buffalo—in which the men participated.[30] He also encouraged the prisoners to produce curios: they polished sea beans, made bows and arrows, and drew pictures for sale. The two Southern Plains women and perhaps the young girl at Fort Marion also "worked over old bead moccasins, and freshened them up with new soles and buckskin linings, all of which were bartered to visitors."[31]

Pratt undoubtedly viewed the drawings as more important than the other objects the prisoners created. He sent books of drawings to people, including his own commanding officer and various humanitarians of the day. Nonetheless, the drawings were for sale and so were readily incorporated into his larger goals for the Fort Marion years. Saint Augustine was a tourist destination, and the drawings allowed the men to be active and to make money. The art supplies Pratt provided gave the prisoners something creative to do.

Carlisle Indian School was a more serious educational undertaking, and Pratt believed that the students needed to focus on work that would assist them in being productive when they returned to their reservations. Although representational images do exist from Pratt's tenure at Carlisle, drawings like those made in Florida were not a long-term part of this productivity. At Carlisle, Pratt required the students to concentrate on education

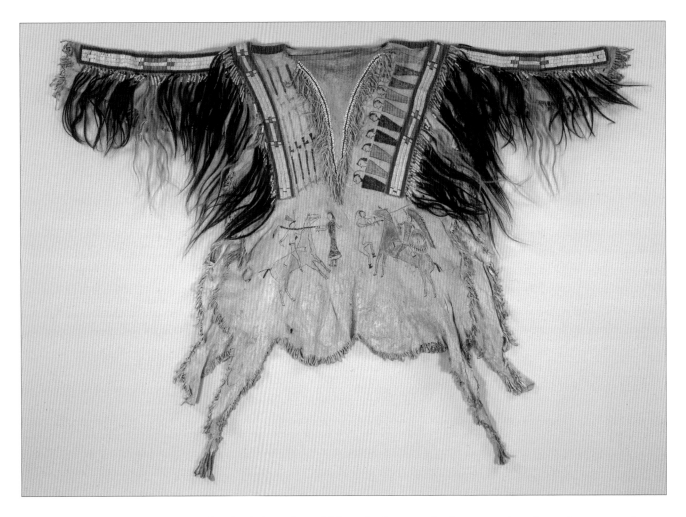

Figure 10.

Back view of a Cheyenne man's shirt painted with battle images, about 1860. Left: A warrior uses what is probably a lance wrapped in otter skin to attack a woman wearing a long dress. Right: A warrior carries the protective power of a shield and uses a lance to touch a Pawnee man, identifiable by his flared-cuff moccasins and hairstyle. At top are (left) eleven pipes indicating war parties the warrior-artist has led and (right) ten partial figures indicating enemies he has defeated in battle. Courtesy National Museum of the American Indian Photo Archives, Smithsonian Institution, Suitland, Maryland, T088034.

that he believed would benefit them in the future, with industrial vocational training a major goal. This kind of education had been unavailable in the Florida prison, but it could be had in a Bureau of Indian Affairs–sponsored boarding school. With a change in administration, art for sale was encouraged at Carlisle, and Pratt detested the practice.[32]

The case had been different in Saint Augustine. Many of the prisoners, though not all of them, created drawings with art supplies that Pratt provided.[33] These drawings helped the men understand their new life, the unfamiliar places through which they had traveled, and the place in which they now found themselves, while enabling them to visually express memories of the lives on the plains from which they had been separated. The men then sold some of the drawing books to visitors to the fort for a dollar or two; many of the men sent money home to their families on the reservations.[34] Some men also sent drawings to their families in Indian Territory, undoubtedly to relay visually some information about the lives they were experiencing so far from home.

Early Studies of Plains Indian Drawing and Painting

The forty years that have passed since the first publication of the Fort Marion drawing books in the collections of the Southwest Museum have seen a profusion of Plains Indian drawings on paper come to light, including a multitude from Saint Augustine. Academic study and the exhibition of these nineteenth-century drawings and paintings have increased dramatically, with the greatest attention having been paid to drawings from the three-year Fort Marion period. When Dorothy Dunn wrote her essay for the initial publication of Eva Scott Fényes's two books, the majority of information concerning Plains drawings was anthropological, concentrating intently on the picture-writing aspects of such images. A brief review of some of the significant publications Dunn had as her references underscores her contribution and makes subsequent changes in the study of such drawings even more apparent.

Nineteenth-century Plains artists created various kinds of pictorial imagery. Some images referenced visions and were often made as rock art in secluded places where people might have sought such power. Some Plains men painted additional indications of supernatural protection on shields and lodges. Many other types of pictorial imagery were historical records painted on hides or drawn on paper. They fall into either of two basic categories. Kiowa, Blackfoot, Lakota, and Mandan people, among others, maintained calendars by drawing cryptic images that enabled people to recollect the events of a previous year or half-year (fig. 9). Other, more fully narrative representations recorded successes in battle and horse capture before the enforcement of the reservation system in the second half of the 1870s. Rock art and paintings on hide predominated, but other pictorial images certainly existed. Some were carved into trees as warnings to others or as messages to people who might have been away from camp on hunting expeditions when the rest of the village changed location.

Paintings on hide robes and shirts became increasingly complex during the second half of the nineteenth century as some artists recorded more detailed representations of battles and hunting expeditions. Such imagery was more common on the central and southern plains, whereas Northern Plains peoples such as the Blackfoot retained stronger ties to less naturalistically rendered horses and figures. Warriors earned the right to render or have someone else draw for them representations of their heroic deeds. As paper gradually became more available on the plains in the 1860s, with greater movement of non-Native people into and across the region, artists turned to this new material, with accompanying pencils, as an additional means of creating art. Although the materials differed, the reasons for creating drawings on paper were initially the same as those that guided paintings on hide robes and shirts.

The late-nineteenth-century research of Garrick Mallery is an important starting point for an examination of studies of Plains drawing and painting, although Mallery was certainly not the first Euroamerican to become intrigued by ways of communication that differed from the alphabet-driven, written languages with which he was familiar.

Linguistics was a major area of concern for the Bureau of American Ethnology, under whose imprint Mallery ultimately worked, and it was in the search for the evolution of separate language branches and of writing systems that Plains drawings and paintings received attention from Bureau ethnologists.

A retired army officer who had been seriously wounded during the Civil War, Mallery had previously worked at the US Geological and Geographical Survey with John Wesley Powell, gathering information about the West. He developed an interest in Native cultures at that time. He devoted the years between 1879 and his death in 1894 to the intensive study of sign language and what he called "picture writing." His publications, particularly his *Pictographs of the North American Indians* (1886) and his massive *Picture Writing of the American Indians* (1893), not only were groundbreaking in their day but also remain essential today for attempts to understand Plains Indian representational imagery.[35] They also established biases that continue to affect investigations of Plains drawing and painting.

Through his work Mallery recorded many images that would otherwise surely have been lost, but he did so with a strong Bureau of American Ethnology focus, which formulated the questions he asked. He gathered information from military officers on the plains and integrated those data into the conclusions he drew. His goal was to determine the origins of writing systems in the evolutionary development of humankind.[36] Mallery examined surfaces that held pictorial writing systems in the Western Hemisphere, including the birch-bark scrolls of Great Lakes peoples, rock art images in various regions, and Plains Indian pictographic imagery. He concluded that when people such as the inhabitants of the Great Plains still used such pictorial forms, the imagery was similar to that of older examples, a conclusion that underscored continuity. His clearly expressed view was that individual variation was *not* a part of Native American cultures, thus denying the kind of increasing complexity that is apparent in Plains drawing and painting. Mallery wrote as if Native cultures themselves, not individual people, were the creators of these images:

> One very marked peculiarity of the drawings of the Indians is that within each particular system, such as may be called a tribal system, of pictography, every Indian draws in precisely the same manner. The figures of a man, of a horse, and of every other object delineated, are made by every one who attempts to make any such figures with all the identity of which their mechanical skill is capable, thus showing their conception and motive to be the same.[37]

Mallery's contributions in bringing together examples of imagery that relayed specific messages and in attempting to decode those messages, as well as his biases, continue to affect current scholarship. Pictographic dictionaries and attempts to further differentiate conventionalized representations form integral parts of many investigations of Plains Indian drawing and painting.[38] The concept of Plains imagery as communication also resonates with contemporary scholars. Mallery asserted, overoptimistically, that

if the simple vocabulary of conventions was understood, then the messages were perfectly clear. Perhaps most negatively, the lack of recognition of individuality constructed by Mallery continued well into twentieth-century scholarship.

Another Smithsonian-sponsored amateur ethnographer of the late nineteenth and early twentieth centuries, James Mooney, was also extremely interested in the peoples of the Great Plains. His 1896 study of the Ghost Dance and its history is but one example.[39] Vision-inspired designs that appeared on shields and some lodge covers were also a primary concern of Mooney's.[40] He chose the Kiowa people as the subject of his most intense research because he thought they were less acculturated than some of their neighbors and so offered a clearer view of "traditional" Plains life.

Mooney's most important published study of Plains representational imagery, *Calendar History of the Kiowa Indians* (1898), is a detailed examination of the shorthand visual icons employed by Kiowa people to record events twice yearly, enabling the group as a whole to recall its history and therefore keep it alive. Mooney analyzed four calendars, and his choice of words reveals his ideas about quality. More detailed representations were better than ones he termed "rude," despite the reality that calendar entries were intentionally cryptic rather than fully narrative. They were used to recount history, the visual entries serving as memory-jogging devices that facilitated the far more important oral narration of events. Mooney also believed firmly that calendars needed to be maintained on hide rather than on paper. He brought his biases clearly into view in his manner of dealing with one of the calendars, which, he wrote, "was originally drawn with a black pencil in a small notebook, and afterward, *by direction of the author*, redrawn in colored inks on buckskin."[41]

For Mooney and many other early scholars of Native American art and lifeways, authenticity was a central issue, and they deplored evidence of alteration of practices brought about by contact with non-Native people. Yet many of these scholars changed the lives of the people they studied, simply by the fact of their own contact with them. Mooney, for example, commissioned the Kiowa artist Silver Horn to create miniature tipi models with painted designs, as well as detailed paintings of the Sun Dance on full-scale hides.[42] Silver Horn also created works on paper for Mooney, including drawings of shield designs and a calendar that he recorded in a notebook similar to those the anthropologist used for his own field notes.[43]

For Mooney, hides were the more important surfaces for Plains Indian paintings, undoubtedly because he considered them more authentic than notebooks with pencil or ink drawings. Yet, the images of the Sun Dance that he commissioned were in no way traditional, because making detailed representations of ceremonial actions was not a typical Plains practice. Apparently, the need that early anthropologists such as Mooney felt to obtain ethnographic information outweighed their dictates against change. This was the era of "salvage" anthropology, when it was believed that information and material objects, including those that would ultimately be classified as art, had to be collected as rapidly as possible before Native cultures vanished, as anthropologists felt certain they

would. The willingness of anthropologists to commission works for their own ends, despite the blatant outside influence such patronage exerted, seems ironic at best. In these cases, the ends anthropologists sought must have seemed to justify the means, and some anthropologists turned blind eyes to their own contradictory, if not somewhat hypocritical, practices.

Given the foundational work of Mallery and Mooney, it is not surprising that twentieth-century studies of Plains representational drawings and paintings of a more fully narrative nature often had the concept of picture writing at their core. That is, researchers attempted to interpret what hoofprints or flying arrows, for example, meant in the context of the subject being depicted. The 1960s were a particularly important decade for increased examination of Plains representational imagery. In 1964 a drawing book from the Fort Marion period filled with images by the Southern Cheyenne prisoner-artist Cohoe appeared.[44] E. Adamson Hoebel and Karen Daniels Petersen provided an introduction and brief commentary for the small volume, closely following previous anthropological studies of Plains representational imagery.

The twentieth-century Smithsonian anthropologist John Ewers made immeasurable contributions to the study of Plains cultures. His dissertation, written for a PhD from Stanford University, was subsequently published as *Plains Indian Painting*.[45] In the book, Ewers explored both geometric and figurative painting on hides, analyzing techniques and style. Although he wrote as an anthropologist, he obviously valued the aesthetic quality of the works he studied.

Throughout his long career, Ewers returned to the subject of Plains representational imagery in several essays. One of them served as an introduction to *Howling Wolf: A Cheyenne Warrior's Graphic Interpretation of His People*, a 1968 book by Karen Daniels Petersen in which she published twelve drawings created by Howling Wolf after his release from Fort Marion.[46] Ewers's essay in the book provided a summary background for the development of Plains works on paper and briefly discussed influences that visiting non-Native artists had on Plains artists. Ewers addressed the development of drawings on paper for new audiences that included army officers in the latter part of the nineteenth century, as well as the unique venue that developed at Fort Marion. Unsurprisingly, the twelve post–Fort Marion drawings by Howling Wolf were most valuable for Ewers because of the ethnographic information they offered about Plains Indian practices. Particularly important for him was a "semi-diagrammatic rendering of a Plains Indian horse race," which called attention to the elements of picture writing that the artist employed and Ewers valued.[47] Ewers offered similar views of the development of Plains Indian painting elsewhere, and he expressed his opinion about the positive influences that anthropologists such as James Mooney had on the Native people with whom they worked.[48]

Petersen's lengthier contributions to the 1968 volume are far more significant than has been generally recognized. She provided a biography of the artist, as well as commentaries on each drawing and the captions that had been added to them by Ben Clark, a scout and post interpreter at Fort Reno, Indian Territory, who knew Howling Wolf.

With the captions as a basis, Petersen interpreted the drawings, gave ethnographic information about the customs and occasions depicted, and raised what are now recognized as vital questions about different views of history. She treated the drawings themselves as historical documents no less valuable because they were visual rather than written.[49]

By far the most significant contribution to the study of Plains Indian drawing in general in the 1960s came with Helen Blish's 1967 publication of the massive volume of drawings created during the reservation period by the Lakota artist Amos Bad Heart Bull. Her *A Pictographic History of the Oglala Sioux* offered interpretations of the more than four hundred drawings in Bad Heart Bull's manuscript, along with essays on his development as an artist, his role as a historian, and the importance of the drawings he created.[50] Although other, more concise essays had accompanied the publication of drawing books from Fort Marion and the Great Plains before this, Blish's work set the stage for more complex, in-depth investigations of Plains artists. Like Ewers, Blish was an anthropologist, but she readily acknowledged Bad Heart Bull's aesthetic concerns and his development as an artist over the twenty years during which he created the drawings that filled his ledger.

Dorothy Dunn included some Plains works on paper in her 1968 *American Indian Painting of the Southwest and Plains Areas*, but her discussion of them was limited.[51] She used the drawings as a way of establishing the background against which Plains painting of the twentieth century developed as an art form. That she approached nineteenth-century drawings and paintings as an art teacher rather than as an anthropologist was, however, an extremely important step in the study of these works. Earlier, in 1965, a particularly influential article by the art historian Howard Rodee had appeared, in which Rodee explored the way in which Plains painting and drawing changed from the early to the later part of the nineteenth century.[52] He emphasized an increased naturalism that resulted as Plains artists had greater contact with non-Native artists and grew increasingly comfortable with new materials such as paper and pencils. Rodee included a discussion of the Fort Marion period in his chronology of defining influences.

In 1971 Petersen published her seminal *Plains Indian Art from Fort Marion*, which offered a detailed discussion of Richard Pratt and the three-year exile of the Southern Plains warriors and chiefs. She identified all the artists and the locations of their works then known from the Fort Marion period, giving at least brief biographical information for each artist. She classified them as major or minor artists on the basis of the number of drawings then attributed to each man. Tellingly, her book included a pictographic dictionary to assist readers of the visual images in understanding the pictorial language at work. The approach she took to some of the issues raised by Fort Marion art and her classification of major and minor artists might be questioned today, given the intervening discoveries of additional drawings, applications of new methodologies, and emerging theoretical considerations. But Petersen's study of Fort Marion art was groundbreaking, and it remains an essential source for all subsequent studies of drawings from the Florida period. She launched an extremely important investigation of drawings by

artists working at Fort Marion, setting the stage for further examination of the ways in which various prisoners approached subject matter and the styles in which they rendered those subjects.

Since the 1970s many other books and myriad articles have appeared in which researchers explore Plains representational imagery in drawings created both on the plains and at the Florida prison. Some have focused on the work of individual artists;[53] others have provided the framework for examinations of changes apparent in drawings created by individuals at different stages of their lives and for diverse patrons.[54] Some scholars have explored the issues of how and why Plains drawing and painting changed from the pre-reservation period to Fort Marion and the reservation era.[55] Still others analyze representational imagery from individual cultures during certain periods.[56] In some cases, entire ledger books have been reproduced, with commentaries exploring the actions depicted on each page and attempting to align them with the battles being depicted.[57] Of particular importance for its in-depth study was the 1997 publication of a book of Cheyenne drawings taken from the Summit Springs battlefield in present-day Colorado in 1869.[58] Other facsimiles have been published through commercial galleries, which began selling increasing numbers of these drawings during the later part of the twentieth century.[59]

Auction houses and galleries specializing in Native American art have sold drawings both as complete drawing books and as single sheets removed from larger volumes. As auction prices for Native American art in general began to escalate during the last few decades of the twentieth century, so did the prices paid for Plains drawings. Undoubtedly as a result of market developments, drawing books have most often been sold page by page through commercial venues, thus eliminating the context for the drawings as part of a single volume. Some galleries have financed facsimiles of ledger books, not only to market the drawings but also as a record of complete books with commentaries generally concentrating on the ethnographic information provided by the artists. Individual warrior society paraphernalia and details of clothing, shields, and body paint, as well as interpretations of pictographic conventions employed by Plains artists, have garnered the greatest interest. Individual artistic styles have also received some study, but not to the same extent as ethnographic information. Students of the drawings have increasingly attempted to align pictorial imagery with the historic incidents or battles depicted. Some commercially funded publications have provided only brief commentaries and pictographic dictionaries; others have been masterful explorations of individual drawings and of the importance of the books as a whole.[60]

Museum exhibitions, too, burgeoned in the late twentieth century. They added in other ways to the public's interest in Plains drawings and to acceptance of the drawings as single-sheet works of art. The largest and most wide-reaching exhibition to date has been *Plains Indian Drawings 1865–1935: Pages from a Visual History*, which traveled from late 1996 to the fall of 1997.[61] For many museums that hold full volumes of drawings—either ones created on the plains in commercially produced, lined accountants' ledgers or Fort

Marion examples generally in unlined artists' drawing books—the need to conserve these fragile works has led to the separation of individual pages from their acidic covers. Indeed, the great majority of paper on which such drawings were made is not of archival quality, and museum conservators have battled to extend the lives of the drawings.

Separating the pages from contact with one another and with the volume's cardboard covers has been beneficial, but it has also altered the way in which these drawings are seen. Not only have they become parts of museum and private collections as rarified objects, but they are also seen as single-sheet entities, hung on walls in glass-enclosed frames. Even when drawings are placed on gallery walls or in display cases sequentially, in the order in which the pages appeared in books, the context is dramatically altered. The origin of the drawings in a book that could be held in one's hands, the pages turned to reveal additional entries, is now easily forgotten. Exhibition techniques have also aided in the sale of Plains drawings as single-sheet creations. Now, more accustomed to seeing them displayed individually, collectors are able to view the pages as self-contained master drawings that can also be exhibited in private homes.

Additional access to high-quality reproductions of Plains drawings is being made possible through digitization projects as museums make their collections available online. The most extensive digital effort to date is Ross Frank's Plains Indian Ledger Art Digital Publishing Project, which in 2010 had seventeen books of ledger drawings from both public and private collections available for viewing online.[62]

The parallels between the ways in which Plains drawings have been collected and the ways in which medieval manuscripts have been treated are striking. Indeed, more than one major private collector of Plains drawings has come to them after a career of studying and collecting medieval manuscripts. European illuminated manuscripts have suffered even more drastic fates over the centuries since their creation, with pages not only separated from the original books and sold individually, but even mutilated. Collectors from at least the sixteenth century forward cut richly illuminated capital letters, for example, from a page and adhered them to other surfaces, often in a different book.[63] This kind of composite creation has, for the most part, been avoided where Plains drawings are concerned; most pages remain untrimmed and intact. Alterations have been made to individual drawings, but at least some of these presumably happened during the nineteenth century and might well have been made by Plains warrior-artists themselves. Several drawings that have come to light show attempts to alter the identities of non-Native enemies by adding long hair, for example, to make them appear Native.[64] Because the federal government, at least on occasion, used Plains ledger drawings as evidence against Plains warriors who had fought non-Native enemies,[65] such alterations were probably made before the drawings fell into the army's possession.

Since 1990 two Plains ledger artists have garnered more attention than any others. The known works of the Kiowa reservation-period artist Silver Horn and the Cheyenne warrior-artist Howling Wolf have each received extensive examinations.[66] Each man created many drawings, and each, in his vastly different way, provided an important view

of a Plains artist working under varying circumstances and for different audiences. As the two most fully studied of the artists of their medium, these men are better known and more widely recognized than their peers. Both artists were exceptional, and both developed their representational skills by calling on previously established practices in their cultures and also expanding their drawings to include new directions, new subject matter, and new styles of art.

Although not intentionally developed to do so, the studies of Howling Wolf and Silver Horn have established a type of canon or standard in the history of Native American art. The existence of a canon leads to comparisons; the works of already recognized artists often become the yardsticks against which the works of other artists are examined. Although Silver Horn and Howling Wolf indeed merit such attention, so do many nineteenth-century Plains artists who have yet to be recognized to the same extent. The canon of nineteenth-century Native American drawing and painting needs expansion, and recent large traveling exhibitions and extensive studies of entire ledger books have been important steps toward this end.[67]

Art at Fort Marion

Although drawings made before and after the enforcement of the reservation system on the Great Plains have received extensive study by anthropologists and art historians, arguably the greatest academic focus has been on drawings created by the Fort Marion prisoners.[68] Richard Pratt encouraged the captives in Florida to draw by ordering drawing books, pencils, crayons, and inks from New York art supply houses for the men to use. He urged them to create images representing their new lives and experiences in Florida and their journey to the strange new land in which they found themselves. In fact, the men created many more images of their previous lives on the plains than they did of their prison existence.

The Fort Marion years saw a fundamental shift in Plains representational drawing and painting. Subject matter diversified as the exiled artists experienced vastly different lives in Florida, and the role of drawing expanded to include a large amount of art made specifically for outside sale. Influences were abundant. The artists in Florida had enforced time in which they could make drawings, and they were exposed to a diversity of visual stimuli. Of course, the men also influenced one another. New subject matter appeared, initiated by some as-yet-unknown artist, only to be taken up by a fellow prisoner and depicted in a different manner. The give and take between Fort Marion artists and the ways in which different men depicted the same subjects are areas that have only begun to be explored in any detail.[69]

Although many Fort Marion drawings were made to be sold to visitors to Saint Augustine, focusing on them solely as "tourist" or "souvenir" art not only demeans them but also ignores the many vital roles they played for their creators. Dislocated from their homes and families, the warrior-artists in Florida drew in a unique atmosphere but were not totally removed from all aspects of their lives on the plains. Some chiefs were among

the prisoners, and just as they had on the plains, these men—such as the Cheyennes Eagle Head and Heap of Birds and the Kiowas Lone Wolf and Woman's Heart—held positions in Florida different from those of the younger men. Pratt conferred with the chiefs, seeking their opinions and support on matters ranging from assisting during a suspected escape plot by Kiowa warriors to selecting younger men as dancers for a public program.[70] To date, no drawings are known to have been made by these elder statesmen of the Florida group; drawing apparently was an activity undertaken by the younger prisoners.

Two Plains women were also transported to Florida. Mochi, a Cheyenne woman and wife of the Fort Marion inmate Medicine Water, was a prisoner because she had been identified as having taken part in a notorious attack on a wagon train and the subsequent kidnapping of four non-Native girls. The other, a Comanche woman, together with her daughter, had refused to be separated from her husband, Black Horse, the child's father.[71] No drawings created by either of the two women or the young girl have come to light. It is generally held that women on the southern plains did not make representational images, although apparently the Cheyenne chief Eagle Head did receive picture letters from his wife in Indian Territory, whether she actually drew the images or had them drawn to her specification.[72] The most prolific of the Fort Marion artists were well-established warriors, Zotom and Howling Wolf among them. Such men, known in their own cultures for their achievements as warriors, would have held positions of honor among their fellow tribesmen in Florida. In the new social system that developed at Fort Marion, their status was probably recognized by fellow captives from other cultures as well.

L. James Dempsey, in his 2007 book *Blackfoot War Art*, which covers rock art and hide and panel paintings from 1880 to 2000, described reasons for making art that can be compared to those of the Fort Marion prisoners.[73] Earlier Blackfoot representational imagery, like its counterparts on the southern plains, was almost exclusively battle oriented. The Blackfoot, however, retained stronger ties to relatively cryptic ways of representing figures and objects than artists farther south generally did. Blackfoot warriors also shared an intense cultural requirement for the truthful representation of a person's accomplishments, which did not diminish after the end of the Plains wars. When Glacier National Park opened in 1910, Blackfoot artists began to make increasing numbers of pictorial images for non-Native visitors. From 1913 to 1930 they also painted panels for the interiors of hotels associated with the Great Northern Railway, both at Glacier and at nearby Waterton National Park.[74] These panels and other paintings were for tourists, but they were also ways of "recording and sustaining their own history in their own traditional ways."[75] In addition, the hotel panels, at least, were commissioned works. Dempsey underscored that the men invited to paint these panels did so not simply for the money the commissions provided but "to take advantage of an opportunity to exhibit some of the sources of their pride."[76]

All the subjects explored by Fort Marion prisoner-artists can be seen in the same light. They are representations of cultural pride, whether they provide accounts of the

surrender of the Kiowa people, the arduous journey to Florida, life in prison, or life on the plains. Surviving the trip to FloFrida and imprisonment there were achievements that can be compared to surviving battles. Zotom's historical records are extensions of the Kiowa calendrical system, and Howling Wolf's renditions of life on the plains are statements of Cheyenne lifeways and of self-worth and cultural values.

Art and Anthropology: Working Together

Inquiries into Plains Indian drawings and paintings as art rather than as purely ethnographic objects are related to the history of Native American art as art while simultaneously remaining distinct from that history. Certainly, the aesthetic merits of Native works, from ceramics and pipe carving to beadwork and architectural murals, have been recognized by many, but not until the 1930s was Native American art exhibited on any significant scale for its aesthetic merits. A 1941 exhibition at the Museum of Modern Art in New York, in which the works were shown as artistic objects without anthropological context, is often cited as the first such major venue.[77]

Today, given the changing nature of art history as a field, its increasing inclusion of different methodologies, and the complexities of exhibiting works from diverse cultures, museums continue to struggle with whether to exhibit Native art solely as an aesthetic creation or to include anthropological information. If the latter is attempted, how much information should be included, and who should provide it? Even staff of the National Museum of the American Indian in Washington, DC have debated this issue. For the museum's inaugural exhibition, they chose to eliminate any major contextual information and allow the works to be seen primarily in an aesthetic light.[78] What is lost or gained in either manner of presentation is very much under consideration.

Anthropology's subjects have generally been so-called Others—tribal peoples from Africa and the Americas and everyone else belonging to cultures different from those of western Europe, such as the peoples of Asia. Anthropologists have long recognized different cultural systems of aesthetics and indeed developed the subdiscipline of visual anthropology to encompass many kinds of imagery, whether or not created by Native people. Art history, however, has been slow to bring Native American art into the larger discipline.[79] The gradual increase in attention paid to Native American art as art rather than solely as ethnographic object comes at a time when the field of art history itself has been expanding rapidly in the United States and altering its basic methods throughout the world. Although precedents are evident much earlier, art history initially developed as an academic discipline during the nineteenth century, its aims tied closely to identifying the artists of specific works and compiling biographies of those artists. By the mid-twentieth century, interpreting works of art—finding the meanings or potential meanings behind the imagery—had become a paramount focus, particularly in the United States. The latter part of the twentieth century saw greater concentration on theory than on the work of art itself, although the two are intricately bound together.

The young field of Native American art history has experienced all these developments and many more, but it remains closely tied to some of the early questions of artistic identity. In part, this concern with connoisseurship, or recognition of individual and cultural differences in Native American art, is attributable to the ahistorical way in which Native American art has often been treated. A notorious exhibition mounted during the 1980s reflected this view when, in displaying African, Native American, and other non-Western arts in connection with works by Picasso and other "major" European artists, the curators wrote label copy explaining that the non-Western material could not be discussed because it had no history.[80]

The ahistorical view is closely connected to the romantic sense that Native arts are unchanging and that the only "real" Native American art was created before European contact. If made after that time, it could be authentic only if it showed no evidence of contamination by non-Native influences. But Native American art, including drawings and paintings made by plains men held in a Florida prison, is not ahistorical. It has a history or, more accurately, multiple histories, and the Fort Marion drawings share in the history of the Great Plains themselves.

Plains Indian drawings and paintings on paper from the nineteenth century have certainly been included in relatively recent survey texts in Native American art history. Such works did not appear in earlier visual surveys of Native art, undoubtedly because of what was seen, and is still seen by some, as their "untraditional" nature.[81] These were drawings made with materials obviously introduced by outsiders, and the representations of figures themselves often suggest the influence of non-Native forms on Native artists.

Anthropological inquiry has most often focused on cultures rather than on exploring the individuality of members of those cultures. In societies such as those from which the Fort Marion inmates came, even though they placed great emphasis on personal accomplishments, the good of the social community was always more important than that of the individual. Art history, conversely, has more frequently focused intently on the individual, often designating certain artists artistic geniuses. But artists are active in specific places at specific times, and those contexts affect and sometimes are affected by the art created in them. Art is a part of cultural expression and therefore reflects some aspects of the culture of its creators, even when it is made in defiance of that very culture.

Neither anthropological inquiry nor traditional art historical methods can supply all the answers to the many questions raised by drawings from Fort Marion. Taken in combination with broader historical issues, the two together can reveal much more about these works.

Drawing and Painting on the Great Plains and in Florida

Plains Indian cultures developed representational systems that allowed them to relay important messages, including directional messages carved into trees and records of individual visions pecked into rocks. Other, more widely known and readily recognized types of representational imagery were concerned with battle successes. Warriors

painted records of their achievements on hide shirts, leggings, and robes. Even body paint often referenced individual accomplishments, with parallel stripes indicative of battle honors and hands painted on a man's chest telling everyone that he had fought an enemy in hand-to-hand combat. Many Native people developed such systems of shorthand pictorial imagery and used it to relay information deemed vital.

With limited exceptions, such as rocks and trees, the surfaces on which Plains warriors rendered images, such as robes, hides, and skin, were connected to the human body. There could be no misunderstanding who the protagonist was, and people of the artist's community, accustomed to the same visual language, could not mistake the nature of the brave action accomplished. A warrior wore on his body signs of his brave actions because he had earned the right to do so. They were clear proclamations of his achievements. He was a walking indication of both cultural history and his own part in that history. Prince Maximilian of Wied, who traveled throughout the northern plains in the 1830s, noted that such images were painted in order to allow a man to hand down his reputation to posterity.[82]

What happened, though, when a man's deeds were removed from his body and placed inside the covers of a book? How did Plains artists, and indeed Plains cultures as a whole, make this transition? Books can be closed; they can be removed from the person whose deeds are recorded in them. How were the deeds celebrated? How did books allow a warrior to hand down his reputation to posterity?

The book, although it could be and was on occasion strapped to a man's body as he rode into battle, was not an article of clothing open to public view.[83] Books were, during the pre-reservation era and even during the reservation years, rare commodities, and warriors often shared them to record their deeds. Many books show the work of several artists, and some even suggest that two artists worked on the same page.[84] Perhaps these men were members of the same war party or the same warrior society. Contemporaneous recorded observations are few, but they do tell us that men sat around the camp, opening the books and using them to tell stories about the battles depicted in them and undoubtedly about related events.[85] Some Plains peoples, such as the Kiowas and the Lakotas, also had calendars that allowed the same kind of preservation of group memory.

For many people in the twenty-first century, books hold a special significance. There is, after all, something precious about a book, an object that can be held and its pages turned to reveal new information, with the promise of more to come in the following pages. When the end of the book is reached, it can always be examined again, in whatever order the viewer desires. Fascination with books obtains no matter what subject matter, factual or fictional, is explored inside their covers. We tend to think of books as primarily textual works with perhaps some illustrations, but the reverse is also common. The connection of artists to books is often strong. Artists' books, as records of their creative outpourings, bound and contained neatly within covers, continue to captivate artists and viewers alike—a phenomenon not unique to any single culture or worldview.

WOHAW

The two books of drawings that Eva Scott commissioned from Howling Wolf and Zotom at Fort Marion are both artists' books and historical narratives. Each artist recorded events from his own life and those of others, on the Great Plains and in Florida. In doing so, both men followed the Plains Indian practice of preserving records of accomplishments through drawing and painting.

Yet, the Florida drawings and the subjects explored in them differ markedly from what had preceded them on the plains. Although Howling Wolf's and Zotom's drawings were rooted in a long-established use of two-dimensional imagery, they expanded the types of subjects beyond the previously customary ones. Some of the drawings mirrored those in which warriors recorded their brave deeds on the plains, but other

Figure 11.
*Wo-haw (Kiowa), untitled, 1875.
Pencil and crayon on paper, 8.5 by
11 inches. Collections of the Missouri
History Museum, St. Louis, Missouri;
N36781, 1882.18.31.*

images referenced new circumstances and met new needs. That both Howling Wolf's and Zotom's drawing books were commissioned directly from them, that the drawing materials were supplied to them, and that they drew images based on both their own choices and those of Eva Scott are but some of the vast differences that distinguish Fort Marion art from traditional Plains Indian art. The men who drew at Fort Marion became self-conscious artists in a wholly different atmosphere.

There is no doubt that artists on the plains were concerned with aesthetics, with the proper way of doing things, whether that was painting a hide with representational imagery, creating geometric patterns on parfleche (folded hide envelopes), or beading and quilling clothing and other objects. What differed dramatically about the Fort Marion art was the captivity of the artists, the manner in which they interacted with patrons, and the new representational schemes to which they were continually exposed. They were taken from their homes to a foreign place and created art at least partially in response to that dislocation. Some scholars might consider them to have stood at the brink of modernity, experiencing the kind of dramatic rupture with the past that many see as a defining characteristic of modernity.[86] The abrupt, forced removal of the prisoners from their families, land, and previous lifestyles, their transportation to Saint Augustine, and their situation there under Richard Pratt's assimilationist and militaristic disciplinary policies certainly constitute such a rupture. Arjun Appadurai writes of modernity as "everyday cultural practice through which the work of the imagination is transformed."[87] The Fort Marion prisoner-artists experienced both dramatic rupture and the continuity of at least some aspects of their previous cultural practices. The art from their Florida period reflects these seemingly contradictory effects.

Books mark the passage of time in various ways. Leafing through a printed book, a reader can enter the story, be it visual, written, or both, at any number of points, reading forward or moving around within the text. The way in which the reader engages with the written word, therefore, has no guaranteed relationship to the order in which the book was written or the order in which events recorded in it took place, whether those events are fictional, factual, or somewhere in between. The same is true of books filled primarily with drawings rather than words.

A few examples are known of drawings made on the Great Plains that sequence events chronologically,[88] but most known drawing books provide no clear evidence—at least none that has been effectively interpreted by contemporary viewers—that the warrior-artists intentionally placed events inside the covers of accountants' ledgers in a linear fashion. The exceptions to this rule are enough to suggest the need for further exploration of the practice, but unfortunately the events recorded by Plains artists are now often difficult to align with their specific references in Plains history. A battle between Cheyennes and their Pawnee enemies, for example, might be any of a great number of such battles that took place during the 1860s and 1870s. And even if the artist did sequence the drawings in a way that was meaningful to him, whether chronologically or by importance of event, for example, the way in which subsequent viewers

Zotom is busy drawing a book

Figure 12.
Zotom, sketch, about 1875, captioned "Zotom is busy drawing a book." The vignettes in this sketch may have served Zotom as a guide for later drawings of events in his life and his people's history. National Cowboy & Western Heritage Museum, Oklahoma City, Oklahoma, 1996.017.0206B.

examine the pages of the book might well have no relationship to the way the artist conceived of the book as a whole.

Artists, particularly those at Fort Marion, where blank drawing books were readily available, might well have worked with plans of which subjects to place in which order on the pages. A sketch by Zotom on lined ledger paper that might represent such a plan shows tiny representations including two buildings with flags, two pairs of riders facing each other, a tipi, a structure created of individual blocks of brick or stone, two views of covered wagons, two of trains, and a man apparently swimming (fig. 12). The handwritten caption on the drawing says, "Zotom is busy drawing a book." Edwin Wade and Jacki Rand have suggested that Zotom's tiny sketches were related to drawing books with images depicting the journey from Indian Territory to Florida, books that were perhaps already on order from customers.[89] Comparison with drawing books that Zotom filled with images at Fort Marion, including the one he completed for Eva Scott, suggests that he followed a visual outline of images to render in his detailed accounts of events leading to the surrender of the Kiowa people and the journey to Fort Marion. Zotom did not, however, always follow the same order or include drawings of all the same events in his Fort Marion books.

One set of four sequential drawings is known from Howling Wolf's work at Fort Marion, through which he tells a story about the gathering for and conclusion of negotiations for the treaty of Medicine Lodge in 1867.[90] But what approach Howling Wolf and other Fort Marion artists took to the order of the majority of images in their books is unknown. Perhaps some men worked from the back of the book forward, and others, from the middle outward. There was no set convention in Plains Indian culture for the use of bound volumes and the "right" way to fill them with images. Antecedents such as calendars that the Kiowa people kept on hides organized events in various ways. Some were linear, some circular, and some serpentine in order.

Art historians and many anthropologists might ask how cultural differences are indicated in Plains drawing and painting. Attempts have been made to suggest stylistic

differences between Cheyenne and Kiowa drawings, for example, but these have not been especially convincing, in part because individual people, not cultures, drew the images. Certainly, men recording their heroic deeds on the plains would have done so in keeping with their culture's assessments of bravery and of what constituted important actions, but they did so in varying styles. The same undoubtedly occurred in Saint Augustine.

Florida and Fort Marion in the 1870s

Most contemporary art historians, and certainly ethnographers, who examine works created by artists, no matter from which cultures or time periods, are concerned with the social context in which the works were made. This holds true for explorations of Plains Indian art in general and Fort Marion art in particular. When assessing alterations in subject matter or style of visual imagery in Plains drawings and paintings made before and after the enforcement of the reservation system, one must consider surrounding historical and cultural changes. Fort Marion represents a distinctive time and place of creation for drawings, a milieu dramatically different from that of the prisoners' homelands.

Some discussions of Fort Marion drawings have treated them as if they were products of the Florida exile, and to some extent this is true. Art, like other remaining evidence of times past, is a document of the period of its creation. Yet, these drawings did not come into being simply because of the situation in which the Plains prisoners were placed. Instead, they helped define for their creators and for contemporaneous viewers and purchasers—not just for readers and viewers today—what Fort Marion was between mid-1875 and mid-1878. Perceptions of the Fort Marion period and of the chiefs and warriors imprisoned there would have been, and would be now, decidedly different if so many drawings had not been made there.

Fort Marion artists created their drawings with materials that were probably new to some of them. Certainly, the ready availability of drawing books and a wide range of inks, pencils, and crayons was something unknown to these men on the plains. Such materials, the encouragement to draw, and the artists' captivity were all part of the impetus for the creation of so many drawings in Florida. Still, the men known to have made these images had to want to do so. Despite the reality of their exile and imprisonment, nothing suggests that any of the men was forced to draw. An atmosphere existed at Fort Marion that encouraged the creation of drawings and inspired experimentation.

Fort Marion was a unique environment in which prisoners from five Southern Plains cultures were held for three years. Although the Cheyenne and Arapaho peoples had long been allies, as had the Kiowas and Comanches, the few Caddo prisoners were more isolated. The Cheyenne and Arapaho group was at least initially housed in different locations in the fort from the Kiowa and Comanche prisoners.[91] Ultimately, the prisoners developed a social system in Florida as they experienced a new, enforced life together. This resulted in an altogether different social dynamic.[92] Some aspects of life on the plains were shared by all the prisoners, including the status of chiefs and prominent warriors, a social structuring that continued in Florida.

Recognizing that Fort Marion was a unique environment, however, does not answer the intriguing question of how a substantial change in cultural attitudes toward drawing occurred there between mid-1875 and mid-1878. Both the creators and the patrons of Fort Marion art came to their roles with varied needs and expectations. No definitive statement can be made about what all the prisoner-artists in Saint Augustine wished to express, nor can any unilateral assessment of the purchasers' agendas be made, but some discussion of the world of Fort Marion and its effect on the art created there can help illuminate many of the messages conveyed by the resulting drawings.

The original collectors and purchasers of these drawings differed markedly from the audiences for whom drawings and paintings were made on the Great Plains. They also differed from one another. For some patrons of Fort Marion drawings, the works reflected what they perceived as the positive efforts that both the Indians and Richard Pratt were making toward education and acculturation. Other people must have collected drawings because they suggested just the opposite—a view of the prisoners as criminals.

The artists who created the drawings, too, differed from one another. They made drawings for a variety of reasons, some of which were little different from reasons for making drawings detailing battle exploits on the plains. Yet, the Fort Marion prisoners came from five diverse Plains cultures, each with its own value system and worldview. Neither the Caddo nor the Comanche culture is known to have had a significant practice of representational drawing or painting for recording battle deeds before the Fort Marion confinement.[93] Perhaps in keeping with that lack of extensive precedent, no drawings have come to light that are known to have been created in Saint Augustine by prisoners from either of these cultures.

Existing Fort Marion drawings are predominantly by Cheyenne and Kiowa prisoners, with a few from the two Arapaho inmates. Thirty-two Cheyenne men and one woman were imprisoned in Florida, and twenty-seven Kiowa men. By sheer numbers, then, the pool of potential artists was weighted toward Kiowa and Cheyenne men. But even this predominance of potential artists would not have resulted in so many drawings if, by either past experience or lack of contemporaneous encouragement, the Fort Marion artists had been uninterested in drawing. Cheyenne culture had a well-established practice of representational drawing and painting prior to Fort Marion, but Kiowa culture differed in the types of imagery that filled daily life. The two Arapaho prisoners, Packer and White Bear, present a problem for any extensive discussion, because only two drawings have been attributed to them from the Fort Marion period. Petersen concluded that they were created jointly by the two Arapaho men because both of their names appear on the drawings.[94] A close examination of the drawings, however, reveals that they were made by one artist alone.[95] The "signatures" are, rather, identifications of the two Arapaho men represented in each drawing.

The Kiowas are well known for their vibrantly painted tipis, vision-inspired paintings on shields, and body and horse painting. Extant examples of Kiowa representational imagery based on daily life experiences, whether related to battle or to other events, were

Figure 13.
Kiowa calendar entry for the summer of 1869, depicting a captured enemy war bonnet above a Sun Dance lodge. The lodge was a standard icon for "summer." Reproduced from Mooney, Calendar History of the Kiowa Indians, *p. 326, fig. 145.*

most frequently used as parts of calendars in the pre–Fort Marion years. Calendar keepers maintained visual records composed of cursory images that marked half-years for the bands of which they were members. Unlike the calendars, or winter counts, of the Lakota people, who recorded only one entry per year, Kiowa calendars included entries for winters and summers of the same annual cycle. Under a barren tree or a black bar standing for winter, together with a tree in foliage or an image of the Sun Dance lodge denoting summer, the calendar keeper recorded a figure or small vignette that suggested a memorable event of that half-year. The winter of 1862–63, for example, saw abnormally heavy snow and was referred to as the "treetop winter," so it was depicted by a tree with a wavy line above it. The summer of 1869 appeared as a war bonnet captured from an enemy (fig. 13).[96] The entries, although small and cryptic, were specific enough to allow the calendar keeper and others familiar with the group's history to recount the incident depicted and its effect on the community, as well as other events from the same time. Calendars ensured the ongoing verbal recounting of history through the mnemonic function of the images.

Only one documented hide painting with representational imagery is known to have been painted by a Kiowa artist prior to Fort Marion,[97] and no known books of drawings have come to light that were created by Kiowa artists before either the enforcement of the reservation system or the Fort Marion confinement.[98] Candace Greene has published one Kiowa drawing made on paper in the 1860s.[99] One Kiowa lodge is well known for the paintings of battle imagery on its cover; it was a gift given by a Cheyenne chief to the Kiowa chief Tohausan, or Little Bluff, in 1845, when the Kiowa and Cheyenne people, formerly enemies, made peace.[100] Of the twenty-four currently known Fort Marion artists, nine were Kiowa, one or possibly two were Arapaho, and the remainder, either thirteen or fourteen, were Cheyenne. Approximately half the Kiowa artists are associated with only a handful of drawings each, whereas the other men created larger numbers of images. From the drawings remaining today, Zotom appears to have been the most prolific of the Kiowas. In comparison, several Cheyenne artists, including Howling Wolf, Making Medicine, and Bear's Heart, created significant numbers of drawings.

With few exceptions, the general subject matter drawn by Kiowa artists did not differ markedly from that depicted by Cheyenne men. Both groups of prisoner-artists created views of their journey to Florida and of their lives there, as well as even more drawings of life on the plains, particularly genre scenes of their villages, hunting expeditions, and other daily activities, along with a far smaller number of images of battle encounters. When battles were portrayed, both Kiowa and Cheyenne artists drew encounters between individuals and larger-scale, panoramic scenes.

An assessment of the prisoners held at Fort Marion written at the time suggests differences one visitor saw among the cultures represented there. Abbie M. Brooks, writing under the pen name Silvia Sunshine, noted, "[The] Cheyennes have a rude system of representing their ideas by picture-writing, which may be traced up to the highest type of communicating thought by letter-writing. In this manner they have preserved legends, written history, and recorded songs." By comparison, she praised the oratorical powers

of the Kiowa and the Arapaho men.[101] Whether or not she was capable of truly appreciating this power, given the language barrier, is unknown, but she clearly singled out the Cheyennes for their pictorial abilities.

Arguably, the single most often reproduced drawing from Fort Marion is one by the Kiowa artist Wohaw.[102] The drawing, depicting a man, presumably the artist himself, standing with one foot in his own Native world, suggested by a tipi and a buffalo, and the other foot in the non-Native world, indicated by a frame house and a steer, offers a comparison to vision-inspired painting rather than a depiction of daily life. Its attraction for contemporary audiences lies in its perceived commentary on the difficulty of living in two worlds and the impossible position in which Wohaw and the other Fort Marion prisoners found themselves. The drawing is without doubt an important one, but it is atypical of Fort Marion work. Unfortunately, through its continual reproduction, it has become suggestive of the entire body of work created in Saint Augustine. This image, with its great individuality, has become a prime object of study among works of art from Fort Marion, a perceived masterpiece ahead of its time, with a resulting lack of equivalent consideration of the larger body of Fort Marion work. Recent investigation of the drawing also suggests that the "two worlds" interpretation resides more in the minds of contemporary scholars than in Wohaw's actual drawing.[103]

What stands out about Fort Marion drawings in comparison with those made by artists on the plains is their diversity of subject matter. Many of the artists rendered detailed views of the plains and their lives there. Although drawing these images was undoubtedly connected to the loss the prisoners felt in being exiled from their homes, the landscape details and the intricate representations of villages suggest that the artists were not trying simply to recall their homes but also to make those homes real to other people. All the Fort Marion drawings were part of a complex system of communication.

The artists also rendered images of many new places they saw and new experiences they had, which their contemporaries on the plains did not. Many drawings of the trip to Florida and life there depict landscapes and architecture that are descriptive of location to a far greater degree than drawings created before the Fort Marion incarceration. At least some of the men drew new places, new environments, and large towns in ways suggesting that they were attempting to capture likenesses of those places. In this way, the Florida men followed Plains Indian practices of employing representational imagery as historical records, whether as expanded calendar entries that became more fully narrative or as records of bravery.

Although the Red River war and its antecedent battles on the southern plains were over, the Fort Marion prisoners were engaged in other kinds of important fights. One of the most important was to maintain some aspects of their cultural and individual identities in the face of powerful forces of assimilation in the unfamiliar new land in which they found themselves, exiled from family and home. Drawings created in the Florida prison were important parts of their now peaceful but vital arsenal.

Figure 14.
Eva Scott, about 1877. Courtesy Acequia Madre House, Santa Fe, New Mexico.

On Collecting and Being Collected

Eva Scott was an artist in her late twenties when she visited Saint Augustine in 1877. Financially secure and attracted to what were then viewed as exotic cultures, she had already traveled widely. Among her many foreign trips were journeys to Mexico, Egypt, Cuba, and Venezuela, in addition to the more standard travels undertaken by wealthy Americans to European countries. Like many other American women of the late nineteenth century, Eva Scott also wanted to be of assistance to the Native people of her own country.

Born in 1849 to a prominent family in New York City, Scott had the opportunity to focus her attention on what truly interested her throughout most of her life. Her father, Leonard Scott (1810–95), was head of the Leonard Scott Publishing Company of New York, a publisher of British journals, and Eva received her early education at Pelham Priory in Pelham Manor, New York, the first girls' preparatory school in the United States.[1] This was followed by art studies in places including New York, Paris, and Egypt. Leonard Scott's health was poor, so the family spent its vacation time in warmer climates.

In 1869 Eva Scott and her parents were in Cairo, Egypt, where they joined three other Americans in renting a private riverboat. On January 27 that year, they set sail for forty-four days on the Nile, from Cairo to the first cataract of the great river and back. The American landscape painter Sanford R. Gifford (1823–80) was a fellow passenger. One of Gifford's letters detailed the travelers' typical day: "We breakfast at 9 o'c, then go ashore, walk or shoot, while the men track [tow the boat from shore]. About 11 o'c the wind generally springs up, when we go on board and lounge, read, write or paint til 4 p.m., when we dine, getting through about 5 o'c in time to enjoy the light of the low sun on the rosy and purple Arabian hills, the sunset and the twilight."[2]

Gifford took notice of twenty-year-old Eva Scott's artistic skill and offered her encouragement and instruction throughout the Egyptian trip.[3] The small group of travelers who sailed up and down the Nile between January 27 and March 12 experienced the great natural beauty of the region and viewed, among other ancient wonders, the sculptural monuments of Thebes and the tomb paintings at Beni-Hassan. Scott's dedication to art grew even stronger as a result of this trip. Sanford Gifford was known for his concern with capturing light in evocative ways, and it may be his influence one sees in Scott's later paintings, particularly those made in California, which clearly show her efforts to capture the special qualities of light.

Eva's father strongly influenced her, too, not only in her pursuit of intellectual fulfillment but also in her development of an independence atypical for young women of the day. An extremely successful businessman, Leonard Scott taught his daughter "how to manage her own finances, how to negotiate a good real estate deal, and how to hold her own in a world run by men."[4] She had not only the advantages of wealth but also a self-assurance encouraged by her far-sighted father. She applied the lessons he taught her throughout her life in many ways.

In November 1878, at Fort Monroe, Virginia, Eva Scott married her first husband, William S. Muse (1842–1911), a lieutenant in the United States Marine Corps. The next year the couple's only child, Leonora Scott Muse (1879–1972), was born. William Muse earned a distinguished record in the Philippines during the Spanish-American War and rose to the rank of brigadier general. The family lived in Mare Island, California, but after ten years of marriage, Eva Scott Muse took their daughter and left the state.[5] The marriage ended in divorce, a rare occurrence in the late nineteenth century and one that suggests another aspect of Eva Scott Muse's self-reliance.

Initially, she and her daughter, Leonora, returned to New York, but after a visit to Santa Fe, New Mexico, in 1889, Eva Scott Muse decided to have a house built in the then small, somewhat rugged but spectacularly beautiful town. As early as 1890 she began spending at least part of her time there. During the later years of the nineteenth century and early years of the twentieth, Santa Fe was growing as an intellectual and artistic center, but it was also a place where women of sufficient income could live what would then have been seen in most parts of the world as unconventional lives.[6] With her fierce independence, Eva Scott Muse definitely qualified as unconventional. She did not live permanently in Santa Fe for many years, though, because Leonora attended schools in England and Switzerland and Eva herself studied art in places including Paris, Morocco, and Egypt.[7]

Eva Scott Muse continued to paint whether she was in California, Santa Fe, or the many other places to which she traveled. Throughout her life, her most frequent medium was watercolor, and her imagery typically was landscapes and architecture (see fig. 3, introduction). Her daughter shared her love of foreign places, and the two traveled to Europe in 1895. On another trip to Cairo, Eva Scott Muse met the man who would become her second husband, Dr. Adalbert Fényes (1863–1937), a man fourteen

Figure 15.
"Mrs. Muse in Egypt, 1895–96(?)." Courtesy Archives of the Pasadena Museum of History, PHS15-6a.

Figure 16.
Benjamin Chambers Brown, Portrait of Leonora Muse, *1898. Oil on canvas, 36 by 26 inches. Courtesy Fényes Collection, Pasadena Museum of History, 2000.019.0077.*

years her junior. A noted entomologist who later became a physician and did pivotal work in the development of radiology, Adalbert Fényes was also a Hungarian nobleman. The two married in Budapest in 1896.[8] They traveled to Vienna but had to shorten their trip because of impending war.

The Fényeses' first home, built in Pasadena, California, was strongly Orientalist, or Moorish, in style. Such an architectural style, crystallizing romantic views of a distant and exotic place, employed patterning, crenellation, window framing, columns, and domes to suggest the foreign and the unusual. Adalbert and Eva Scott Fényes surrounded themselves with beauty, and their house reflected the range of their tastes. The interior view shown in figure 18, complete with peacock, dramatically conveys their desire to live with references to the exotic. In the later years of the nineteenth and early years of the twentieth centuries in the United States, many people who could afford to incorporated such contrived styles, or "fabricated realities," into their homes and the collections they amassed.[9] Public architecture, as well as private, included exotic elements.

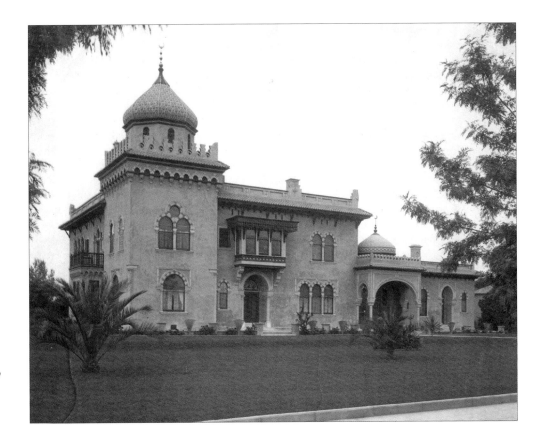

Figure 17.
The first Fényes house, at 251 South Orange Grove Avenue in Pasadena. Courtesy Archives of the Pasadena Museum of History, PHS1-1.

Architectural manifestations of Orientalism, especially in private settings, offered opportunities for a type of stage that could fill the imagination with visions of exotic and distant cultures that had little, if anything, to do with the actual East those manifestations sought to reference.

For some colonial powers, such as England and France, Orientalism reflected their historic physical hold over parts of Asia. For the United States, the hold was only symbolic, a power not physical but mental. By appropriating aspects of the region in a way that denied what Asia and its inhabitants were, Americans placed themselves in positions of superiority. British and French artists and writers did this as well, but their emphases differed. French artists focused more often on intensely academic paintings of harems and other subjects too risqué for most British and American audiences. They also depicted many battles of the Napoleonic era, whereas the British favored biblical imagery.[10]

For Americans, Orientalism suggested a new wilderness, a place distant and exotic that surpassed the frontiers of North America. Yet, the reality of the East was usually subsumed under a veneer of exoticism that divorced it from any true connection to locale. Holly Edwards has suggested that the flowering of Orientalism in the 1870s and 1880s offered a kind of therapy for the United States during the post–Civil War decades, when

Figure 18.
*Interior of the first Fényes home in
Pasadena. Courtesy Archives of the
Pasadena Museum of History,
PHS1-20.*

the former enemies were unable to reach a renewed sense of union.[11] In addition, Orientalism carried with it strong overtones of American nostalgia for rapidly vanishing nature and for the simpler life of the nineteenth century. Even the romantic horseman of the Orient can be compared to cowboys and, for some, the valiant Native warriors of the Great Plains.[12]

When Eva Scott first moved to California, she observed that artists—many of them newly arrived from other parts of the country—had no gathering place and no support system. She was accustomed to a different kind of social climate, one in which artists

Figure 19.
Left to right: *Eva Scott Fényes;*
her daughter, Leonora Muse Curtin;
her granddaughter, Leonora Frances
Curtin; and Adalbert Fényes, on the
lawn behind the Fényeses' second
home, now the Pasadena Museum
of History. Courtesy Archives of
the Pasadena Museum of History,
PHS21-2.

and patrons mingled freely. Her experiences with the artists with whom she had studied and worked and from whom she had commissioned paintings had made her aware of the importance of interaction among people interested in the arts. One model for her was the well-known painter William Merritt Chase (1849–1916), from whom she commissioned portraits of her parents in 1880; his New York studio was continuously open to younger artists. In California, Eva Scott Muse began to draw around her a circle of artists. Her patronage was diverse, and the artists she encouraged in her California home worked in a variety of styles.[13] After she remarried, the Fényeses' Pasadena home became a kind of artists' colony or salon where creative people, especially painters and writers, found the company of others with similar aims invigorating.

In 1899 Eva Fényes met the photographer and writer Charles Lummis (1859–1928), a man of many talents who was deeply concerned with preserving important architectural structures in California and the greater Southwest.[14] One of his particular goals was the preservation of California missions. Fényes shared Lummis's enthusiasm for saving historic structures, and she aided his effort to record all the missions in California by making pencil sketches and watercolors of them. The two also joined forces in establishing the Southwest Museum in Los Angeles; Lummis founded the institution and Fényes partly financed it.[15] In addition, the Pasadena Museum of History is housed in Adalbert and Eva Fényes's second home, an Italianate-style house they had built in 1906.[16]

Eva Scott Fényes also maintained her Santa Fe home and traveled there regularly, generally with her daughter. In 1928 she, her daughter, and her granddaughter watched as a new house was built, one designed by the artist William Penhallow Henderson (1877–1943) and the California designer Wallace Neff (1895–1982).[17] Eva Fényes was intimately involved in the arts community in Santa Fe when she was in residence there. She maintained at her Santa Fe home a collection of small self-portraits provided, at her wish, by the many artists who visited her. Her personal papers in California also reveal many small sketches and portraits made by a multitude of artists, Native and non-Native, whom she knew.

Eva Scott traveled widely throughout the United States, as well as abroad. She made numerous trips to Saint Augustine, Florida, both before and after she married her first husband. During one of those trips, in 1877, she commissioned the books of drawings now in the Braun Research Library's collection at the Autry National Center in Los Angeles. Although not such an exotic locale as Egypt or Tunisia, Saint Augustine between mid-1875 and mid-1878 offered another kind of extraordinary experience. There, Southern Plains Indian chiefs and warriors were held in exile but were also available for viewing, as it were—indeed, for interaction—by visitors to the fort. The proximity of the Southern Plains prisoners to visitors helped eliminate some of the visitors' misconceptions and fantasies about them, yet because the inmates were so far removed from their homes and ordinary lives, romantic, imagined perceptions not dissimilar to those that fueled Orientalism were able to survive. One of Richard Pratt's aims in allowing such visits was to help dispel the negative views that non-Natives held of Southern Plains people, and vice versa—but fantasies are difficult to destroy.

Some visitors to the fort believed that Native people had been mistreated, but others undoubtedly held alternative views. The year 1876 saw not only celebrations of America's centennial but also the two most publicized defeats for the United States Army during the Plains Indian wars, those at Rosebud and Little Bighorn. Although neither battle took place on the southern plains, Euroamericans tended to lump all Plains peoples together. Articles and editorials in the *New York Times* illustrated the public's diverse opinions, some blaming Custer for the disaster at Little Bighorn and others blaming an apparently evil Sitting Bull.[18] Pratt did whatever he could to improve views of the Native prisoners in his charge and separate them from negative opinions generated elsewhere. For example, his timing of a staged "buffalo" hunt at Fort Marion on July 4, 1875, the summer after the prisoners' arrival in Florida, was an attempt to enlist them in an Independence Day celebration. Additional performances and dances were held throughout the remainder of the imprisonment.

Eva Scott visited Fort Marion repeatedly when in Saint Augustine. There she met the Kiowa Zotom and the Southern Cheyenne Howling Wolf, both in their middle to late twenties—close in age to Scott herself. Both prisoner-artists created many drawings during their three-year captivity in Florida, but each approached his work very differently. As the inscription Scott wrote on the inside front cover of the drawing book she

Figure 20.
Eva Scott's inscription on the inside front cover of the drawing book she commissioned from Howling Wolf, 1877. BRL, 4100.G.2.

commissioned from Howling Wolf tells us, she gave Zotom many of the topics or subjects for his drawings, whereas Howling Wolf preferred to choose his own. She wrote: "I sent to New York for the two books and gave many of the titles—or subjects—for the drawings to Zotom. Howling Wolf preferred to choose his own subjects. E.S."

In her later life, Eva Scott Fényes maintained interests in the nation's prison systems and in Native arts; both interests began in Florida. She met the Plains prisoners at Fort Marion at a time when Saint Augustine was developing as a tourist destination. Its mild winter climate greatly attracted people like Scott, who hated the cold, and her father, whose health required warm weather. During her visits there, she spent considerable time with the Southern Plains exiles. An article in *Harper's Weekly* on May 11, 1878, listed Eva Scott among the women who volunteered their time as teachers for the younger prisoners who wanted to learn to read and write English.

Antebellum Florida was considered one of the last American frontiers, equivalent to the American West.[19] Tourists had been attracted to Florida before the Civil War, and

Figure 21.
Cathedral, Saint Augustine. Courtesy Archives of the Pasadena Museum of History, Fényes-Curtin-Paloheimo Papers, box 45, folder 1, p. 14b.

Figure 22.
Bear's Heart (Southern Cheyenne), "Catholic Cathedral, St. Augustine," from his ledger book, about 1875. Courtesy National Museum of the American Indian, Smithsonian Institution, D206231.

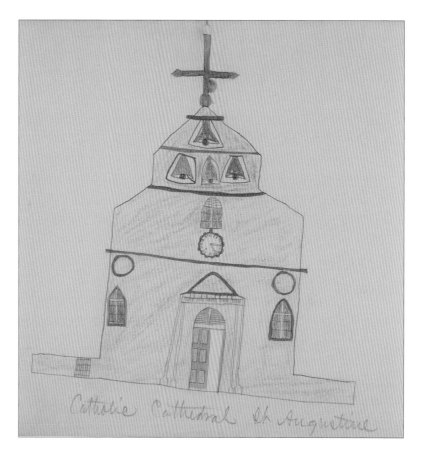

by 1869 visitors had again begun journeying to the South. Some came, as they had previously, for health reasons; others simply sought escape from northern winters. The early 1870s saw improvements in transportation and accommodations in many Southern towns, Saint Augustine among them.

By the time the Fort Marion prisoners arrived in Saint Augustine, Florida's frontier status was fading, but it was still an exotic location, full of swamps and alligators, not to mention evidence of Spanish presence centuries earlier. It had its own Native American population, too—the Seminole people—and the Seminole wars were part of pre–Civil War history. Together with the geography, the flora and fauna, the Seminoles, and local history, the Cheyenne, Kiowa, Arapaho, Comanche, and Caddo people held at Fort Marion brought Florida and Saint Augustine into a world of exoticism rivaling that of distant Asia.

Eva Scott Fényes's papers are filled with photographs and sketches of people she knew and places she visited. In the Saint Augustine she visited in the 1870s, many images of the city, of Fort Marion, and of the Southern Plains prisoners were widely available, some dated and others not. Among the photographers active in the area during the later nineteenth century were Alvord, Kellogg, and Company; O. Pierre Havens; Upton and

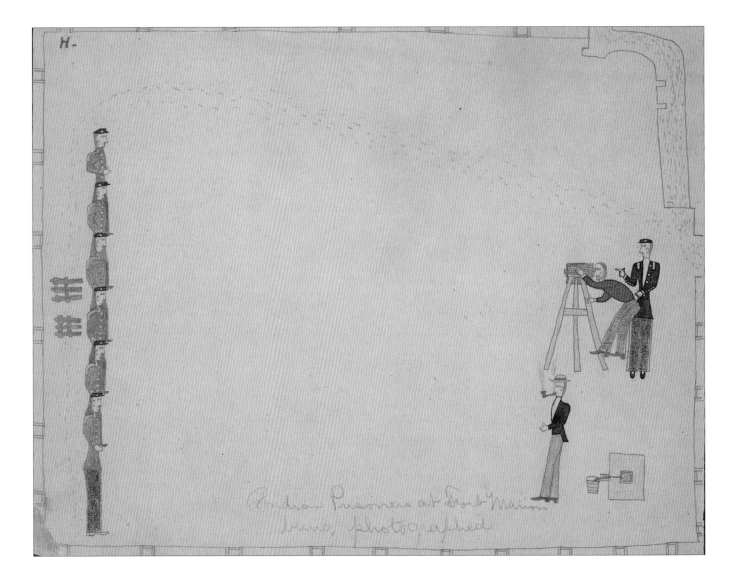

Figure 23.
Making Medicine (Southern Cheyenne), "Indian Prisoners at Fort Marion being photographed." Pencil and colored pencil on paper, 1875. Courtesy National Anthropological Archives, Smithsonian Institution, Manuscript 39B.

Havens; E. and T. Anthony; and a group known as the Florida Club.[20] Their photographs were collected by tourists and used by some of the Fort Marion artists. Detailed photographs of Saint Augustine's architecture can be compared with drawings that some Fort Marion prisoners made of their new surroundings. At least one prisoner-artist, a Cheyenne named Making Medicine, drew a picture of a photographer taking pictures of the men. A sketch of "Champ," dated March 9, 1878, and inscribed "To Miss Scott," found among her other mementos of Saint Augustine, is most certainly of the artist James Wells Champney, who also frequented Saint Augustine during the winters while the Fort Marion men were there. That the young Eva Scott had contact with other artists, both Native and non-Native, in Florida is in keeping with her established practice by that time and with the way she surrounded herself with artists throughout her life.

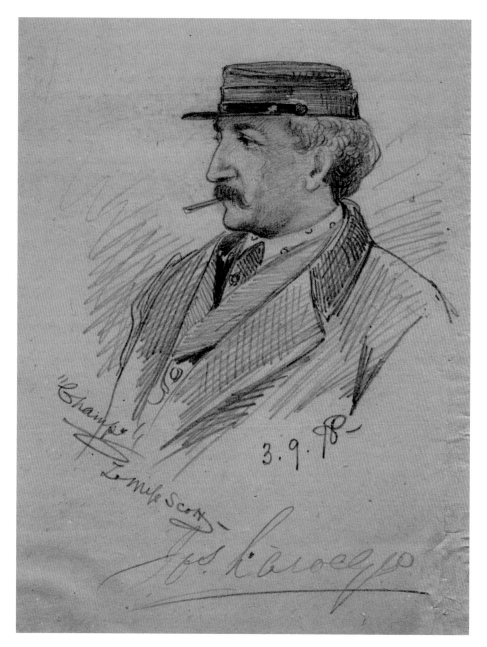

Figure 24.
James Wells Champney, To Miss Scott, March 9, 1878. Courtesy Archives of the Pasadena Museum of History, Fényes-Curtin-Paloheimo

Eva Scott Fényes's connection to Native American artists was not limited to the relatively few visits she made to Saint Augustine. She spent her later life partly in Santa Fe, New Mexico, another city where works on paper by Native artists were being encouraged, exhibited, and collected. In October 1920 she obtained a small self-portrait by the Hopi artist Fred Kabotie, who was then a nineteen- or twenty-year-old student at the Santa Fe Indian School. The self-portrait bears the inscription "Drawn for Mrs. Fényes at Indian

Figure 25.
Fred Kabotie, self-portrait, inscribed "Drawn for Mrs. Fényes at Indian School Santa Fe, 15 Oct '20." Courtesy Archives of the Pasadena Museum of History, Fényes-Curtin-Paloheimo Papers, box 67, folder 39.

School Santa Fe. 15 Oct '20," proving Fényes's knowledge of activities under way at the boarding school at that time. An additional small self-portrait of Kabotie is contained in Fényes's papers in Santa Fe.[21]

In 1918 a small group of students at the Santa Fe Indian School had begun working on their art informally with the wife of the school's superintendent, shortly after John Dehuff (1872–1945) was appointed to that position. DeHuff had met his wife, Elizabeth Willis (1886–1983), while both were teachers in the Philippines. When they returned to the United States so that John DeHuff could accept an appointment at Carlisle Indian School in 1913, they married.[22] Carlisle was where Richard Pratt had inaugurated the off-reservation boarding school project he had fought for while at Fort Marion. He incorporated many of the practices he had employed in Florida at Carlisle, including having the students' hair cut and exchanging their Native clothing for uniforms. Pratt was gone from Carlisle by the middle of 1904, so the DeHuffs did not work with him there, but his influence was still a factor.

In Santa Fe, Elizabeth DeHuff brought seven boys from different pueblos into her home to draw and paint images of dances and other activities familiar to them. Otis Polelonema (1902–81) and Fred Kabotie (1900–85) were both from Hopi; Velino Shije Herrera (1902–73) was from Zia Pueblo; Miguel Martinez and Juan Jose Martinez were from San Ildefonso Pueblo; and Guadalupe Montoya and Manuel Cruz were from San Juan Pueblo (now known as Ohkay Owinge).[23] Each of the students had shown strong artistic skills. By 1919 Elizabeth DeHuff had organized an exhibition of the students' work at the Museum of New Mexico. From 1919 forward, the museum maintained its support of Pueblo Indian painting.

Santa Fe was a small community during the first part of the twentieth century, and people with similar interests sought one another's company. Eva Fényes and Elizabeth DeHuff apparently were close friends. Following Fényes's death in early 1930, DeHuff, who corresponded regularly with her mother in the East, answered a question that had been posed by her, writing that, yes, the Mrs. Fényes who had just passed away was the friend who had lent her the money for her house.[24]

That Eva Fényes and Elizabeth DeHuff developed a friendship is not surprising. Both recognized the value of the arts and supported the development of Native American artists. Both lived at least part of their lives in Santa Fe at a time when artists were being widely encouraged to come to work and exhibit in New Mexico. During the first few decades of the twentieth century, community leaders wanted to develop Santa Fe as an exotic and artistic center. The exotic came through the promotion of Native people and their arts and, to a somewhat lesser extent, the Hispanic people of the area and their creativity. The director of the Museum of New Mexico, Edgar Lee Hewett (1865–1946), was among those most prominent in encouraging a view of Santa Fe as an arts destination. Fényes and DeHuff both knew Hewett and many of the artists who came to New Mexico during the 1920s.[25] Fényes's interaction with both non-Native and Native artists continued for as long as she spent time in Santa Fe.

The activities of young Native artists at the Santa Fe Indian School bear some similarity to those of the Fort Marion prisoners of the 1870s. The students in Santa Fe were generally younger than the Florida men, but both groups of artists were in locations away from their homes and creating works on paper largely for outside audiences. Certainly the longing for home figured into the subject matter that artists in both places selected for depiction. The Pueblo students focused their attention strongly on public ceremonial dances and a few other topics of broad interest, including views of women forming, painting, and firing pottery. Unlike some of the Fort Marion men, the Pueblo artists apparently did not depict their lives at school. Teachers and patrons alike in Santa Fe encouraged them to make pictures of dances and genre subjects. Pueblo dances, in particular, were strongly promoted by Hewett and those around him. The watercolors created by the students working with Elizabeth DeHuff exerted a strong influence on subsequent Native painters, one result being an extensive exploration of dance subjects.

Eva Fényes purchased a painting by the slightly older San Ildefonso artist Crescencio Martinez (1879–1918), either with Hewett's assistance or—more likely, given her established interaction with artists and her independence—directly from the artist himself, perhaps even commissioning it.[26] Completed in 1918, shortly before the artist's death, the painting is of a single antelope dancer from San Ildefonso Pueblo. Hewett was a major patron of Crescencio Martinez and also commissioned works from him, including a series of twenty-four intricately detailed paintings of dancers and drummers rendered in a manner very similar to that in the work Fényes obtained.[27]

San Ildefonso was a major site in the development of Native American painting during the early years of the twentieth century. Indeed, the painting on paper that began there in 1900 when Esther Hoyt came to teach at the pueblo's day school is seen as the beginning of the tradition of Pueblo painting.[28] Crescencio Martinez was older than the students who studied art with Hoyt, but his sister Tonita (1847–c. 1910) was married to Alfredo Montoya (1892–1913), one of the early San Ildefonso student painters. Another relative by marriage, Julian Martinez (1879–1943), also painted at the pueblo. Crescencio Martinez was painting by 1900 and selling his work by 1907. By 1917 he was considered the founder of the Pueblo painting movement.[29] It is no surprise that Eva Scott Fényes obtained a work by a man who was becoming so well known, especially through Hewett's patronage. Martinez apparently signed his work only when he was asked to do so, and Fényes's painting has no signature. This lack of identification is at odds with the usual way she worked with artists.[30]

In 1921 Fényes commissioned two paintings from Fred Kabotie, one of Elizabeth DeHuff's students. Each is a "close copy" of works that the Hopi artist painted the same year for Hewett.[31] One is titled *Havasupai Dance* and shows four dancers, two men and two women, rendered diagonally on the drawing page, with no reference to physical landscape.[32] The other is a rare interior view of a kiva, or ceremonial structure, where two men are preparing objects to be used in a Buffalo dance; items of clothing and ritual paraphernalia are carefully depicted. Although Hewett apparently averred that these two images revealed secret information, Kabotie's correspondence with Fényes denies this, stating that both the Buffalo dance and the Havasupai dance could be performed at any time, suggesting that he was revealing nothing that could not be shared.[33]

Kabotie's letter to Fényes answered questions that she had posed to him about the two paintings. He was particularly detailed about his painting *Preparing for a Buffalo Dance*, undoubtedly because she asked him to explain the objects he had drawn. He indicated that he did not know what everything in the Hopi painting meant but would try his best to answer her questions. Although the letter from Scott is not preserved with the painting, Kabotie's letter is, and his response gives a strong indication of her desire to understand the image. At this stage in her life as a patron of art created by Native artists, Fényes was extremely interested in the subjects Kabotie depicted, the symbolism involved, and what the objects in the works she commissioned from him were.[34] Similarly, her desire to know more about the images in the works she commissions is apparent in the captions she

added to Howling Wolf's and Zotom's drawings, each frequently handwritten on the left-hand page facing the right-hand page on which the drawing was made.

Eva Scott Fényes died in 1930, just before the direction of painting by Native American artists in Santa Fe changed. Under the supervision of Dorothy Dunn (1903–92), the Santa Fe Indian School again took the lead in Native American painting. Although Dunn was at the Indian School for only five years, from 1932 to 1937, the course she set for Native American art in her classroom, known as the Studio, has remained a strong force in Native art to this day. For many people, Studio-style painting *is* traditional Native American painting.

A greater variety of cultures was represented among the young artists in Dunn's Studio than among those with whom DeHuff had worked. Although Studio-style painting was far more complex than a simple stylistic description can convey, it, too, was done on paper, and the most frequently used medium was opaque watercolor. Firmly outlined forms were solidly filled with flat applications of color. Landscape references were infrequent, except for the occasional stylized plant. Subject matter remained heavily genre and dance focused, although some contemporary and nostalgic scenes appeared. For some of the Studio artists, especially those of Diné, or Navajo, heritage, cultural signifiers such as rainbow figures and other celestial elements appeared above the other figurative forms. As J. J. Brody has made apparent, the earlier Pueblo paintings developed under DeHuff's tutelage and at nearby San Ildefonso Pueblo were generally far more complex compositionally, with foreshortened figures turning in space and often with far larger numbers of figures interacting.[35] Some of the earlier Pueblo painters were experimenting effectively with three-dimensionality as they modeled their figures to create illusionistic space. These kinds of experiments were comparatively rare in Studio-style painting, which seems to have been directed more by outside forces, including both Dorothy Dunn and the Santa Fe arts community as a whole.

Dunn published her book *American Indian Painting of the Southwest and Plains Areas* in 1968. It was fitting that she wrote the introductory essay for the 1969 publication of the two drawing books that Eva Scott had collected at Fort Marion in 1877; the two women were connected through their lives of art, their roles as patrons of Native arts, and their knowledge of Elizabeth DeHuff. These three women provide a continuum from Fort Marion to Santa Fe, a thread linking what were some of the earliest drawings on paper made by self-conscious Native artists for outside patrons to DeHuff's unofficial art classes at the Santa Fe Indian School and to Dunn's later Studio, where other young Native people began to make art as self-conscious artists for a large audience. The sixty years and more suggested by these connections were times of immense change for Native Americans. Native artists in Saint Augustine and in Santa Fe recorded many of the alterations in their people's lives.

Collecting and Commissioning Works at Fort Marion
That Eva Scott collected the two drawing books by Howling Wolf and Zotom at Fort Marion is one aspect of those volumes' history. A related yet different part of their

genesis is that Scott commissioned them from the artists, as her handwritten inscription in Howling Wolf's book reveals. The collecting and the commissioning of works each offer a view into the characters of the artists and the ultimate owner. Many people collected drawings from the Southern Plains men at Fort Marion, and Richard Pratt sent books of drawings to other people who might support his agenda for Indian education and assimilation. He campaigned tirelessly for the release of the prisoners, and because of this aim, he sent drawing books to military leaders, humanitarians, and government officials of the day. Although Pratt might have asked specific prisoner-artists at Fort Marion to create books of drawings, no evidence exists that he asked them to portray specific subjects.[36]

So far, the two books now in the collection of the Autry National Center of the American West are the only ones known to have been commissioned at Fort Marion in the way Scott's inscription suggests: "I sent to New York for the two books." Considering her own status as a young artist, she might have sent for art supplies for herself and then given two drawing books to the young men imprisoned in Florida. Her inscription also says that she gave many of the subjects or titles of works to Zotom, whereas Howling Wolf preferred to choose his own. That the men accepted her commission is clear, as is the fact that each did so in his own way, exercising his own judgment about how to approach the commission. Zotom wanted guidance, and Howling Wolf worked more independently.

Other works were commissioned from prisoners at Fort Marion. Some of the men, including Howling Wolf and Zotom, painted women's fans. Pratt's correspondence indicates that a copy of a book of drawings commissioned from Zotom by the writer and activist Harriet Beecher Stowe (1811–96) had been delayed because the young Kiowa man was flooded with requests for fans.[37] In what manner Stowe's drawings were commissioned and what suggestions, if any, she might have offered Zotom are unknown. It seems unlikely that Zotom had an actual book of drawings that he was copying for Stowe. Perhaps she had seen a book of his drawings of events surrounding the imprisonment of the Southern Plains chiefs and warriors and requested one with similar subjects.

What influences the purchasers of women's fans might have had on the subject matter the artists rendered on the fans is impossible to reconstruct. One fan painted by Howling Wolf is now in the Arthur and Shifra Silberman Collection at the National Cowboy & Western Heritage Museum in Oklahoma City. Three vignettes appear on its semicircular linen surface. One shows a hunter pursuing a deer, and another is a rendition of a wounded buffalo goring the horse of a hunter, who has apparently fired two arrows into the buffalo's body. The final third of the fan's painted surface shows two warriors carrying and wearing full regalia, including warrior society staffs, and two elaborately painted lodges, one with a full feathered headdress positioned on a pole nearby. Although the circumstances surrounding the creation of this fan are unknown, it is difficult to imagine that the graphic scene of the buffalo attacking the horse was painted as a requested image, considering the fan's use as a Victorian woman's object.

Although Harriet Beecher Stowe commissioned a book of drawings from Zotom, and other purchasers of Fort Marion drawings may have done so as well, Eva Scott's commissioning of works by Zotom and Howling Wolf remains unique in the history of Fort Marion art as we know it today. Stowe was extremely involved in the human rights issues of her day and was, herself, a creative writer, but she was not a visual artist like Scott. Nor was Stowe a volunteer teacher at the fort. Any influence she might have had on Zotom must have been quite different from Scott's.

Both of the artists whom Eva Scott selected to fill drawing books for her were men who created many images at Fort Marion. In a pivotal 1971 study, Karen Daniels Petersen classified Zotom and Howling Wolf as major artists because of the number of works then known by each man, and more have come to light since then. By 1971 Petersen had found 67 drawings by Howling Wolf, including 8 created jointly with another Southern Cheyenne artist, Soaring Eagle (1851–post-1886), and 108 by Zotom.[38] She provided lengthy biographies for some of the Fort Marion artists, including Zotom,[39] but she did not give one for Howling Wolf in her 1971 volume, undoubtedly because she had already done so in a 1968 publication that focused exclusively on the twelve drawings the Southern Cheyenne man is known to have made after his return to Indian Territory. Howling Wolf's works have been subjects of intense scrutiny, and many more drawings have been attributed to him since Petersen's work was published.[40] Far less attention has been paid to Zotom's drawings, despite the larger number of them. Works by both men have been included in various exhibitions of Plains Indian drawings and paintings.[41]

Howling Wolf, the son of Eagle Head (d. 1881), who was also a Fort Marion prisoner, was born in 1849. He came to young manhood during the time when the Southern Cheyenne people and their allies were fighting desperately to maintain their territory and their way of life. Eagle Head was a chief and had been a strong supporter of the peace faction of the Cheyenne people led by Black Kettle in the 1860s. Howling Wolf, then a teenager, was probably with his father and Black Kettle at the Sand Creek Massacre in 1864, when the sleeping village, supposedly protected by a flag of peace, was attacked by Colorado militia men. Subsequently, Howling Wolf took part in many major battles, some of which he discussed with the Smithsonian anthropologist James Mooney in 1902. Howling Wolf had counted coup (performed culturally-recognized brave deeds), had apparently led war parties, and had risen to a level of leadership in the Cheyenne Bowstring warrior society prior to his imprisonment.[42]

At Fort Marion, Howling Wolf made many drawings, but few of them focused on the Florida experience or even included non-Native people. His earlier drawings are more complex than the ones he created for Eva Scott, undoubtedly because by 1877 his eyesight was failing.[43] Treatment attempted in Florida had made matters worse, and Pratt fought for a way to have Howling Wolf sent away from Saint Augustine in order to save his vision. Finally, in July 1877, private benefactors provided the support that enabled Howling Wolf to travel to Boston in the company of a young army officer on his way north to be

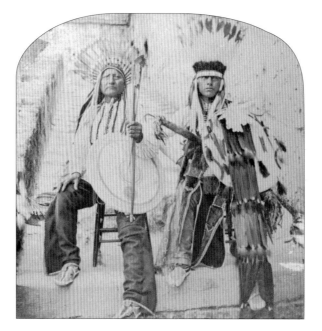

Figure 26.
Howling Wolf (right) and his father, Eagle Head, at Fort Marion. Courtesy Archives of the Pasadena Museum of History, Fényes-Curtin-Paloheimo Papers, box 45, folder 1, p. 2c.

married.[44] Boston was home to the Massachusetts Eye and Ear Infirmary, then the best medical center for vision treatment in the country. Howling Wolf did not return to Saint Augustine until December that year, the sight in one eye gone but that of the other saved.[45] Although dates placed on drawings from Fort Marion are often suspect, Howling Wolf's book for Scott was filled during the winter of 1877. No known Fort Marion drawings by him bearing even suggested dates after Scott's book have come to light. Thus, her drawings by Howling Wolf may be the last ones he created in the Florida prison.

Although Howling Wolf wanted to stay in the East for further study following his release from Fort Marion in mid-1878, he was unable to do so because of poor eyesight. Instead, he returned to the Cheyenne and Arapaho reservation and worked in various ways, trying to follow the manner of life he had learned in the East. But like nearly all the Fort Marion men, he found the reality of reservation life depressing. He died in 1927 in an automobile crash during a trip home from Texas, where he had been performing in a wild west show.[46]

Zotom, too, was an accomplished warrior who had taken part in battles against Native and non-Native foes before his imprisonment. Born in 1853, Zotom was four years younger than Howling Wolf but had been engaged in the same kind of intense struggle to preserve Kiowa life. Accounts provided both during and after Fort Marion refer to Zotom as strongly self-willed and initially difficult for Pratt to control. Ultimately, Zotom became a bugler at Fort Marion. Following his release from prison, Paul Caryl Zotom, as he was then known, went to New York for study that would lead him to become a deacon in the Episcopal Church. He returned to Indian Territory six years after

his arrest. Confronting the difficult conflicts of readjustment to life on the reservation, he left the ministry in 1894. He died in 1913.[47]

Zotom and Howling Wolf were not only established warriors and noted artists, undoubtedly respected by younger prisoners in Florida, but also expert dancers. When, with Pratt's encouragement, a benefit was organized in Saint Augustine, the more senior chiefs being held at Fort Marion selected their best dancers, Zotom and Howling Wolf, to represent their cultures at the event.[48]

Howling Wolf and Zotom as Artists

Although the two prisoner-artists shared much, problems arise in comparing their Fort Marion drawings. From an anthropological and purely contextual standpoint, an initial difficulty in analyzing their work is that the two men were from different cultures. This is more significant than it might seem at first glance. Although some writers have discussed Kiowa artists and how their work at Fort Marion developed from the Plains Indian practice of recording heroic actions in battle and although various Kiowa people have offered assurances that such imagery did exist, little visual evidence of pre–Fort Marion battle imagery remains. By comparison, Cheyenne warriors were prolific as artists of painted hides and, as paper became available, of drawings that detailed bravery in war. The Kiowa people were skilled historians, with select calendar keepers who marked important events on hide and on paper; Cheyenne people generally did not maintain these types of records.[49] Both groups, however, used their representational systems, whether calendars or drawings on paper and paintings on hides, as vehicles for maintaining cultural memory.

Familiarity with calendar entries representing noteworthy events might have been part of the reason Zotom, a Kiowa, often chose specific, identifiable events to record in his Fort Marion drawings. The tiny vignettes that appear on the sketch Zotom apparently used as a guide for drawings detailing the surrender of the Kiowa people and the prisoners' trip to Florida (see fig. 11, chapter 1) offer an intriguing comparison with entries in Kiowa calendars. Zotom's sketch is more than a crib sheet; it is a calendar of events, arranged linearly, which the artist often followed in depicting the events that led to his life in Florida and the reality of making drawings for purchasers like Eva Scott. He was a historian who took the Kiowa practice of cursorily noting events and expanded it, in his finished drawings, to produce fully detailed, narrative visual accounts. Perhaps it was through association with artists from other Native cultures or through the different representational systems he encountered in Florida that he began to expand cryptic suggestions into full illustrations. That the incidents leading to the Kiowa prisoners' arrest and their trip to Florida were the subjects he most often repeated underscores his close ties to Kiowa practice. Zotom was indeed a historian, and his sense of history—his recording in detailed visual format the events that led him to Florida—is one of the most telling aspects of his book of drawings for Eva Scott. Zotom was relaying the history of the Kiowa people, focusing intently on the prisoners who were incarcerated in Florida.

People from other Southern Plains cultures became parts of the narrative because they, too, were imprisoned.

Distinctly different subjects also appear in Zotom's drawing book—themes unknown in his other drawings and in Fort Marion art as a whole. The drawing labeled "Bride and groom," for example (see plate 12, chapter 3), and the view of a child's funeral (see plate 13, chapter 3) may well be autobiographical, but they also suggest the possibility of Eva Scott's keen interest in Kiowa customs. Later in her life, when she obtained paintings from the Hopi artist Fred Kabotie, she requested information about what he had depicted, which underscores her need to understand his life and what he rendered. Perhaps the two images from Zotom's book were subjects she suggested. But whether Scott chose the subjects or Zotom did, both drawings contain content of importance to the artist. These images of tender family moments have no obvious counterparts in other known Kiowa drawings from the Fort Marion period or earlier. Another image, this one of a persimmon tree on an oval patch of landscape (see plate 16, chapter 3), is also so distant from Kiowa (or Cheyenne) imagery that it, too, suggests Scott's involvement. Although there is no way to reconstruct with certainty which subjects she provided, those that are not found elsewhere in Zotom's Fort Marion work offer the best possibilities.

No matter which themes Zotom chose independently, Eva Scott might have guided him by suggesting, as one artist would to another, that he explore personal and emotional subjects. Whether or not this is true, her offering topics for Zotom to illustrate underscores the more active role she played in the development of his book of drawings than the one she played in Howling Wolf's work. Zotom had, however, already filled books with drawings before 1877, when Scott commissioned him. Although concretely dated drawings from Fort Marion are few, the man who drew the images in Scott's book was already an extremely competent artist, confident of his ability to render narrative images of historical incidents. Zotom's 1877 drawing book includes subjects and approaches to those subjects that he had already honed during his confinement in Florida, as well as images that explored new ground.

Fort Marion drawings in general do not focus on Plains Indian warfare. Although some battle scenes exist, they are far outweighed by representations of life in Florida, the journey there, and more peaceful aspects of life on the plains. The difference between the percentages of battle images made before the Florida imprisonment and those made at Fort Marion is startling: roughly 90 percent for the earlier years and only 10 percent for Fort Marion.[50] Some scholars have argued that the men were advised against depicting or were even forbidden to depict battles.[51] Such views deny the Fort Marion artists the ability to have determined for themselves what might have been unacceptable under the circumstances in which they found themselves. Although imprisoned, these men still made many decisions that affected their lives in Florida.

Despite the relative paucity of battle images in Fort Marion art, Zotom provided three in his book for Scott. One she labeled "A Kiowa chasing a Navajo" (see plate 5, chapter 3), although it is unlikely that the man in the full feathered headdress is a Navajo.[52] Another

drawing bears the caption "A scene in Indian Warfare Battle between Osage and Kiowa braves" (see plate 17, chapter 3). Again, the caption may be in error in its identification of the enemies depicted. But even if these two titles are inaccurate, it is clear from Zotom's visual representations that both drawings are of battles between Native enemies.

The third battle drawing (see plates 27 and 28, chapter 3) differs markedly. It comprises two facing pages in the drawing book and incorporates a large number of figures. The battle is between the United States Army and Native forces. The soldiers have wagons and cannons, and only one man, apparently the highest-ranking officer visible, is on horseback, raised saber in hand. A few Kiowa warriors have bridged the seam of the book, but most of them appear on the right-hand page. Almost all of them are mounted and moving toward the battle on the facing page. Zotom's "great battle" is different in scale from his other two renditions of warfare, and it also stands out because the Kiowas' enemies are army troopers. Drawings detailing Plains warriors battling non-Native enemies are exceedingly rare in Fort Marion art. It is still uncertain whether this was subject matter the artist selected for himself or a subject that Eva Scott suggested in her desire to know more about Plains Indian life.

Gus Palmer Jr. has studied storytelling among the Kiowa people as a way of relaying memories in day-to-day life and of perpetuating larger, culture-wide narratives, which often recount the actions of tricksters and heroes.[53] He has established the characteristics of good Kiowa storytelling, as well as reasons why storytelling has continued. A major impetus is to keep hope alive.[54] In the depressing atmosphere of the Fort Marion imprisonment, this function would have been vital. Stories need to be told accurately, say Kiowas, "like they are real."[55] Storytelling also involves interaction between narrator and listeners. Listeners cannot be passive; they must enter into the narrative whenever they can. In order to facilitate this, stories are left "wide open."[56] In Palmer's experiences with Kiowa narrations, "participation made all the difference: to be both listener and participant makes Kiowa storytelling manifest and whole."[57]

The inscription that Eva Scott wrote on the inside front cover of the book she commissioned from Howling Wolf, stating that she gave many subjects and titles to Zotom, is difficult to align with what we know about Zotom as an artist who had created multiple drawings of many of these same historic events before he accepted Scott's commission. But considering the requirements for telling a story the Kiowa way, as described by Palmer, Zotom's willingness to have Scott provide at least some of the subjects and titles can be understood as a way to allow viewers, taking the role that Palmer ascribed to listeners, to enter the dialogue. Zotom might have allowed Scott to be an active participant in accord with his understanding of visual storytelling and its connection to Kiowa oral narration, especially because she had commissioned his book. Her suggestions of subjects, along with the captions she wrote to accompany the drawings, placed her in a pivotal position in the storytelling in which Zotom was engaged.

Additionally, Zotom's apparent desire to have Eva Scott suggest subjects may have been tied to the Kiowa practice of maintaining calendars. Since this was a commissioned

Figure 27.
Howling Wolf, circa 1874 to mid-1875.
Ink, pencil, and crayon on paper, 8 by
12.25 inches. Page 32 of a ledger in the
Allen Memorial Art Museum, Oberlin
College, Oberlin, Ohio. Gift of
Mrs. Jacob D. Cox, 1904.1180.9,21.

book of drawings, the artist might have approached it in the same way in which Kiowa calendar keepers accepted their responsibility to record what the community considered memorable events of various years. If so, then obtaining Scott's views of what she wanted to see represented would have seemed appropriate to Zotom. In comparison, members of cultures such as Howling Wolf's apparently were accustomed to greater freedom in selecting deeds to represent in their visual war records, as long as they adhered to the truth.

Howling Wolf came from a cultural and artistic background very different from Zotom's. Although both Kiowas and Cheyennes valued heroic actions highly, large numbers of remaining nineteenth-century Cheyenne drawings and paintings indicate that Cheyenne warriors used representational art as part of the cultural recognition of those actions. Howling Wolf arrived in Florida already practiced in the Cheyenne system of recording battle exploits. He also entered Fort Marion as an experimental artist who had begun to expand the subject matter he drew to include scenes of courting, ceremonies, and hunting buffalo.[58] His competence as an artist before Florida is clear also in his willingness to turn figures in space, to foreshorten both humans and animals, and to

employ with great skill pictographic elements that suggest past, present, and future actions. Howling Wolf's work changed in Florida in dramatic ways. Despite his previous practice in recording battle encounters, he drew these subjects infrequently at Fort Marion. Few elements of pictographic shorthand are apparent in his Florida work, and although his sense of design was extremely strong, his later work from Fort Marion begins to suggest the deterioration of his eyesight.

Zotom was a historian in many of the drawings he created for Eva Scott, but he did offer some views of the plains with telling details concerning his culture. In comparison, Howling Wolf was a focused ethnographer. If we consider ethnography to be descriptive anthropology, then what Howling Wolf did in the great majority of his drawings in Eva Scott's book, as well as in many he created in other volumes throughout his Fort Marion period, was to provide ethnographic views—visual descriptions—of Cheyenne life. His chiefs wear extremely detailed garments and hold other objects indicative of their position in Cheyenne society. Members of warrior societies carry readily recognizable emblems of those groups, and women engage in daily activities that were essential to the maintenance of life.

Howling Wolf's pre–Fort Marion drawings are almost exclusively battle oriented.[59] They are autobiographical and biographical, depicting his own exploits and those of several other men, including his father, Chief Eagle Head, and another Cheyenne chief, Heap of Birds (d. 1877). Both men were imprisoned in Florida, and Heap of Birds died there. Howling Wolf also rendered a warrior society dance, with himself and the members of his warrior society, the Bowstrings, in prominent positions, and a Sun Dance, in which the artist, wearing a feathered headdress, is among the few men allowed to ride into the Sun Dance lodge, something only the bravest men could do. A courting scene is less obvious in its testimony about the artist's standing as a warrior, although among the Cheyennes, a young man could not court a woman until he had proved himself in battle. The courting representation, therefore, is a recognition of Howling Wolf's position as a warrior. The final nonbattle image in Howling Wolf's pre–Fort Marion ledger is one of a buffalo hunt. Hunts were not testimonials to a man's battle prowess, but they did indicate his success in providing food for his family and the village as a whole.

In instances in which the encounters Howling Wolf drew before his imprisonment have been aligned with known events, his drawings are accurate historical representations. This is in accord with the Cheyenne need for honesty, which was evidenced in many ways, particularly in the manner in which men, whether warriors recounting their heroic encounters or storytellers recalling ritually important narratives, told stories.[60] In the book that Howling Wolf drew for Eva Scott, although it is probable that he recorded specific events in many of the images, they are not readily recognizable as such. He drew no panoramic battle scenes or identifiable actions that would make the events decipherable. He did so at times, in other Fort Marion drawings; the four-page sequence he drew of the preparations for and negotiation of the Medicine Lodge Treaty is a striking example.[61] The majority of his Fort Marion drawings, however, are focused on detailed presentations of

information about people and objects, cultural practices, and places. His work in Eva Scott's book is descriptive, whereas Zotom's is often more historically narrative.

This does not mean that Howling Wolf did not intend to communicate with people who viewed his drawings. Quite the contrary: he was telling them a great deal about his culture. Contemporary assessments of Native people writing about their own cultures rather than allowing non-Native people to write about them sometimes refer to this practice as autoethnography. Autoethnographers place themselves in control rather than yield control of information to others. One definition of autoethnographies holds that they "self-consciously explore the interplay of the introspective, personally engaged self with cultural descriptions mediated through language, history, and ethnographic explanation."[62] To this list, I would add visual information. Plains Indian imagery, even the more fully pictorial forms developed by many men at Fort Marion, is narrative; it is also language.

Among the synonyms for autoethnography are the terms *narrative ethnography* and *native ethnography*.[63] All the terms are appropriate for Howling Wolf's drawings. Through his images, he was an ethnographer describing himself and his people, visually interpreting information about his culture for others. Contemporary Native autoethnographers are sometimes referred to as practitioners of postmodern ethnography.[64] Howling Wolf and any of the other Fort Marion prisoner-artists concerned with rendering cultural information of their own selection were also "bicultural insiders/outsiders"; *transcultural* is another currently used descriptor for such exchange.[65] Many researchers have used the concept of "culture brokers" for people who bridge cultures through various types of actions.[66] These phrases apply to Howling Wolf as well, but given his intent focus on descriptive anthropology connected to his autobiography and to his own culture, *autoethnographer* is the more appropriate term.

Although it can be argued that Howling Wolf did not offer "explanations" in a classic ethnographic sense, he may have provided Eva Scott with at least some of the information that allowed her to add captions to his drawings. Unlike Zotom, Howling Wolf preferred to select his own subjects. In this way, and in the way he rendered his images, he controlled the information conveyed about his culture and drew what he considered important to relay—nothing more and nothing less.

To a greater degree than Zotom, Howling Wolf was concerned with pattern and design, with colorful repetitions and alterations of shape and line. Zotom tended to be less meticulous about such decorative details, but he paid careful attention to turning figures effectively and suggesting that they occupied real space. His figures, both human and animal, often appear in foreshortened and three-quarter positions. Both men were adept at rendering landscapes as settings for the actions they depicted, but they chose to employ their pictures of places differently. With the exception of the lone persimmon tree and flowers that appear as the subject of one of Zotom's drawings (see plate 16, chapter 3) and a few images in which he cursorily suggested the ground on which a building or a few figures stood, the Kiowa artist reserved his full landscapes for scenes

of the surrender of the Kiowa people and the prisoners' journey to Fort Marion. Howling Wolf, on the other hand, provided complete landscapes for everyday views of life on the plains, in which people move within richly hued and extremely detailed renditions of his homeland (see, for example, plates 50–54, chapter 4).

Other drawing books filled with images by each of these artists are known from the Fort Marion period. A close examination of the works of each man demonstrates that Zotom repeated imagery in his drawings much more often than Howling Wolf did. Zotom used fully one-third of the pages in the book commissioned by Eva Scott to render views of the journey through Indian Territory and of cities in the Midwest and East through which the prisoners passed on their way to Saint Augustine. Although Howling Wolf, too, occasionally drew images of Florida, he far more often produced views of life on the plains.

That Howling Wolf and Zotom approached the drawing books Scott gave them in different ways is clear. Yet, all these observations have to be tempered by Scott's inscription concerning Howling Wolf's preference for choosing his own subjects and Zotom's willingness to accept suggestions. Perhaps Zotom did so more readily because he was less practiced in narrative drawing than Howling Wolf. How extensive Scott's recommendations were and how pronounced her influence was remain unknown, but it is difficult to imagine her, a young artist herself, exerting excessive control over another young artist. Whether or not topics were proposed to them, both artists controlled the way they rendered those subjects and what information they included. What Howling Wolf and Zotom each provided in their respective drawing books were works of individualism that, in spite of the artists' captivity, stand as testaments to the creative outpouring of one brief period in Plains Indian art. The stories they tell and the histories they reveal can be only partially grasped, but their significance is clear.

Howling Wolf's experience with and exposure to representational drawing and painting on the plains did not stop him from expanding his repertoire of subjects and the manner in which he rendered them. Most of his drawings for Eva Scott portrayed animal hunts and other genre scenes from the plains, but some intriguing subjects in his book offer little comparison to other known drawings. His rendition of a Plains man fishing (see plate 53, chapter 4), although it fits the category of "daily life," is certainly an atypical subject for drawings made either on the plains or at Fort Marion. The inmates did enjoy both sailing and fishing for sharks, which, as Pratt recorded, they called "water buffalo."[67] Perhaps Howling Wolf's drawing showing a man fishing at home offered a connection between his past and present lives.

Another uncharacteristic drawing for Howling Wolf is one of his buffalo hunts (see plate 36, chapter 4). Although such images were drawn frequently in Florida, Howling Wolf's is dramatically different because the hunter is not a Plains Indian, but a United States soldier, his uniform clearly rendered. This might have been the artist's way of suggesting that other people hunted buffalo on Cheyenne land, thus endangering his people's main food source and an animal vitally important to their worldview. Whatever

the reason he drew it, his buffalo hunt stands out among his other drawings and those of other Fort Marion men.

Like Zotom, Howling Wolf drew for Scott a scene that is labeled a wedding (see plate 58, chapter 4), but he approached his image very differently from the way the Kiowa did. The Cheyenne wedding is a larger, panoramic scene with onlookers, including a non-Indian army officer. Zotom's couple sits under an umbrella, whereas Howling Wolf's bride and groom walk toward their lodge in the camp, which sits in a fully landscaped setting.

That both Zotom and Howling Wolf rendered weddings, or what Scott labeled a wedding and a bride and groom, is intriguing. Other Fort Marion artists may have drawn this subject as well, but given the captions that Scott provided for her books, viewers are led to recognize the subjects as what she labeled them. Her captions, like others applied to Fort Marion drawings, instantly became permanent parts of the works and altered the ways in which viewers understood them. Even though the captions are wrong in some instances, their presence generally outweighs the visual narrative the artists provided. Viewers in the late nineteenth century would have accepted the titles without question, just as most subsequent viewers have. In this way, Scott's power over the men and their drawings was paramount.

Captions or titles direct viewers to interpret images in specific ways and to look for particular indicators that verify the title. In Zotom's drawing, viewers examine the "bride and groom" and the way they are seated with certain objects, including the umbrella above them. In Howling Wolf's drawing, viewers looking closely observe the sword the man carries, as well as other objects, and people of importance to the narrative.

Not only do people respond differently to works of art, but also each time a viewer examines the same work, his or her response differs from the previous one. The first examination may carry with it moments of discovery and intrigue, and subsequent viewing may continue this kind of discovery if the viewer looks again with discriminating eyes. More information can thus become available. Others may view works initially with fascination but lose interest with additional examination. Either way, no two viewers respond to the drawings in precisely the same manner. Eva Scott's original examination of the drawings she commissioned from Zotom and Howling Wolf must have been filled with an artist's characteristic intensity. It must have carried with it associations arising from her knowledge of the men, the prison, the classroom, and Saint Augustine. In subsequent years, the drawings would have helped maintain some of these memories, as well as her sense of the works as artistic expressions. Yet, her responses to the drawings presumably changed over time, because she had changed with intervening experiences.

Zotom and Howling Wolf had multiple intentions as they fulfilled Scott's commission. Among those were recording historical events in which they had taken part, recalling life on the plains, and rendering their new surroundings and activities in Florida. They also, arguably, became self-conscious artists in the unfamiliar place in which they drew their images. Each man experimented widely in his drawing book, moving

subject matter well beyond what had been customary in his culture on the plains. Even if some of Zotom's experimentation was spurred by Scott's giving him titles or subjects for drawings, the ways in which he rendered those subjects involved creative exploration of his own.

The captions or titles found on Scott's drawings raise the question of their origin and whether Scott's inscription in Howling Wolf's book refers to these handwritten notations or to the subjects of the drawings themselves. Might the wording of her inscription be an indication that she provided titles only after the fact, rather than give them to Zotom before he drew, as a way of guiding his creativity? And would Howling Wolf himself have selected titles to apply to his drawings?

An examination of the drawings and their captions supports the view that Scott provided titles for Howling Wolf's drawings after the fact. The long caption for one drawing in his book (see plate 42, chapter 4) certainly suggests that Scott recorded information that the artist, Richard Pratt, or the interpreter at Fort Marion, George Fox, might have offered: "One of the Indians holds a Tomahawk, the other a sword. The string of disks down their backs is composed of silver dollars beaten out thin." The last sentence, in particular, represents Eva Scott, the artist, providing visual analysis: "The Wigwam is presented in a different position from that given in the first picture of one." Scott apparently felt the need to point out the altered position of the lodge in this later drawing, whether to ensure recognition of the lodge, or "wigwam," as she called it, by other viewers of her book or to point out Howling Wolf's artistic virtuosity.

Men who made many drawings during their three-year confinement at Fort Marion would have been affected by the artwork of their fellow inmates. The case of the two wedding scenes offers a tantalizing suggestion of just this type of influence. Whether Zotom drew his view first, at Eva Scott's suggestion or from his own inspiration, or Howling Wolf rendered the subject first, both men explored what may be the same subject in Scott's books. Each of them also provided views of buffalo hunts, village life, and warrior society gatherings, all of which are frequent subjects among extant Fort Marion drawings.

Commissioning drawings from two individual artists indicates a more personal relationship between the patron and those men than merely collecting works from them might suggest. Patrons have long had, and continue to have, great influence over artists with whom they have contact. To collect a book of drawings from the Fort Marion prisoner-artists required no knowledge of the men. Given Scott's position as a volunteer teacher at the fort, she already had a stronger connection with the prisoners than mere visitors to the fort would have had. The commissions that Howling Wolf and Zotom accepted carried with them an acknowledgment of that connection.

Men on the Great Plains who were asked by other warriors to portray their deeds on either hide or paper might be considered to have been warrior-artists working on commission, albeit in a dramatically different cultural setting. They would have adhered to the truth of the heroic narrative as imparted by the warrior. Such warrior-artists drew

or painted images for others because they were seen as being more highly skilled. Howling Wolf, for example, rendered images of his father, Eagle Head, in battle, as well as the Cheyenne chief Heap of Birds. In each of these images, the battle details are clear, but this did not interfere with Howling Wolf's freedom to experiment (see fig. 52, chapter 4).[68] As Scott's books from Fort Marion attest, her commission did not inhibit either Howling Wolf's or Zotom's ability to render images in diverse ways, either.

Elsewhere during the late nineteenth and early twentieth centuries, Plains Indian artists accepted commissions to draw and paint various kinds of imagery. Perhaps the best known are the many commissions that the Kiowa artist Silver Horn fulfilled. Some of these were for specific subjects that would not have been rendered in pre-reservation Kiowa society. As Candace Greene has discussed, Silver Horn began drawing representations of Kiowa stories "for his own pleasure," but General Hugh Scott, who had an avid interest in Kiowa narratives, commissioned him to draw many more. Hugh Scott censored some drawings and undoubtedly requested specific images to illustrate stories he had already gathered.[69] James Mooney also commissioned hide paintings from Silver Horn that illustrated intricate details of events surrounding the Kiowa Sun Dance.[70]

Both Hugh Scott and James Mooney were acting as anthropologists, and their primary goal was to obtain cultural information. Scott was cognizant not only of his personal desire to gather as many Kiowa narratives as possible but also of the need to publish only those illustrations that would not be offensive to an American public. Some of the Sanday, or trickster figure, stories would have been too sexually graphic.[71] Mooney, who had decided to work among the Kiowas during his Smithsonian-sponsored research because they were less acculturated than many other Plains groups, sought ritual information, as many other early anthropologists did elsewhere, in their rush to gather as much as possible before Native people and their practices disappeared altogether.

Eva Scott was extremely different from Hugh Scott and James Mooney. She was not an anthropologist, nor was she resident on the Great Plains among people living there. She was a volunteer teacher working in a prison in Florida with exiled Southern Plains chiefs and warriors. She was a non-Native, to be sure, but as a woman, she was in a position very different from that of Hugh Scott and Mooney. In addition, she was a skilled artist of approximately the same age as the men from whom she commissioned her books of drawings.

Unlike what is known about many other patronage relationships between Native artists and non-Native people during the late nineteenth and early twentieth centuries, such as those of various Great Basin and California basket weavers and their patrons, no evidence indicates that Eva Scott maintained long-term contact with Howling Wolf and Zotom after their release from prison. Her role as their patron ended, and the artists themselves, like the other Fort Marion prisoner-artists, soon stopped creating drawings like those they had made in Florida. From existing evidence, it appears that Scott's commission of Howling Wolf and Zotom was a single event. Later in her life, she did obtain works from other Native artists, as discussed earlier.

Eva Scott's Presence in Howling Wolf's and Zotom's Books

Like the papers of other visitors to Saint Augustine in the 1870s, Eva Scott Fényes's personal papers contain photographs of the prisoners and the city, but she used two of those images in important ways when she created title pages for the two drawing books she commissioned. That Scott considered Howling Wolf and Zotom artists rather than merely exotic curiosities is clear in the way in which she commissioned the books themselves and the way she employed these photographic portraits. Her title pages each feature a photograph of the artist and his name; she also identified Zotom by tribal affiliation. The elaborate lettering of each page and the very titles she selected for the volumes placed the drawings in context. In smaller lettering, "Zo-Tom" is specifically identified as "the artist" of his volume, which is titled *The Life of the Red-Man. Illustrated by a Kiowa Brave* (see plate 1, chapter 3). The title page for the second book, *Scenes from Indian Life. Drawn by Howling Wolf*, includes not only the artist's photograph but also the dated inscription "Fort Marion, St. Augustine, Fla. 1877" (see plate 32, chapter 4), corresponding to the way Scott recorded the artist's name, the date, and the place of collection for many of the other works she obtained throughout her life.

Scott's use of photographs on the title pages placed the two men in the company of other artists of the time from other cultures. Artists' portraits were an important means of establishing the artistic personality, of making the artist known as both an individual and a professional in late-nineteenth-century America.[72] Throughout the majority of her life, Scott was surrounded by other artists. In Florida, she clearly included the two Plains men from whom she commissioned these drawings in that world of artists she so valued. Conforming to the manner in which individual artistic personalities were typically noted in the art world, she preserved both the self-portraits each man provided in his drawings and the artists' objectified photographic likenesses—photographs were becoming increasingly available at the time—uniting the self-portrait with the visual record captured by the photographer.

Scott's identifications took an important step beyond the more general artist identifications and captions added to many other Fort Marion books. She presented each man as an artist, recognizable by his style because each volume contained the work of only one man. Although many other Fort Marion books contain drawings by a single artist, some were filled with images by two or more men. Zotom and Howling Wolf presented many self-portraits in their books, their identities sometimes indicated by captions but more often by clothing and accouterments. But objectified views of the men, offered through photographs taken by others, added another dimension to views reflecting the ways in which they wished to be seen.

The photograph of Howling Wolf on Scott's title page came from a stereocard that showed him seated by himself on stone steps at Fort Marion. Zotom's was cut from a group photograph of nine warriors. Because of the different sizes of the men in the original photographs, Scott created a background for Zotom's image, something she did not do for the larger photograph of Howling Wolf. She also framed Zotom with her own

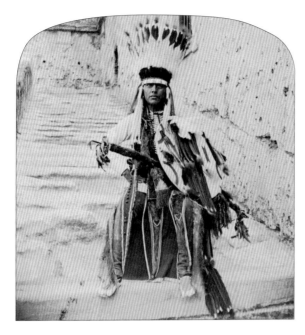

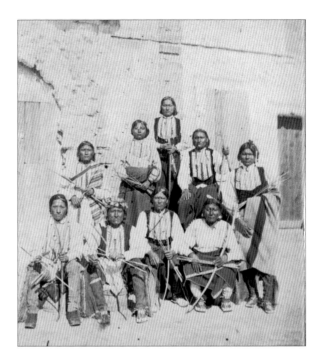

Figure 28.
Howling Wolf at Fort Marion.
Courtesy Archives of the Pasadena
Museum of History, Fényes-Curtin-
Paloheimo Papers, box 45, folder 1,
p. 2a.

Figure 29.
Group of prisoners at Fort Marion.
Zotom sits at far left in the front row.
Courtesy Archives of the Pasadena
Museum of History, Fényes-Curtin-
Paloheimo Papers, box 45, folder 1,
p. 2b.

renditions of bows and arrows similar to those the Kiowa artist holds in the photograph. With her adjustments for the sizes of the photographs, she was able to make the ornately embellished lettering of the books' titles approximately the same size, and the two covers were equally balanced. Each man is framed, whether only by the elaborate lettering of the title or, in Zotom's case, also by what would have been clear nineteenth-century signifiers of Plains Indian identity—bows and arrows. It is noteworthy that the Fort Marion men appear, as they did in many photographs, in Plains clothing, not in the military-style blue uniforms that Pratt requisitioned for them, uniforms that would soon become closely associated with off-reservation boarding schools. Although photographs do exist of the men in their prison uniforms, the images that Scott chose for her title pages emphasize the lives and identities of the men on the plains, not in Florida. So, too, the majority of the drawings that Zotom and Howling Wolf made for Eva Scott reflect their lives on the plains, not in prison.

Just after the Civil War, certain types of books developed as nostalgic ways of remembering others and became a strong part of much of American culture, particularly for women. Leather-bound autograph books became important keepsakes, their popularity undoubtedly building on the great losses that many families endured during the war.[73] Such personalized keepsakes, as well as the continuing practice of maintaining scrapbooks, added to the records of people's lives. That artists' books could become mementos of experiences is evident in the drawing books that many visitors to Saint Augustine collected from Fort Marion prisoners between mid-1875 and mid-1878.

By the 1870s, photography was growing as a means of preserving memories. Albums designed specifically for the standardized sizes of early photographs were newly available.[74] Such books bear striking similarities to the visual books created by Fort Marion artists. Photographers were at work in Saint Augustine, making photographic records of the prisoners, other people, and sites in the city. Some Fort Marion drawings are clear references to such photographs.

Eva Scott purchased her two books of drawings directly from the artists during her 1877 trip to Saint Augustine. Each of the volumes was a commercial drawing book measuring approximately six by ten inches, filled with unlined pages. She obtained the two small books from New York. Because Richard Pratt repeatedly ordered art supplies, including books, for the men to use, Scott's decision to order her own books for Zotom and Howling Wolf is important. Hers were smaller than many other Fort Marion drawing books; although a variety of dimensions exists, eight-by-ten-inch pages were more common. Scott's books were also hardbound, whereas the majority of other Fort Marion drawing books had soft covers. Eva Scott's ordering a different type of book for the two artists she selected and her commissioning of the drawings, in addition to the careful manner in which she subsequently maintained the volumes, reveal much about her attitudes toward the artists and their works.

By adding decorative script in multiple colors and adhering partial photographs to the title pages of each book, Scott combined the practice of maintaining scrapbooks with her collecting of the artists' books, bringing together two important uses for books in the 1870s. She also added decorative elements by framing Zotom's photograph with two bows and three arrows—clear, stereotypical signifiers of Indianness. Perhaps Scott believed that Howling Wolf's photograph alone, without such a device, clearly established his identity as a Plains warrior. Howling Wolf wears a feathered war bonnet and holds a lance and an elaborately decorated shield; he needs no additional script to establish his identity. Even the decorative text Scott used for Howling Wolf's title page, while revealing her hand in its creation, is simpler than the title she provided for Zotom's book. *Scenes from Indian Life. Drawn by Howling Wolf* is a clear statement of fact. Her inscription for the other book is both more dramatic and more definitive in categorizing the artist: *The Life of the Red-Man. Illustrated by a Kiowa Brave.*

The photographs on the title pages are personalized records of the two men, but they were also part of Eva Scott's way of leaving her imprint on their work. Through her selection of the photographs and her decoration of the title pages, she determined how the artists would be identified. In Zotom's case more than Howling Wolf's, she established the roles by which he must be known: Zo-Tom the artist, red man, Kiowa, and brave. These active interventions would have framed a viewer's initial opening of the volumes.

That the artists of Scott's books are identified is not unique among surviving Fort Marion drawings. Many books collected during the three years of the Plains Indians' incarceration include written inscriptions stating that the drawings were made by a particular prisoner. Probably most of these inscriptions, as well as captions identifying the

subject matter of individual drawings, were provided by Richard Pratt, by one of the teachers at the fort, or by the interpreter, George Fox. They added these captions and artist identifications—though not all of them are accurate—for the purchasing audience, which was unfamiliar with Plains representational imagery and valued artists' signatures and titles for works of art. Such identifications were neither required nor valued on the Great Plains during the nineteenth century, because artists made drawings for use within their own cultures. Warriors knew who had the right to render which images, and drawing books were used in ongoing cultural contexts to recall and thus maintain the group's history. The images, combined with verbal narrations, told the stories that were important to tell, and group memories kept those stories alive.

Commissioning works of art, no matter by whom or during what period, often entails a combination of voices, the artist working in accord with the commissioner. Both Zotom and Howling Wolf were practiced, skilled artists, but given the inscription Scott provided, it can be argued that her own voice was more at work in Zotom's book than in Howling Wolf's. Much has been written about the situation of captivity of the Fort Marion artists and about influences that affected their art, but little attention has been paid to the effects of specific patrons who purchased drawing books from them. In most cases, it is unknown whether a drawing was made specifically for an individual purchaser or for a general audience. The Autry National Center's books offer an important opportunity to explore drawings created by two known artists who were commissioned to create them for a single patron.

Like Scott's title pages, the captions she added to the drawings form an overlay on the artists' work. They reflect the way Scott herself saw the drawings and have altered the ways in which others during her lifetime and since then have understood them. Captions tell the viewer what to see by identifying the action or the image. If we were not told that Zotom's drawing reproduced as plate 19 (chapter 3) is of the Kiowa surrender at Mount Scott, how would we respond to it? How different is our response because we have been directed to see a certain subject?

Titles of works of art or captions and descriptions associated with those works have been discussed as treacherous; they often take precedence over the visual information provided by the work itself and lead viewers to accept what the words say rather than what the visual language says.[75] This tendency is not unique to Plains Indian drawing and painting, but it is perhaps even more treacherous in this regard than it is for works of art from Europe, for example. There, at least, by the time the Fort Marion drawings were made, written text was a primary source of information. Among Plains societies, however, the visual was combined with oral narrative. The weight might well have been with the storyteller, who recounted heroic actions and other events in cultural history, but visual images played important roles as mnemonic devices to spur memories of events.

Although memories were the impetus for drawings made at Fort Marion, requests made by Eva Scott and perhaps by others directed some of those memories. Some events were undoubtedly seen as more important than others, as well as more readily

understandable to outside patrons unfamiliar with Plains Indian cultural history. This recognizability would have aided in the communication potential that the artists, their patrons, and their jailer, Richard Pratt, all undoubtedly sought to realize.

Collecting Native American Art in the Late Nineteenth Century

Drawings created by Southern Plains warrior-artists during their confinement in Florida were extremely popular collectibles. Perhaps less so, but still desirable, were miniature bows and arrows that some of the men made and the sea beans they polished.[76] There are also tantalizing suggestions that the two women at Fort Marion and perhaps the young daughter of the Comanche woman made beadwork for sale to visitors at the fort.[77]

Native American art of various forms had been collected from the first years of European contact, wherever in North America that contact occurred. This was one of the major ways in which people initially learned about each other—Europeans from the Native people they met and what they made, and Native people from Europeans and what they offered for trade. What was made and subsequently traded of course varied from place to place, but portability was a strong factor in many such encounters and the exchanges they engendered. Ruth B. Phillips has explored the concept of "trading identities" in the Northeast from the eighteenth century through the early part of the twentieth century.[78]

Beadwork and miniature bows and arrows created at Fort Marion undoubtedly held different appeal for women and men. Although it is impossible to establish with certainty, drawing books, too, might have been gendered purchases. Even if men controlled the household money in the 1870s, women made important selections of personal possessions and objects for the home. Richard Pratt sent drawing books to influential men who might be of help in his "Indian cause," including Bishop Benjamin Whipple of Minnesota; Pratt's own superior, William Tecumseh Sherman; and the commissioner of Indian affairs, John Quincy Smith. Other books filled with drawings, as well as fans painted with imagery, were collected by women, two examples being Eva Scott and Harriet Beecher Stowe. Although the kinds of works that Phillips examined were quite different from commercial drawing books filled with images at a Florida prison, Fort Marion drawings were portable and vivid forms of expression for the artists who made them. They were, and remain, ways of trading identities. Men who made these images communicated visually, often in great detail, about aspects of the lives from which they were exiled, their histories, and their current lives. Like the creators of the works that Phillips explored, whom she briefly discussed as autoethnographers,[79] the Fort Marion artists made choices about what to draw and how to do so.

Native arts were collected extensively during the latter part of the nineteenth century. Baskets, pottery, quilled birchbark, and beadwork reflected not only the skills of the people who created the works, most of whom remained unknown by name to their collectors, but also the romanticism of lives close to nature. As Elizabeth Hutchinson has explored, Native-made items including blankets, baskets, and pottery were available even to buyers who could not travel to places where these were made; department stores

made the collection of Native American art easy.[80] As North America became more enveloped in industrialism, a return to handmade works offered another romanticism of the past, one not necessarily connected to American Indians. Such nostalgia, combined with a new, growing awareness of what had been destroyed or was disappearing because of US policies and actions against Native people, brought many collectors to value Native artworks. In their search to establish cultural independence from Europe, both the United States and Canada, by the 1920s and 1930s, used Native American art as an indicator of their national aesthetics.

Although numerous people collected books of drawings from Fort Marion, they must certainly have done so for differing reasons. For some, the drawings were souvenirs of a trip to Florida, a trip made more exotic by their contact with the imprisoned Plains warriors. For others, they were indicators of the ingenuity of the artists, who, as Pratt intended, used their time in Florida wisely and earned money to send home to families in Indian Territory and to purchase items for themselves in Saint Augustine. For at least a handful of others, Scott among them, the drawings were works of art. As an artist herself, she would have valued them not only for their exotic manner of representation but also for their creativity. And regardless of why the drawings were originally collected, they have not remained in any single category for everyone who has viewed them since. They exist between categories, as liminal works that cross many boundaries.

As contemporary studies have made clear, Eva Scott viewed the Native artists whose drawings she collected as men who fulfilled her era's definition of the exotic and the "Other." That she also valued the drawings as art moves her view of them into another realm. Molly Mullin, among others, has written about the ways in which anthropological objects made by Native American people were redefined as art.[81] Certainly, many people who have both viewed and studied Plains Indian drawings and paintings, including Fort Marion art, have seen them first and foremost as works of anthropological interest. The drawings are filled with renditions of warrior society paraphernalia and other items of Plains material culture, often rendered with extreme clarity. But they are more than sources of anthropological information, and Scott was among those who were first aware of this reality.

Scott's reasons for collecting drawings by Zotom and Howling Wolf will never be known completely. But considering her subsequent history as a patron and supporter of artists in California and Santa Fe, her collecting cannot be considered a simple adjunct to the type of Indian art collecting that filled homes of the late nineteenth and early twentieth centuries with baskets, textiles, pottery, and beadwork. Works on paper by Fort Marion prisoners are unique, notwithstanding the preceding and subsequent history of representational imagery on the Great Plains. They were made as means of self-expression and as ways of communicating with both non-Native people and prisoners from other Native cultures.[82] For Scott and perhaps for their creators—given the extended contact they had already had with outsiders, including visiting artists, during their Florida exile—these were self-conscious works of art. Scott must have collected them as such.

Because she commissioned the drawings and presented them in the way she did, with title pages identifying each artist, Scott in effect changed the way in which the art would be perceived. The drawing books were hers, so her alterations of them and their meanings were initially for herself. As others presumably viewed the books and ultimately as they passed to her daughter and granddaughter and then to a museum, the adjustments she made to the drawings altered the ways in which many other viewers engaged with and gathered meaning from them.

Scott may have selected Howling Wolf and Zotom to fill her drawing books, in part, because she wanted examples of work by artists from two different cultures. This would have provided her with a greater diversity of subjects and approaches to those subjects than if she had selected, for example, two Cheyenne prisoners. In this way, her approach to the commission might be seen as reflecting a certain anthropological interest, as well as an artistic one. As an artist, she undoubtedly recognized that each man was skilled in a different way, and she sought the two out for that reason as well. Even from the incomplete record provided by drawings that remain from the Fort Marion period, it is clear that both Howling Wolf and Zotom created many drawings there. Each also held a position of respect among his fellow prisoners, at least those from his own culture. Scott, like many other well-to-do humanitarians of the day, was interested in the plight of American Indians and in prison reform. She brought her position of privilege to Florida and worked to help the younger men learn to read and write. Such volunteer activities carried with them hope for a better future for the inmates and brought her into repeated contact with at least some of the prisoners.

Although many people who collected drawings at Fort Marion probably did so primarily for their souvenir value, Scott cannot be counted simply as a member of this group. Her reasons for commissioning and collecting the drawings she did from Howling Wolf and Zotom were far more complex. She may well have wanted a memento of the caliber and complexity of these drawings to aid in the recollection of her days in Saint Augustine and her contact with the prisoners there, but she also brought many other associations to her transaction.

Scott must also have shared in the romanticism of her day concerning exotic cultures. American Indian populations had diminished precipitously, and the most intense battles of the Plains wars were recent memories when Scott came to Florida. These two facts brought conflicting views to the plight of the Indians, as many Americans of the day would have referred to the resulting circumstances. That Scott volunteered her time at Fort Marion and that she worked with the two artists from whom she commissioned drawings suggest her sympathies for the men and her recognition of various realities of their past, their present, and their potential future. All these factors would have affected the ways in which she viewed the drawings she commissioned from Zotom and Howling Wolf in 1877. Clearly, her role as a patron of the arts during the latter part of the nineteenth century was complex.

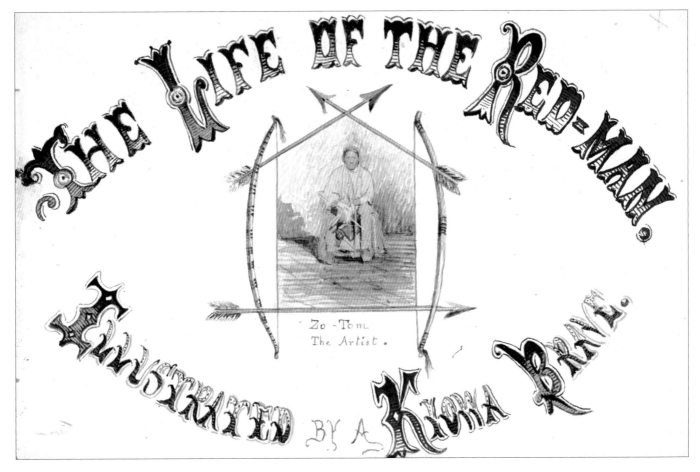

Plate 1.
Title page created by Eva Scott for Zotom's book of drawings. BRL, 4100.G.1.1. All of Zotom's drawings in the book are in some combination of graphite, colored pencil, and possibly crayon. All pages measure 6 inches high by 10 inches wide.

Zotom

Kiowa Artist as Historian

Plate 2. "A Kiowa Camp."

Zotom's illustration of a Kiowa village, his first drawing in Eva Scott Fényes's book, is one of his representations in miniature. Nine small figures and six lodges indicate the varied activities of a restful time at home and the three-dimensionality of the space the village inhabits. Zotom portrayed the men and one woman in differing positions, some turned in profile, others in either full or partially frontal view. The group of lodges further defines the real space in which the activities occur. In all probability the artist recorded not a specific day but his pleasant memories of the life from which he had been exiled.

The lodges, drawn as if vibrantly painted, offer a suggestion of actual Kiowa lodges, but the majority of Plains Indian tipis were unpainted. Kiowa people told the Smithsonian anthropologist James Mooney, who worked on the Great Plains in the 1890s, that fewer than one-fifth of their lodges had painted covers.[1] The most frequent pattern encompassed three parts: an upper band that included the smoke flap; a middle zone; and a lower band that often mirrored the basic design of the upper level. Mooney collected some miniature models of Kiowa lodges for display at the 1904 world's fair, but his project never reached completion. Twenty-nine miniatures are held in the collections of the Smithsonian's National Museum of Natural History. Zotom was one of the artists who worked on the tipi project for Mooney.

Zotom's rendition of the Kiowa camp in the Scott book includes four lodges showing the three-part design. The lodge at the far visual left features an equal-armed cross, rendered in green. Mooney learned that such a cross was an indication that the lodge's design had been dream or vision inspired. The tipi to the far right has a blue central field filled with white circles, which may indicate stars. Lodge designs were passed down through families who held the rights to them, as they are today. Some lodge designs and the visions that inspired them came with restrictions on actions that might be performed in or near

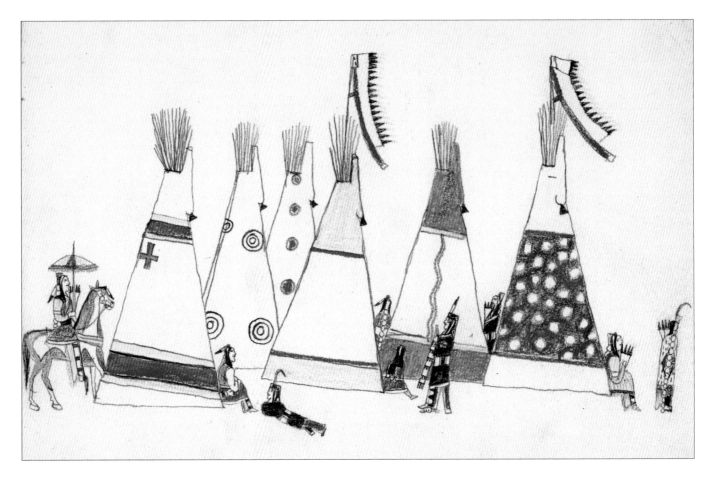

Plate 2.
BRL, 4100.G.1.2.

the tipi or on other specific behaviors. Mooney noted that the Bear Tipi of the Kiowa-Apache chief White Man came with restrictions about who could sleep in it, and another Kiowa-Apache man, Dävé ko, owned a lodge with a moon design that prevented boys from playing in it. Mooney reported that at least one man, upon inheriting a lodge design after his father's death, felt that the taboos associated with it were too difficult to adhere to and that owning the lodge was dangerous. He chose to abandon the lodge on the plains, thus ending its use and accompanying restrictions.[2]

Above two of the lodges can be seen headdresses placed atop poles, which are out of sight behind the tipis. Lodges with important headdresses nearby were probably those of acknowledged leaders who had the right to wear such elaborate war bonnets. On at least one occasion, a successful war party on a raid to revenge the death of a fellow Kiowa warrior captured an enemy's war bonnet and brought it home. The Kiowa calendar entry for that summer includes the standard rendition of the Sun Dance lodge, which designated summer, and, above the lodge, the enemy's headdress (see fig. 12, chapter 1). Considering the placement of the two war bonnets in Zotom's drawing, they are more likely Kiowa ones.

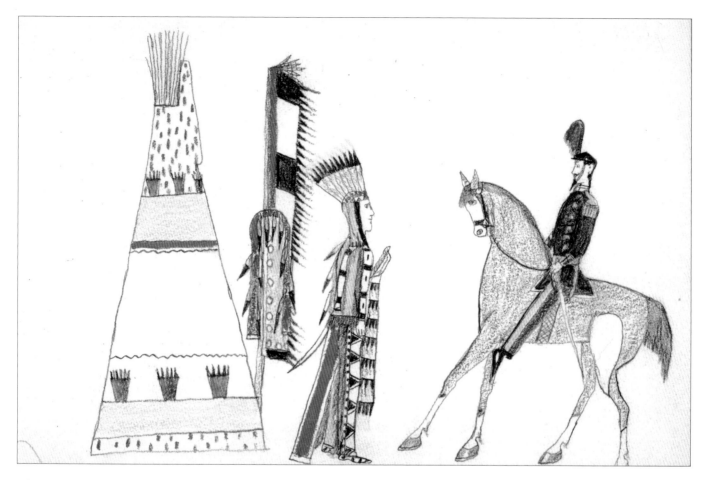

Plate 3. "A Chief receiving a stranger of importance"

Plate 3.
BRL, 4100.G.1.3.

With figures rendered on a much larger scale than that of plate 2, Zotom provided another view of a portion of a Kiowa village. Here, one Kiowa man stands in front of a painted lodge and faces a mounted officer. Both are men of importance. The Kiowa figure, whom Scott labeled a chief, wears an upright feathered headdress, carries a saber with a long, feathered trailer, and is otherwise dressed elaborately, as befits a meeting of significance.

The lodge behind him, presumably his own tipi, is elaborately painted with a design reminiscent of the so-called Tail Picture tipi that belonged to the noted Kiowa leader Big Bow. In a variation on the tripartite design, the lodge has two bands of trapezoidal forms—green in Zotom's drawing, whereas Big Bow's lodge had red forms—with small, upright triangular elements on their upper borders. Zotom might have used the Tail Picture tipi as his model but altered aspects of the design because he did not have the right to use it. Whether or not Zotom intended the man in this drawing to be Big Bow, the figure is obviously a leader and an accomplished warrior. His shield and feathered banner appear behind him.

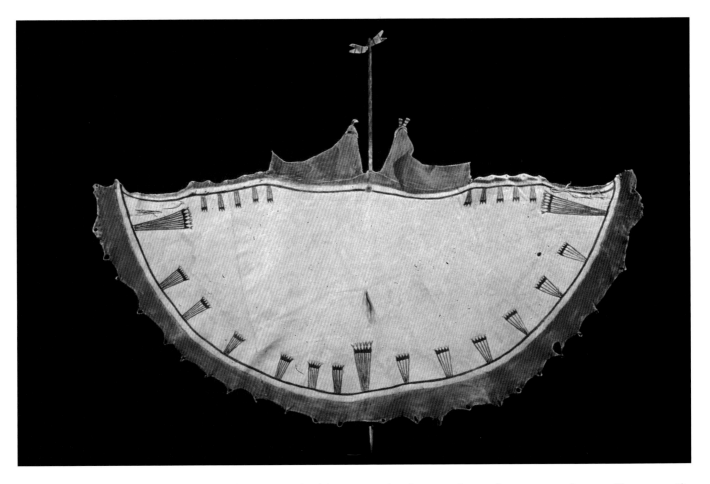

Figure 30.
Model of Big Bow's Tail Picture tipi. Hide and pigment, width 53 inches. Department of Anthropology, Smithsonian Institution, catalogue no. E245003.

The mounted soldier wears the dress uniform of an 1870s infantry officer, specifically that of a second lieutenant, as indicated by the plumed cap.[3] The officer also has a beard. Although artists on the plains did not typically create portraits through facial details, they did sometimes depict beards to identify the ethnicity of non-Native figures. Here, given the soldier's uniform, such a key to cultural identity would have been unnecessary, which suggests that Zotom intended to represent a specific person rather than a generic officer.

Zotom, like other Fort Marion artists, drew images of Richard Pratt in the role he played in negotiating the surrender of the Kiowa people, in his subsequent assignment of taking the prisoners to Florida, and in various places in Florida. When the artists rendered him in either profile or frontal view, his beard is often visible. Later in Scott's book (plate 24), Zotom recorded a meeting of his own with Pratt in 1871. The representations of Pratt and of the unidentified "stranger of importance" here are similar in many ways and different in others. On this page the officer has gold epaulets, whereas Pratt does not in plate 24. Pratt rides a standard army saddle with metal stirrups; here the officer's feet are inserted into trapaderos, or stirrup covers. Finally, unlike in plate 24,

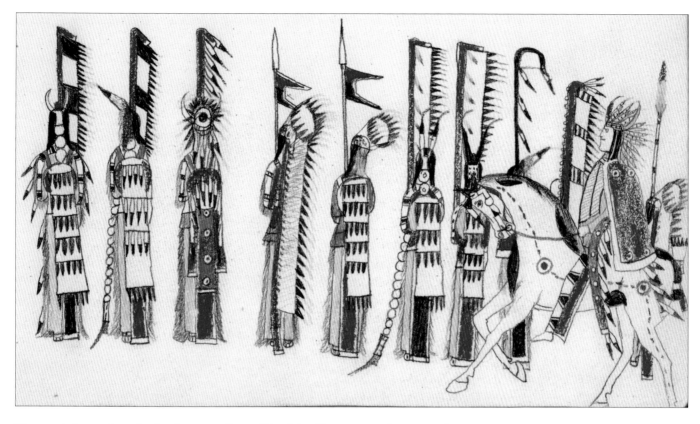

Zotom did not identify this figure as Pratt. The "chief" receiving the visitor here is not Zotom; perhaps the artist was not a witness to this meeting and could not identify who the officer was.

Plate 4. "A Kiowa war-dance."

Many of the Fort Marion artists experimented with the placement of figures on the drawing page and with ways of suggesting three-dimensional space. Foreshortened figures, men and horses turning in various ways, and standing figures presented from behind, such as those Zotom rendered here, all testify to the diverse ways in which the men offered views of their lives on the plains and their new experiences in Florida. Influenced by one another's experiments, as well as by those of visiting artists and by the Euroamerican representational schemes to which they were exposed in Saint Augustine, the Fort Marion artists eagerly tried depicting novel subjects and using new ways of rendering ones they had previously explored.

Both Zotom and Howling Wolf represented gatherings of their cultures' warrior societies with lines of warriors whose backs face the viewer (see plates 41 and 55, chapter 4). Zotom's figures here are intriguing for the ways in which he has carefully delineated differences between the warriors through their lances, headdresses, war bonnets, shields, and other individual items, such as lines of flat, circular, ornamental hair plates. His

Figure 31.
Detail of plate 4 showing the third, fourth, and fifth figures from the left.

Figure 32.
Detail of plate 4 showing the last three figures on the right.

Figure 33.
A reservation-period drawing, possibly by the Kiowa Silver Horn, of a warrior wearing a red cape like the one shown in plate 4. Photograph by Addison Doty. School for Advanced Research, Santa Fe, NM, SAR. 1990-19-4A.

experiments in representing the back forms of standing war bonnets are particularly striking. The third man from the left appears in full rear view, whereas the two men next to him have turned their heads slightly, so part of their hair is visible and their headdresses angle to the right, giving a partial profile view. The same is true of the final war bonnet, rendered at the far right of the drawing page.

The mounted figure, complete with red cape and horned, feathered headdress, carries a staff different from those of all the others. That he wears a red cape and carries a lance with alternating black and white bands, along with the bent lance of the figure behind the warrior's horse, indicates that this warrior society is the Kiowa Black Leggings Society.[4] In 1854, Gulhei, or Young Mustang, battled Mexican soldiers and tore a red cape from the Mexican commander just before killing him. Gulhei returned to the Kiowa camp with the cape. Even though it was a personal possession and thus extremely significant to Gulhei—it continues to be so to his descendants—the red cape rapidly became an important symbol of bravery for the Black Leggings Society.[5] A Kiowa warrior wearing a similar cape and headdress appears in another book of Kiowa drawings dating from the reservation period. Both men's horses are painted in ways suggesting visions or power. Similar designs appear elsewhere in Kiowa drawings.[6]

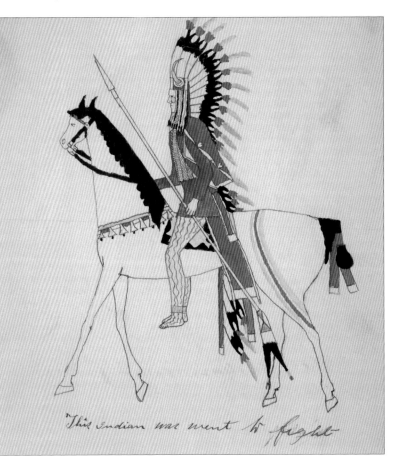

"This indian war went to fight"

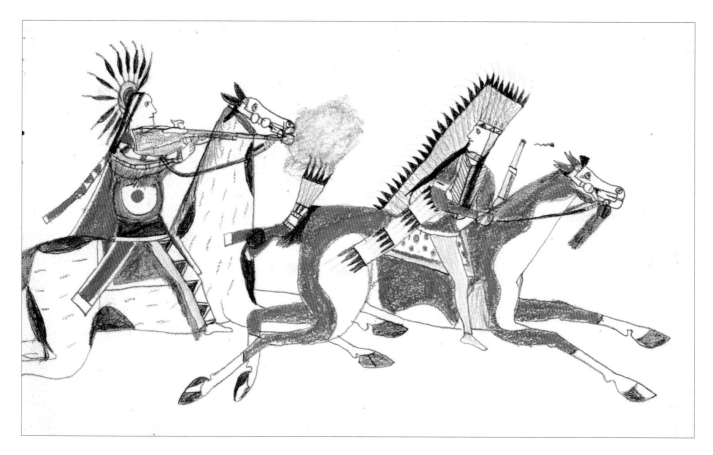

Plate 5. "Running from an enemy. A Kiowa chasing a Navajo"

Plate 5.
BRL, 4100.G.1.5.

This scene, in which two mounted figures race from left to right across the page, is one of only four drawings in Zotom's book for Eva Scott that detail battle exploits, a subject depicted more frequently on the plains before the Fort Marion confinement. Both men in the drawing carry shields and guns, but it is the man on the left who fires his rifle. A cloud of smoke emerges from its muzzle, in front of his horse's mouth. The bullet that has been discharged appears in front of the other rider as a circular form with a wavy line behind it to suggest its movement. Although the forward rider angles his head backward to look at his enemy, his full feathered headdress is still visible. Part of his upper body turns in space, so his bone breastplate and both arms are apparent; his left arm comes forward slightly toward the viewer. The warrior who fires his gun wears an elaborate headdress with feathers encircling his head, and his braid is wrapped in red cloth. Both his shirt and leggings have bold black-and-white designs indicative of beadwork.

The two captions Eva Scott supplied for this drawing confuse rather than clarify what Zotom has depicted. The label "A Kiowa chasing a Navajo" leads us to read the rear rider as the Kiowa warrior and the man on the right as the Navajo. Indeed, the man firing the gun wears what may be a long red cape, not unlike that worn by the mounted figure in

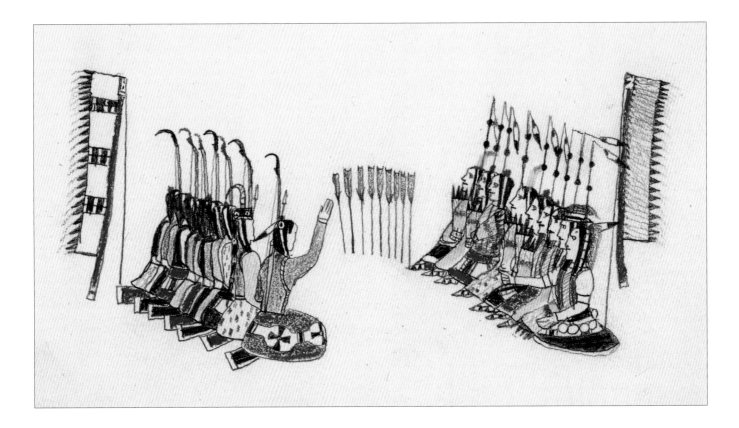

Plate 6.
BRL, 4100.G.1.6.

plate 4, and his shield design is similar to a portion of a shield and a horse's paint seen in plate 28. The colors and the type of beadwork and fringe on his shirt and leggings also identify him as a Kiowa. Yet, the full feathered war bonnet of the fleeing warrior, the manner in which his horse's tail is tied, and the scalp lock tied to the horse's bridle are also Plains Indian characteristics rather than Navajo ones. Nothing is immediately apparent in Zotom's drawing to support the identification of either of these warriors as Navajo.[7]

Plate 6. "Gambling with hair pipe. (an ornament made of oyster shells and manufactured only in Jersey City.) The game consists in laying the little ornament on one arm, then throwing it up and catching it in one hand, the spectators then guess in which hand it is hidden."

Eva Scott's lengthy caption for this drawing relays the information necessary to understand the basic nature of the game in which these men are engaged. An oyster-shell hair pipe was a tubular ornament, at least one and a half inches long, that by the time Zotom lived was most frequently worn as part of a necklace or breastplate. Its antecedents were archaeological-era shell beads, but by the latter part of the nineteenth century,

non-Native people were making the ornaments for trade with various Native cultures.[8] What Scott describes could, alternatively, have been a bone or another small object. Native people throughout the Great Plains used such pieces in a variety of games in which they gambled in pairs or in larger groups like the one shown here.

Gambling and other kinds of friendly contests abounded in Native North American cultures; men and women had their own variations. But through the details Zotom provided in this drawing, he suggested something more about the game of chance. The men seated on the left all hold bows with either red or black feathers visible at their ends. At the far end of this line of men is a feathered headdress. A headdress of a different pattern appears behind the man in the foreground on the opposing side. There, each man sits next to a different kind of staff or lance, each with a single feather and two circular forms. Each man on this side also holds a feathered fan.

Zotom did not record such differences without a reason. He was undoubtedly portraying men who belonged to different Kiowa warrior societies, each of which had its own insignia. Warrior societies—men's fraternal associations—were found throughout much of the plains, and some of them continue today. During the nineteenth century, men from the same group provided support for one another in battle and throughout life. They served other important roles, such as policing the camp at ceremonial times. Friendly rivalry often existed between groups, and a game waged between men from two warrior societies became something more than a casual passing of the time. Members of different warrior societies competed with one another in many ways, on the battlefield and off. The camaraderie that was vital for men who risked their lives together fighting mutual enemies developed variously through Plains warrior societies, and friendly contests such as gambling were part of that structure. Recounting heroic actions after battle, with members of one warrior society attempting to outshine those of another, was another friendly but important contest between societies among various Plains groups.

Zotom has not been content simply to present these men gambling. He has used the opportunity of this subject to explore the representation of three-dimensional space in an extremely successful manner, by angling the two lines of figures diagonally. Figures overlap one another, and the two headdresses anchor the edges of the field of vision. The upright arrows stuck into the clearly understood ground on which the men sit not only serve as markers for keeping score in the game but also denote the far point of the space represented.

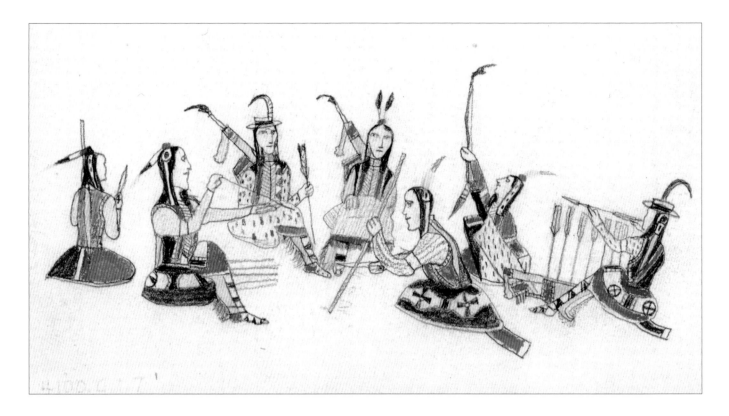

Plate 7. "Making bows and arrows"

Seven men are engaged in various stages of the manufacture of bows and arrows in this drawing. An elongated oval space is circumscribed by the seated men, and the artist has again used the arrangement of the figures and their postures as effective tools to suggest three-dimensionality. Figures in profile coexist with a man who sits left of center in a three-quarter turn, while the man most centrally positioned is in a full frontal posture. Zotom was among the most experimental of the known Fort Marion artists in his willingness to explore figurative positions. He worked repeatedly to present fully foreshortened figures successfully.

Zotom has individualized the men through variations in their clothing and posture. The two men looking toward the viewer stand out; each has a quiver angling across his back, its upper portion visible above one of his shoulders. These distinctive quivers, probably made from mountain lion hide, appear in various drawings created by Plains artists at Fort Marion and on the plains.

That the men are working together as they create bows and arrows reflects the reality of Plains life, in which many activities were communal. From carving the arrow's shaft to ensuring its straightness, from fletching, or attaching feathers, to making the bow itself, men such as those Zotom drew replenished their hunting tools continually. At Fort Marion the men made miniature bows and arrows to sell in Saint Augustine. They also

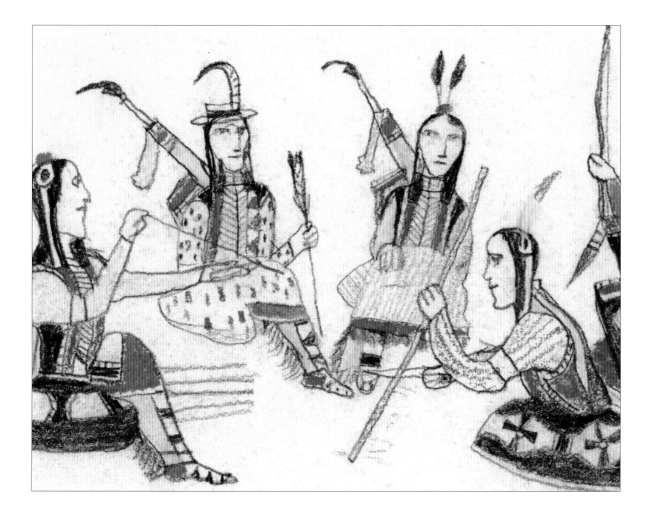

Figure 34.
Detail of plate 7.

used full-sized long bows at the fort when they gave archery lessons to some of the visitors, including some women. During the latter part of the nineteenth century, archery was beginning to develop as a recreational pastime in which American women participated. This was a time when the benefits of exercise were being extolled, and archery suited women perhaps better than lawn tennis, its closest competitor as a woman's sport. Given players' need to bend over to pick up dropped balls, women's garments, especially tight corsets, were uncomfortable and even, it was suggested, dangerous. Archery offered a less painful alternative.[9]

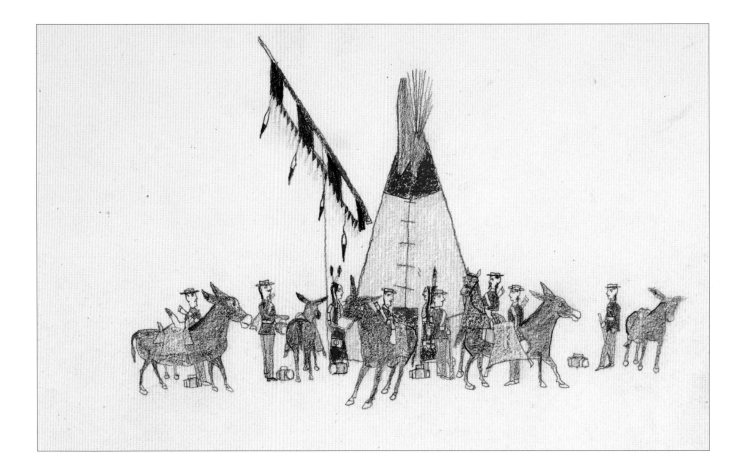

Plate 8.
BRL, 4100.G.1.8.

Plate 8. "Mexicans trading with Indians"

Native people of the southern plains had repeated contact with people from Mexico and what is now New Mexico, both in guarded friendship and in war. In this drawing, Zotom depicts an activity that took place often, especially during the nineteenth century, when Kiowa people traded for goods with Mexicans, or Comancheros, as they were frequently called in contemporaneous accounts. Traders would travel to agreed-upon meeting places on the southern plains to exchange items desirable to each side.

Zotom has carefully illustrated the Mexicans' gray pack mules, showing their bulky bodies, large heads and ears, and white muzzles. They differ markedly from the horses in his drawings, which appear as more delicate animals. Only one horse is part of this image, rendered in red and partially obscured by a mule, but drawings in the Autry National Center's book in which Zotom rendered horses on a similar scale make the contrast apparent.

The Mexicans, as they are labeled, have come to trade in front of the lodge of a noted warrior, as the feathered lance beside the tipi attests. Two warriors are there to receive the visitors, who have unloaded at least part of their goods. Comancheros brought guns,

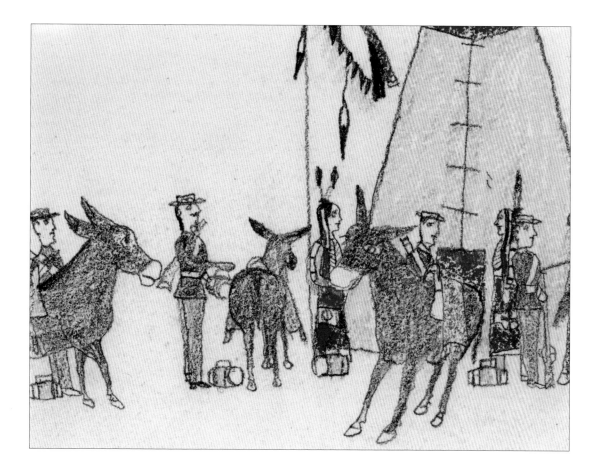

ammunition, textiles, and some silver to trade with the Kiowas, but their most impor-
tant commodities by the time just preceding the Fort Marion years were probably agri-
cultural products, especially corn and foods made using corn. For their part, the Kiowas
bartered buffalo meat and hides, before massive hunting of buffalo by non-Natives out
for sport and hides destroyed the once enormous herds. Horses, mules, and cattle were
also exchanged. Zotom has suggested nothing large being traded in this drawing, so the
scene may depict an initial visit from a few of the Mexican traders while others wait away
from the camp. Accounts exist of Comancheros being robbed of their goods when they
came near a Plains village unsuspectingly, and caution had become a practice for at least
some traders by the late pre–Fort Marion period.[10]

Comancheros would not have dressed in the homogeneous way Zotom has rendered
the men here. Perhaps they are not simply traders but rather a small group of Mexican
soldiers who have come to visit the Kiowas, bringing items to exchange.

Despite the extremely different subject matter, Zotom has used a composition here
similar to the one he employed in the preceding drawing, of men making bows and
arrows. The space indicated by the arrangement of figures is elliptical, and men, mules,

Figure 35.
Detail of plate 8.

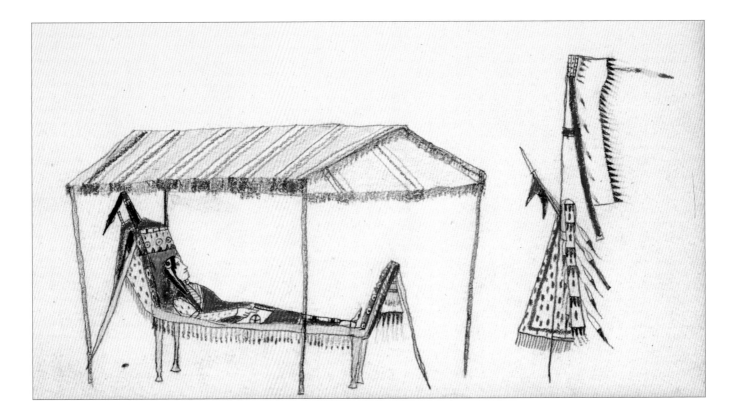

Plate 9.
BRL, 4100.G.1.9.

and horses turn in various ways to help define their positions in the three-dimensional world suggested on the page.

The largest element of the image, the tipi, is centrally placed, where it both anchors the figures and defines the far limits of the space Zotom provided for the scene. A feathered lance, rendered larger than its actual size would have been relative to the men depicted, is held aloft on a pole outside the lodge. Its dramatic, diagonal angle and prominent location create a strong visual element that makes the composition more active than a vertically placed lance would have done.

Plate 9. "Sleeping in a wig-wam."

Many of the Fort Marion prisoners drew representations of men relaxing at home on the plains, and these images often included views of vibrantly patterned sunshades formed by placing blankets or robes over wooden frames. Sometimes, arbors fashioned from bent wood and covered with branches or foliage also appear. Here Zotom rendered a very different type of resting place: the man reclines on a four-legged bed frame under a peaked sunshade of striped textiles, which Eva Scott referred to as a *wigwam*, a term generally associated with the Eastern Woodlands and portions of the subarctic regions of North America rather than the Great Plains. Some Plains groups, however, did employ back rests and types of beds. What Zotom has drawn here might well be such a bed

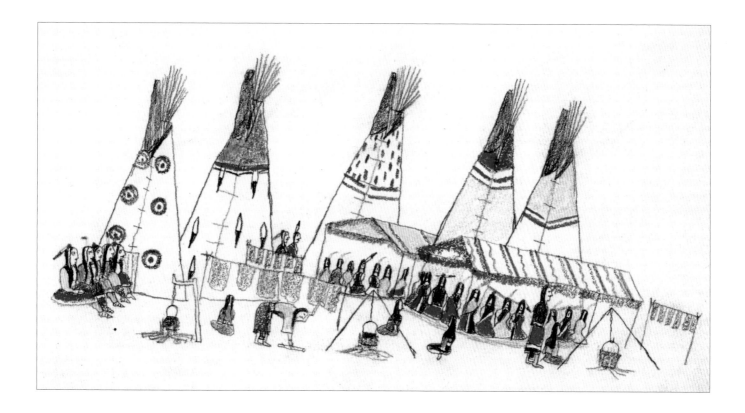

frame, adapted from those used among Prairie Plains and Eastern Woodland cultures. That sunshades of the style represented here were undoubtedly used is also suggested by the next image in Zotom's book. Fringed, striped textiles were received through trade with either Mexicans or New Mexicans. Woven blankets and serapes from both areas were highly regarded on the southern plains.

The man in his elaborate bed is obviously a warrior of distinction. His feathered headdress and lance are among the carefully rendered items of dress that stand on a pole outside the sleep structure.

Plate 10. "Celebrating a successful hunt."

Another village scene gave Zotom the opportunity to present a great deal of information about life on the plains and to experiment with the placement of figures in space. Two peaked sunshades are situated in front of the lodges on the right of the pictorial space. Beneath these awnings, at least eighteen men have gathered, all viewed from behind. The colors of their shirts and robes, as well as their hair and the feathers each man wears, result in a rhythmic pattern of lines and blocks of color. The five men who sit to the far left of the pictorial space look on and also provide the visual boundary for the space of the camp represented. Racks of drying meat and perhaps hides appear, as do three fires with kettles hanging from supports. The women in the drawing are positioned close

Plate 10.
BRL, 4100.G.1.10.

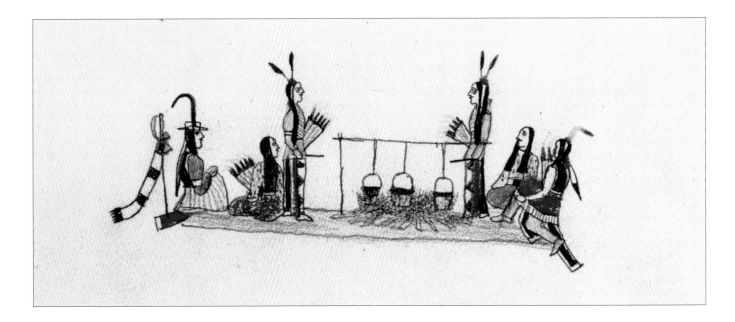

Plate 11.
BRL, 4100.G.1.11.

to the fires and cooking areas, standing, sitting, or, in one case, bending to pick up something needed for a task. Zotom has carefully rendered the different ways in which the women sit. The two nearest the center of the drawing appear seated with legs bent to one side.

Five painted lodges, each decorated in a different way, stand at the rear of the pictorial space. The whole drawing, like several others by Zotom in the Autry National Center's book, is organized elliptically, echoing the village arrangement. The drawing also makes clear Zotom's tendency to angle his images downward to the visual right. Such a diagonal slant appears repeatedly in the book, as well as in other drawings the artist created at Fort Marion.[11] It is a defining characteristic that makes much of his work identifiable even if names or captions have not been applied to the images.

Plate 11. "Cooking and eating."

Zotom continued his description of daily life on the plains with a view of six figures gathered around a fire with kettles of food. He carefully balanced the representation of one standing and two seated figures on either side of the fire. The two standing figures face each other. Each man wears two upright feathers in his hair, and each holds a stick and a feathered fan. Two of the seated figures also hold fans. The precision of detail and the formally balanced arrangement of the figures imply that Zotom has rendered something more than a simple gathering to share a meal. Rather, the formality suggests what might be a ceremonial occasion.

Rather than place his figures and the fire and kettles in the clearly understood but otherwise undefined space he offered in his previous representations in Eva Scott's book, here Zotom has rendered the ground on which the figures gather. The ground line has

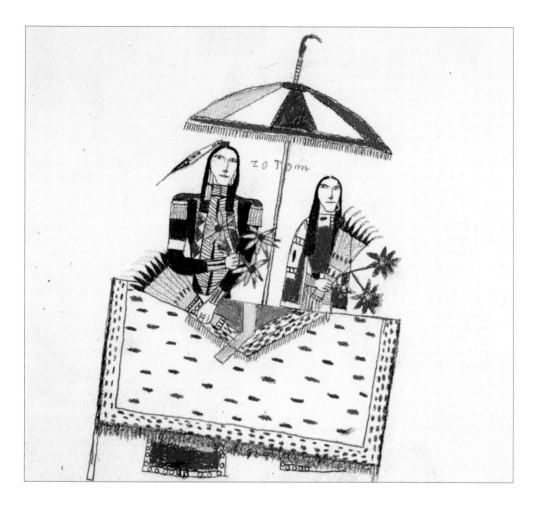

eliminated the downward angle of the composition seen in some of Zotom's other Fort Marion drawings.

Plate 12. "Bride and groom"

Rendering his figures in full frontal positions, Zotom offers what Eva Scott's caption identifies as a bride and groom. The couple are dressed elaborately, and each carries a feathered fan and flowers. They appear under the shade of a vibrantly colored umbrella, with a patterned blanket in front of them. Once again, the entire composition slants diagonally to the right.

Zotom has printed his own name on this picture. Only one other drawing in Eva Scott's book includes Zotom's handwritten name, and that, the last one in the book (plate 31), identifies him as one of the students in a Fort Marion classroom. In that drawing, Zotom wrote his name in script, with a line connecting it to the head of the student with whom he identifies. His fellow prisoner and artist Making Medicine apparently included his signature in the same way on Zotom's drawing. The name written on the drawing

Plate 12.
BRL, 4100.G.1.12.

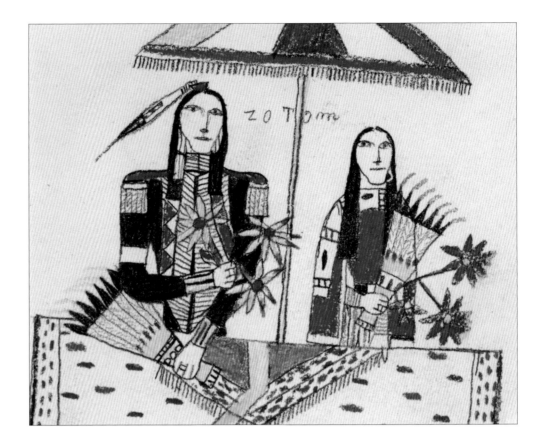

Figure 36.
Detail of plate 12.

of the bride and groom differs in that it is printed and is unconnected by a line to the head of the male figure; such clarification was unnecessary because only one man is represented here. If Zotom intended this drawing as a self-portrait, then he further ensured that viewers would recognize his intention by including his name. This seems far more likely than his having affixed an artist's signature, as most artists working in the Euroamerican tradition would have done.

If Zotom has identified himself as the man in the drawing and if the caption is correct, then the artist has provided a view of his own marriage. Wedding portraits were a Euroamerican tradition to which the Fort Marion artists might well have been exposed during their years in Florida. Many visitors to the fort undoubtedly questioned the prisoners about their cultures' practices, such as customs surrounding marriage. Few other readily recognizable images of marriages appear in known Fort Marion drawings, but Howling Wolf apparently included one in his book for Eva Scott. His view (see plate 58, chapter 4) depicts more figures joining in the celebration, unlike Zotom's exclusive focus on the bride and groom. The scale of Zotom's figures and their formal presentation offer an intriguing comparison to formal Euroamerican wedding portraits that he might have seen in Saint Augustine.

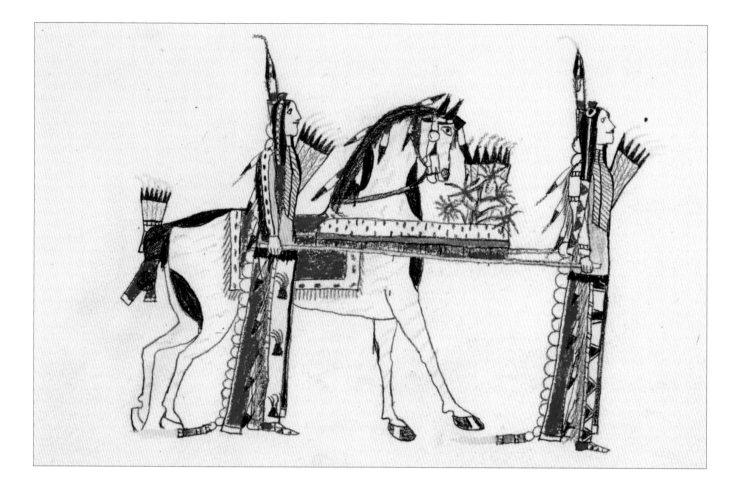

Plate 13. "A funeral."

No other known Fort Marion drawing is as intimately poignant as this one, in which Zotom rendered a funeral, apparently that of a child. Two men, dressed well for this solemn occasion, carry their burden, a textile-wrapped or cradleboard-encased figure, between them. What may be a feathered headdress or fan and what are certainly flowers of the same style rendered in the marriage image (plate 12) in Eva Scott's book appear with the deceased.

The Kiowa men carrying the bier wear clothing of a type that Zotom depicted various times in his drawings. The leggings worn by the man on the right, with their diamond-patterned beadwork, both men's breastplates, and their long rows of hair plates are indicative of Kiowa representations. The man on the left wears more distinctive leggings with bear claw designs rendered in black on the white background of the drawing page.

Plate 13.
BRL, 4100.G.1.13.

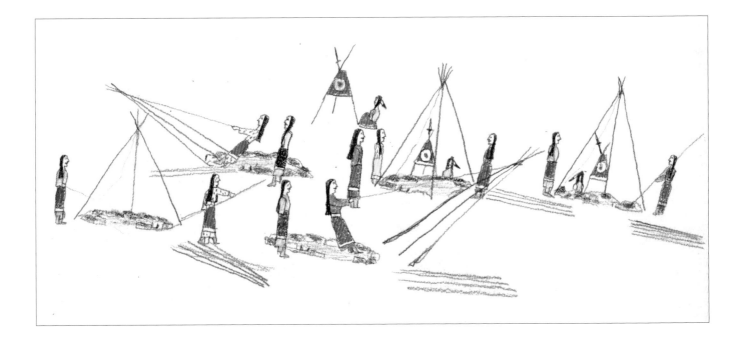

Plate 14.
BRL, 4100.G.1.14.

Plate 14. "Moving from a village."

In one of the few drawings Zotom made illustrating activities unique to women, many minute figures dismantle lodges in preparation for a move. Raising and lowering lodges were generally women's responsibilities, and here Kiowa women work together for the effective and rapid movement of camp. The woman on the far left holds a line attached to the crossed tripod support of the tipi. She is ready to lower the support, something the women above her and to the right, in the central pictorial space, are already doing. Other women hold lodge poles or stand near poles that have already been removed. Among many Plains Indian groups, women owned the lodges, whether tipis or earth lodges. Exceptions included the vision-inspired painted tipis of the Kiowas, which were generally owned by men.[12]

The oval shapes of the lodge interiors are suggested by the gray pencil areas Zotom has rendered. He has depicted objects inside the lodges and perhaps stones that held the sides of the lodges more securely closed. Three lances and perhaps shields are visible on tripods.

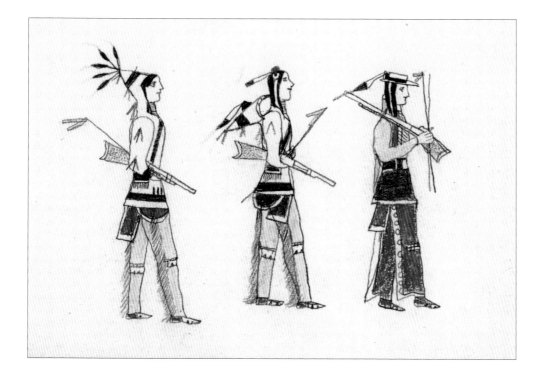

Plate 15. "Starting on a hunting expedition."

Standing out for its simplicity in comparison with most of Zotom's other drawings, this line of three figures moves from left to right across the page. The men carry guns, and two may have arrows. The middle man may be carrying a support for the guns, which the men will use when they have found their prey; its V-shaped end will act as a kind of tripod. If it is not a gun support, then he may be carrying a pipe.

Whether the men are hunting animals or enemies, the hunt must be taking place in cold weather, for two of the men wear short, white, hooded *capotes*, or cloaks. Fashioned from wool trade cloth, such items of clothing are more frequently represented in drawings by Plains Indians from farther north, among whom such attire was more vital than it was in parts of the southern plains. Northern Plains Indian drawings usually depict much longer garments than these.

Even in this relatively simple drawing, Zotom has differentiated the men's clothing. The man on the visual left and the one in the center have their loincloths tucked up, probably into their leggings. Each of them also has a bag or an ammunition pouch visible over his capote. The straps of each bag cross the front and back of the hunter's chest diagonally, and the fringed pouch itself, just large enough for the hunter to reach his hand into, hangs on the man's right side. Zotom also varied the angles of the guns carried by the men, most obviously in the way the lead hunter has placed the barrel of his rifle over his shoulder. No enemies must be nearby, for these men do not appear ready for combat.

Plate 15.
BRL, 4100.G.1.15.

Plate 16. "A persimmon tree and prairie flowers"
In one of Zotom's most striking drawings in Eva Scott's book and in all of his known work, a tree and flowers appear on a patch of variegated ground. This landscape is the *subject* of his drawing, not the mere setting for some other event. Landscape representations were visible to the Fort Marion men in many ways. The prisoners were not confined to the fort, and as they walked about town, they viewed a wide range of advertisements, newspaper images, and works by non-Native artists. The impetus for this drawing could have come from many sources. That Zotom rendered one of only a couple of known drawings from the three-year period that illustrate landscapes with no buildings or figures again underscores his penchant for experimentation.

Such a landscape, with no apparent connection to historic events and with no figures moving in it, suggests the need that Zotom, like many other Fort Marion artists, surely felt to make his home territory understandable to the people he met in Florida. The deep red fruit and flowers of Zotom's landscape are descriptive and sensual. He is representing space, as he does throughout his book of drawings for Eva Scott, but here he allows the specifics of a part of his homeland to take full control of the drawing page. Whether this was one of the subjects that Eva Scott suggested to the Kiowa man will never be known, but it is distinctly different from the remainder of the representations Zotom drew for his patron.

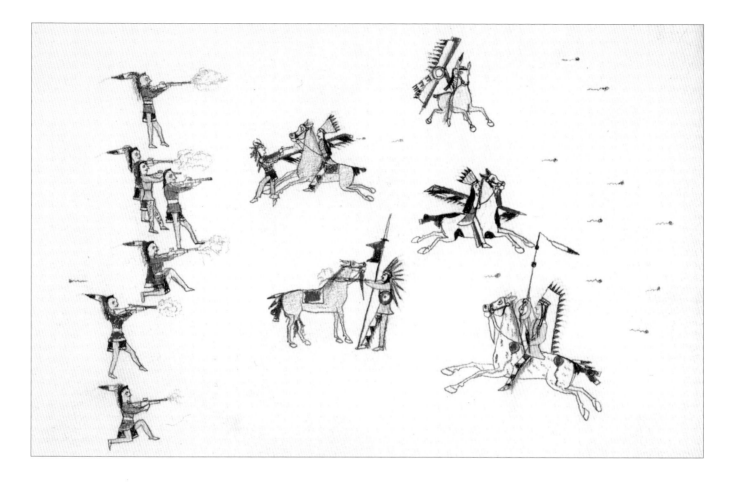

Plate 17. "A scene in Indian Warfare Battle between Osage & Kiowa braves." Comparatively few battle images are known from the Fort Marion period, whereas such subjects predominate in drawings created before the end of the Plains wars and appear in many from after the enforcement of the reservation system. Zotom drew only four in his book for Eva Scott, and three of them are panoramic scenes with figures rendered in miniature. Here, in great detail, Zotom filled the drawing page with the intense heat of a battle between Kiowa warriors, on the visual right, and their Osage enemies. He carefully rendered the telling differences in clothing and hairstyles that distinguished men from each culture. The Osage warriors, standing or kneeling, fire their guns at the Kiowa warriors and their horses. The dark blasts emanating from the guns and the bullets moving toward the right edge of the page indicate that the Osage warriors are capable enemies. Only one Kiowa fires a gun at the Osage forces. The other Kiowas are still mounted; each carries a lance of some type, and three shields are also visible. The Kiowa warriors wear different styles of feathered headdresses: one has a full feathered trailer, and two others are feathered upright bonnets. A fourth man wears a flaring headdress that may identify him as an *ondé*, a brave man who has distinguished himself in battle.[13]

Plate 17.
BRL, 4100.G.1.17.

Figure 37.
Detail of plate 17.

The Osage men wear shirts, short loincloths, and either fringed leggings or body paint on their legs. Their close-cropped hair rises from their foreheads, and most of the men wear roaches, headdresses generally made from porcupine guard hair, turkey beard hair, or deer hair. Single feathers protrude from their roaches or from hair spreaders, flat ornaments often of bone or metal that were placed between two parallel rows of animal hair to separate them while also attaching the headdress to a man's own hair.[14] One Osage warrior, who has moved forward from the line on the left and is in close combat with one of the mounted Kiowa men, has a different style of headdress, perhaps suggesting his status in his own culture.

The Kiowas and Osages were frequently at war before making peace in 1837. The same treaty brought peace between the Kiowas and the Creeks, or Muskogees. The peace between the Kiowas and the Osages and Creeks was never broken, even though, as James Mooney related, relationships were "strained" with the Osages because Osage men sometimes served as scouts for the US military forces who battled the Kiowas and other Southern Plains peoples throughout subsequent decades.[15] Thus, unless Zotom has drawn Osage warriors fighting in their roles as scouts, the battle he depicts here took place before the 1837 peace—indeed, before he himself was born. Either interpretation is feasible. Artists on the plains, as well as some known from Fort Marion, must have drawn representations of important battles that they knew from oral history rather than from personal experience. If not Osage warriors, then the enemies here might be Pawnees, because hostile encounters between them and the Kiowas continued for a much longer time.

Scouts who worked for the US Army had no unique, official uniforms until late in the Plains wars. Before then, they often wore a combination of military uniform items and Plains Indian attire. Depending on their commanding officer's understanding of the Plains system of warfare, scouts might also be allowed to wear their own cultural insignia and signs of honor into battle. If Zotom has here rendered the Osages acting in their roles as scouts, he has done so in a way that follows the Plains practice of differentiating culture groups by characteristic clothing, accouterments, and hairdressing. Drawing them in blue military uniforms, even if the scouts in fact wore them, would have obscured the cultural identity of the enemies these Kiowa warriors battle.

Zotom has used the battle scene, as he did in other pictures in Eva Scott's book, as an opportunity to move figures in space. Enemies to the left are rendered in ways that suggest different positions and overlapping space. The mounted Kiowa warriors move in multiple directions. Three horses are in profile, and the man with the upright war bonnet who rides the black-and-white horse angles slightly toward the viewer; Zotom has subtly rendered the front portion of the horse larger than the back. Above this rider, yet another Kiowa warrior looks out toward the viewer. Both his head and that of his horse are fully foreshortened, and the horse's body appears to be in the process of turning.

Plate 18. "Indian Camp Wichita Mountains. Capt. Pratt arranging for surrender of the Indians—Nov. 1874"

Plate 18.
BRL, 4100.G.1.18.

Here Zotom rendered in minute detail the scene of the surrender of the Kiowa men in the Wichita Mountains. He included this scene in other drawing books as well (figs. 38 and 40), most notably in a book that Richard Pratt gave to Commissioner of Indian Affairs John Quincy Smith in March 1877 and in a drawing now in the National Cowboy & Western Heritage Museum (fig. 38). The three views are strikingly similar, with the mountains carefully depicted in the background. Army wagons and wall tents stand in the middle distance to the right of the central scenes, and numerous unpainted tipis rise at the center. The three drawings show one large tipi with its sides pulled back, in front of which Kiowa people and one army officer either sit or stand. A single Kiowa man is silhouetted against the open space of the larger lodge. One of his arms is raised and he is in partial profile, the back of his head and the side of his arm visible.

In Camp the night after surrender

Figure 38.
Zotom, "In camp the night after surrender." National Cowboy & Western Heritage Museum, Oklahoma City, Oklahoma, 1996.017.0205B.

The three renditions differ in one small but extremely important detail. In Eva Scott's drawing book, the Kiowa man with his arm raised holds a knife, but in the other two drawings, he does not. The absence, as I discuss shortly, may have had to do with the different patrons for whom the drawings were made.

Although the caption that accompanies the drawing in the Scott book indicates that this is a view of the surrender, it assigns an incorrect date to the action depicted. The gathering took place after Big Bow agreed to surrender the large band of Kiowas under his leadership to army forces. Big Bow, although he was involved in many of the raids for which other Kiowa men were sent to prison in Florida, was not among those incarcerated. According to Pratt, Big Bow negotiated privately with the commander at Fort Sill to bring his band in if he himself avoided punishment.[16] Although Pratt attempted to dissuade his commander from entering into the agreement, the Kiowas under Big Bow's leadership surrendered, and Big Bow avoided incarceration. The surrender took place in February 1875, not November 1874, as Eva Scott's caption indicates.

Figure 39.
Detail of plate 18.

That the incident depicted in Zotom's drawing is the night after the surrender is made clear by the lone figure with the knife. That evening in early 1875, Richard Pratt and interpreter Philip McCusker, along with the Kiowa leaders Kicking Bird and Napawat, were invited to a dance to be held at Big Bow's lodge. Pratt later recorded:

> *The camp was in a narrow valley in the mountains. It was the dark of the moon.... The tom-toms were beaten, and the Indians sang, and there was much talking in their Kiowa language.... The music made several brave starts, but no one danced.... Finally...a powerful young Indian near the chiefs took from his belt a large butcher knife and stuck it in the ground...[and] he danced wildly with grotesque crouching, swaying, and posturing in excellent time to the music.*
>
> *When he had finished, he reached down and seized the knife as though to use it in stabbing and in the most threatening manner stepped over on to the blanket where I was and leaned over me. On the instant it seemed certain that harm was intended, all the Indians were excited and the chiefs were urging him on. There was a struggle between this Indian and an Indian sitting just back of me. Then the dancer stepped back into the open space and held up a blanket. He thrust the knife into it several times and cut it into pieces, making it worthless, threw it on the ground, and there was general approval. Replacing the knife in its sheath on his belt, he picked up his blanket, wrapped himself up, and sat down.[17]*

Although Pratt and the interpreter feared for their lives, what they had witnessed was probably what is generally known as "soldiering," in which a member of a warrior society destroys the property of someone in the village who has committed an offense. The destruction of property could be much greater than the single blanket cut to shreds here. For serious misconduct, all a man's horses and his lodge might be destroyed. Some time later, Pratt learned that the dancer was Zotom himself and that under directions from Big Bow, he was shaming a Kiowa man who had refused to begin the dance

when he was told to do so. Thus, Zotom drew an incident with which he was intimately familiar, having played a major role in it.

That the drawing in Scott's book includes a clear rendition of the knife, whereas the one in Commissioner Smith's book does not, may be tied to the patrons themselves. It is difficult to imagine Scott suggesting that Zotom draw this specific incident, but she certainly might have suggested that he provide views of events leading to the prisoners' arrival in Florida. The book Pratt presented to Commissioner Smith was one in which two artists, Zotom and the Southern Cheyenne Making Medicine, made drawings. Neither man included any actual battle scene in the book and thus nothing apparently menacing. One of Zotom's drawings in it is captioned "Almost a battle. Sweet Water Cr. I.T. 1871," but the potential battle he depicted—an 1871 encounter between Kiowas and army troopers at Sweetwater Creek in Indian Territory—was averted when a warrior came forward with a white flag of truce. It was Pratt who met with the Indians during that encounter to negotiate and help avert the impending battle (plate 24).

By comparison, Eva Scott's book does contain battle images. Zotom rendered both a one-on-one encounter (plate 5) and larger, panoramic battle scenes. Whether the absence of such subjects from the book Pratt gave to Smith was due to Pratt's urging that only peaceful subjects be portrayed is unknown, but Pratt recognized the value of Fort Marion drawings as tools to gain support for the men under his care and the programs he wished to implement. His presentation of the book of drawings to the commissioner of Indian affairs is evidence of his aims. That Zotom's images focused on incidents leading to the Kiowas' surrender, the prisoners' journey to Florida, and their life there might have reflected not only the artist's preferences but also Pratt's plan. Making Medicine's drawings of incidents from daily life on the plains and several activities in Florida are also scenes of peaceful industry that would have fit with Pratt's desire to promote only the best views of the prisoners under his care.

A slight variation of the night after the surrender of Big Bow's band also appears in a drawing curated in Richard Pratt's papers. It has long been identified as having been drawn by another Kiowa prisoner at Fort Marion, Etahdleuh Doanmoe. Pratt himself apparently provided this identification, although the history of the drawing and those that accompany it in Pratt's papers is unclear. Apparently, either Pratt or his son Mason bound various pages of drawings together in a book titled *A Kiowa Odyssey.* The drawings detail the surrender of the Kiowas and the prisoners' trip to Fort Marion, as well as some aspects of their lives in Florida. In this book, the captions take on entirely new meanings, for someone has typed identifications of what is depicted directly on the drawings themselves.[18] Despite the long-held identification of this drawing in Pratt's papers and others as being by Doanmoe, closer examination suggests that Zotom might have drawn several of them, including the one illustrating the night after Big Bow's Kiowas surrendered. The stylistic similarities, the compositional format, and even the diagonal slant of the drawing indicate that Zotom probably drew the scene. Why Pratt or his son might have misidentified the drawings, crediting them all to Doanmoe, is unknown.[19]

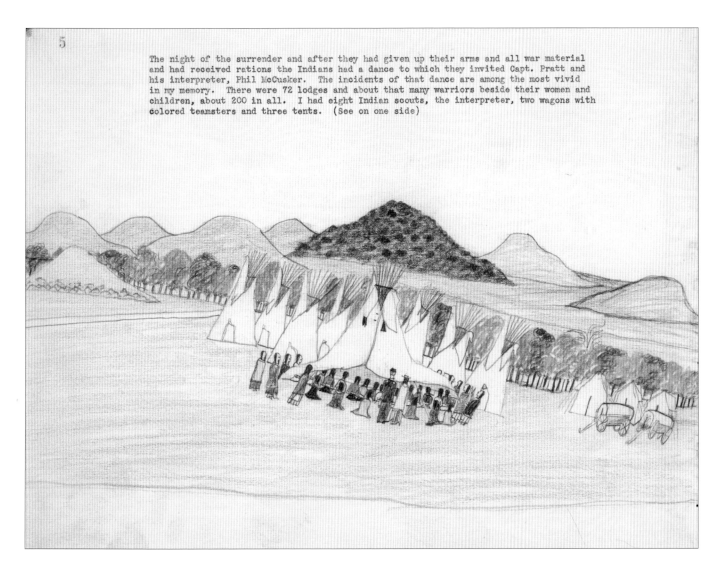

5

The night of the surrender and after they had given up their arms and all war material and had received rations the Indians had a dance to which they invited Capt. Pratt and his interpreter, Phil McCusker. The incidents of that dance are among the most vivid in my memory. There were 72 lodges and about that many warriors beside their women and children, about 200 in all. I had eight Indian scouts, the interpreter, two wagons with colored teamsters and three tents. (See on one side)

Figure 40.
Etahdleuh Doanmoe or Zotom, drawing labeled "The night of the surrender." Richard Henry Pratt Papers, Yale Collection of Western Americana, Beinecke Rare Book and Manuscript Library, 1005357.

Plate 19.
BRL, 4100.G.1.19.

Plate 19. "Surrender at Mount Scott. Troops meeting Indians"
Zotom continued his visual narrative of the steps that led to the Fort Marion imprisonment by including this view of the Kiowa people, their horses loaded with their possessions, moving in a row in the middle ground of the drawing. They follow a covered wagon that carries three figures. In the foreground, a double column of cavalrymen moves from right to left. Zotom has been careful to render the soldiers and their horses larger than the horses and figures of the Kiowa people in the middle ground. In the distance, hills and small trees continue the sense of diminishing scale with which Zotom organized his drawing. Forms in the foreground are not only larger but also darker in color, which suggests that the artist was experimenting with atmospheric perspective— the reality of the way we see objects in the distance as lighter and less distinct. The large, dark mountain toward which Big Bow's band of Kiowas moves is Mount Scott, the highest mountain in the Wichita Mountains and therefore a landmark in the region.

This was a scene that Zotom rendered repeatedly during his three years in Florida, and it may be referenced by the second grouping in the sketch the artist created of the incidents leading to Fort Marion (see fig. 11, chapter 1). In the cryptic sketch, one Kiowa man, carrying a flag, rides toward a mounted soldier. In the more complete drawing Zotom created for Eva Scott, the cavalry figure with the flag is part of a much larger force coming to meet the Kiowas. Zotom rendered the incident similarly in the Smith book, again with obvious foreground, middle, and background spaces.[20]

Plate 20. "Fort Sill—Eleven miles from Sill. In fore-ground, guard-house in
which the Indians were confined."

Plate 20.
BRL, 4100.G.1.20.

Prisoners from various Southern Plains groups were brought from their home territories
to Fort Sill, in present-day Oklahoma, to begin their journey together to Saint Augus-
tine. Zotom depicted Fort Sill numerous times, as did other Fort Marion artists, includ-
ing Chief Killer, a Southern Cheyenne.[21] Here, in the foreground of his pictorial space,
Zotom has rendered the building in which some of the prisoners were kept. The long,
low, stone structure differs from the other buildings depicted at the fort: it was actually
the fort's ice house. Not surprisingly, the ice house appears prominently in most repre-
sentations of Fort Sill made by the Fort Marion prisoners. Its importance is apparent even
in Zotom's sketch of events leading to Fort Marion (see fig. 11, chapter 1). The long
building, with its obvious block construction, appears just left of center in the sketch.

No figures inhabit the space of Zotom's drawing. Rather, he concentrated on visu-
ally describing the place and its setting, with the Wichita Mountains in the back-
ground. He set the large flagpole and flag near the center of the composition, where the
parade ground would have been. The buildings that served as enlisted men's housing and
officers' quarters have been detailed, as has the fort's hospital, the large structure to the
far right, which had been completed just the previous year.[22] The isolation of the ice
house in the foreground is both real and figurative; the men's imprisonment there iso-
lated them from their families and homes.

Plate 21. "Arrival at Caddo."

The prisoners traveled by covered wagon from Fort Sill to the Caddo Indian Agency, some 165 miles east of Fort Sill. Zotom provided more details of the journey in other drawings than he did here, but Richard Pratt's description of the way in which the prisoners were transported, like animals, makes the absence of specifics in Zotom's drawing even more telling:

> There were eight army wagons to carry the prisoners, in each of which one end of a long chain was securely bolted to the center front end of the bed of the wagon and reached back to the rear where a staple had been fixed so that end could be padlocked. The prisoners, when placed in the wagons, were strung on this chain by putting it between the legs above the shackle chain, and they were alternated to sit, one on each side. On the bottom of the wagon where had been placed a quantity of hay. When each wagon was loaded, a link on the end of the chain at the rear was put over the staple and padlocked so that escape was impossible.[23]

Eleven wagons rather than eight appear in Zotom's drawing, again a view of a place without visible people. The wagons have been angled so that one end and a portion of the cover are visible on each, making them unmistakable as covered wagons.

Zotom detailed several sizes of buildings in the portion of Caddo he drew, but what hints at the importance of the stop at Caddo is the series of small, dark, closely spaced black rectangles that appear against a slightly red ground just left of center and the row of faintly rendered parallel lines in front of those black rectangles. The ominous black smoke angling diagonally to the left behind the last building adds vital information: the

dark shapes represent a train drawn by a steam engine. The Caddo Agency, in Indian Territory, was where the prisoners were transferred from wagons to a train for their trip farther east. Pratt recounted that only one of the prisoners had previously been on a train; Chief Lone Wolf had traveled to Washington, DC, several years earlier. The other prisoners, understandably, had mixed reactions to train travel: "As the train started, the prisoners were at first greatly interested, but as it increased in speed beyond anything they had ever experienced, it was plain that some of them were not a little disturbed, and these at first pulled their blankets over their heads and quit looking out."[24]

The seemingly deserted place that Zotom has depicted is unsettling, as if he intended to relay some of the anxiety involved in the train trip through the eerie emptiness of the train stop.

Plate 22. "Bathing scene in Washita River Indian Territory. 60 miles from Sill"

As the prisoners made their way from Fort Sill, before reaching Caddo, the wagon train stopped to camp each night—whenever possible, near water. Here Zotom has depicted a stop along the Washita River that gave the men an opportunity to bathe. The journey was undertaken in late spring, and the dust that filtered into the wagons, as well as the way in which the men were chained together, undoubtedly made them eager to enjoy the water of the river.

Zotom depicted various levels of the scene. A foreground of riverbank and trees opens to reveal the river, three men in the water, and many others on shore. Additional ground separates the men from the pyramidal shapes of the white army tents and the wagons beyond. All these details—the river, its banks and trees, the men, the tents, and the wagons—were necessary to effectively relay the narrative of this stage of the journey east.

Plate 22.
BRL, 4100.G.1.22.

Figure 41.
Detail of plate 22.

This event, or ones like it that occurred during the wagon trip from Fort Sill to Caddo, was included as a small entry in Zotom's linear record of important events on the way to Florida (see fig. 11, chapter 1). It appears next to the very dark rendition of a train along the upper row of Zotom's sketch. Even in this miniature drawing, Zotom included a detailed wagon positioned next to the river and a man swimming. Such evenings in camp surely were the times that came closest to some relief for the prisoners, who did not know what their futures held. Since it was not customary on the plains to keep adult male captives alive, many of the Fort Marion–bound prisoners must have expected to be killed at any moment.

Plate 23. "Departure from Fort Sill"

At Fort Sill the men and their army guards began their trip east, a trip that would take them on the train suggested in the drawing of Caddo through major cities including Indianapolis and Nashville. Zotom chose not to render those aspects of the journey in Eva Scott's book but instead concentrated on locations on the plains.

Here he has again rendered Fort Sill, this time with the icehouse prison in the center of the pictorial space. As in plate 20, the fort's flag flies conspicuously, and the architecture of the military quarters has been detailed. Mountains appear in the background. In front of the icehouse, horses and wagons loaded with prisoners are ready for departure. One can see prisoners sitting inside the three wagons that are shown in partial front view. It was at Fort Sill that the Kiowa and Comanche prisoners were joined by prisoners from other Southern Plains tribes to be sent to Florida. In the foreground, two rows of soldiers angle outward, one to each side of the two officers at center, whose plumed caps have been carefully rendered. The troopers either are standing guard or are ready to begin their own journey escorting the prisoners.

Plate 23.
BRL, 4100.G.1.23.

Richard Pratt described the precautions taken when the prisoners were loaded into the wagons, as well as a suggestion of the agony the families of the prisoners felt:

> *During these preparatory operations, in the presence of their people, a strong force of troops ready for action controlled the situation. The friends of the Indians were permitted to come to them after they were in the wagons and to say their good byes. A great many Indians gathered to witness the departure. Two troops of the Fourth Cavalry...formed the guard. There was some evidence that their tribesmen would attempt a rescue at the start or en route. Loud wailing by the Indian women, which was not interfered with, came from their masses crowded on the hillside and about the grounds during these preparations. As we moved away, and throughout that long march, every precaution was observed by advance and rear guards and flankers well out on both sides. At every night two army wagons were set far enough apart to admit one of the prisoners sleeping between them, and five fifth chains were padlocked together making a continuous chain on which the prisoners were strung, half on one side and half on the other, the ends being padlocked to the wagons.*[25]

Although Zotom depicted onlookers in other drawings he made of this subject, here he included none of the many tribal members who camped at Fort Sill until the prisoners left, nor did he give any clear indication of the grief the Indians felt. Additional drawings clearly show the way in which the prisoners were chained together at night.[26]

Plate 24. "ZoTom coming to Capt. Pratt with flag of truce in '71. On Otter Creek—S.W. part of Indian Territory."

In a work depicting an early encounter between Zotom and Richard Pratt, the artist and Pratt are mounted, and each is dressed in clothing that denotes his rank in his respective society. Zotom carries his shield and a gun. Pratt, in his plumed cap and detailed uniform, has his saber at his side. Like Zotom, Pratt appears to hold a gun in his left hand. This is a meeting held under a flag of truce, but both men are cautious, guns at the ready in case the truce is broken.

The incident portrayed here may be the same one Zotom depicted in the Smith book, where it was labeled "Almost a battle. Sweet Water Cr. I.T. 1871."[27] Sweetwater Creek and Otter Creek, then in Indian Territory, are tributaries of the Red River. Throughout 1871, federal troops stationed at Fort Sill searched for Kiowa and Comanche warriors who had been engaged in war and in horse and cattle theft in Texas. At various times, cavalry and Kiowa and Comanche forces were close to each other, and battle seemed

Plate 24.
BRL, 4100.G.1.24.

imminent. Pratt was with forces from Fort Sill under Colonel Benjamin Grierson when, in 1870 as he recalled, a large number of Kiowas was found off the reservation, just west of Sweetwater Creek. Both the warriors and the soldiers readied themselves for battle, and the cavalry, in battle formation, advanced slowly toward the Kiowas:

> We continued to move toward them at a walk until they were only a half mile away, when one of their number came toward us carrying a white flag. Colonel Carpenter sent me with the interpreter to meet him. He told us that the Indians did not want to fight and that Chief Kicking Bird would like to talk to the commanding officer. I took him to Colonel Carpenter and he gave his message to the colonel. General Grierson came back just then and sent the Indian to tell Kicking Bird to come out and meet him, and taking the interpreter and a small party we rode toward the Indians. Kicking Bird came forward with an equal number of his men and he and the General had a long conference. Then Kicking Bird sent a message to his men and they disappeared.[28]

Pratt noted that the real reason Kicking Bird asked to meet with the commanding officer, as was suggested by later evidence, was to allow the women and children who were with the warriors time to dismantle their camp, which lay well outside the reservation boundaries. By the time the "long conference" was over, the camp had been relocated to reservation land.

Here Zotom presents himself as the warrior who carried the white flag of truce and rode out to meet Pratt and the interpreter. Zotom focused his attention solely on himself and Pratt, leaving the interpreter out of the drawing. The artist has inscribed his name above his self-portrait to ensure that his part in the important event is clear. The name, again, is not a signature, but rather an identifier of the brave warrior who was willing to ride out to meet his enemy under the flag of truce. In the drawing in the Smith book, Zotom presented a far more encompassing view of both the army and the Kiowa forces in their battle-ready positions, with the warriors moving through the hills and the infantry aligned in four rows in slow movement toward what then appeared to be a forthcoming battle.[29] The Native warrior, presumably Zotom, although he is not identified in the wider-angle drawing, is but a tiny figure amid the multitude of army and Kiowa forces. Although both of Zotom's drawings are labeled 1871, Pratt wrote that the events had taken place in 1870.

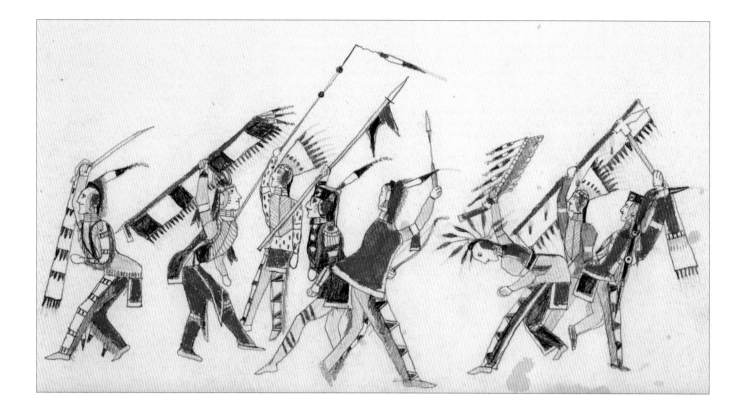

Plate 25. "An Osage War-dance."

Plate 25.
BRL, 4100.G.1.25.

Staunch enemies until the 1837 peace treaty ended their major hostilities, Osage and Kiowa people had contact with each other in ways that moved beyond the battlefield. Noted for their distinctive hair styling, dress, and dance, the Osages performed a war dance that Kiowas undoubtedly observed on occasion. According to Thomas Battey, a man of Quaker faith who came to teach on the Kiowa and Comanche reservation, the Kiowas enacted the Osage war dance, in perhaps a more exaggerated fashion than the Osages did.

Although Battey described in some detail a Kiowa performance of the dance, calling it an Osage dance,[30] the Kiowa dancers may have been performing what has become known as the Omaha dance, which incorporated some elements of the Osage war dance. The two peoples, Omaha and Osage, were closely related. The most telling characteristics of an Osage warrior appear in Zotom's drawing. The men's heads are shaved on the sides, allowing a high crest to remain at the top of the head, extending from front to back. Into the crest, a deer- and porcupine-hair roach might be attached, as is seen in Zotom's drawing of the figure at the far left and on the man just right of center. A second, obvious indicator of Osage identity is the way in which the shaved sides of the men's heads have been painted bright red. Other dancers wear different types of headdresses, but each has the distinctive shaved hairstyle and most of them have the sides of their heads

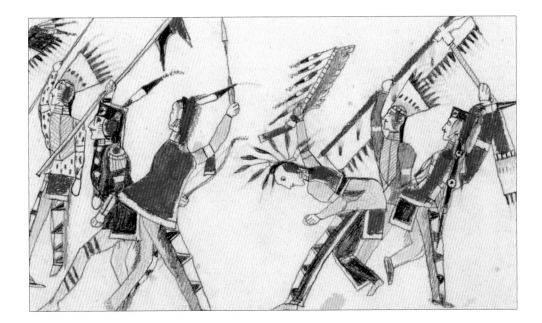

Figure 42.
Detail of plate 25.

painted red. Indeed, the Cheyenne name for the Osages was Red Shaved People.

Since this is a war dance, each of the figures carries a weapon that might be used in battle. Various lances are held aloft at diagonal angles. A saber, an arrow, and a pipe tomahawk are also seen, as is a green quirt, a wooden board to which feathers are suspended. The latter might have been used in counting coup or striking an enemy. The dancers' dress is varied and includes bone breastplates, a red cape, and, at far left, a fringed shirt with a V-shaped insert from which hangs additional fringe. Some of the other items of clothing depicted could just as easily have come from any of several other Southern Plains cultures. The similarity of the beaded designs and fringe on the leggings to those Zotom represented in drawings of Kiowa warriors is particularly obvious.

Two figures share the central space of the composition, moving in opposite directions. Given their places in the drawing, they may represent men who hold relatively prominent positions in their respective warrior society or societies. One of the men wears a red cape similar to that seen in plate 4. Here, the red roach, another signifier of the Black Leggings Society, is also visible, whether it indicates membership in that group or is simply an additional reference to the Osages or to the Omaha dance itself.

The Southern Plains men in Florida danced on various occasions, including the one for which Zotom and Howling Wolf were selected as the best dancers from the cultures present at the fort. One drawing of a dance attributed to Doanmoe in Richard Pratt's papers is labeled an Omaha dance, and it suggests movements similar to those depicted here.[31]

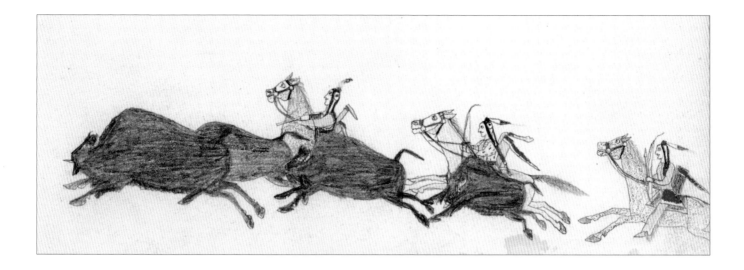

Plate 26. "A Buffalo-Hunt."

Plate 26.
BRL, 4100.G.1.26.

Among the most frequently represented views of life on the plains that Fort Marion men drew were hunting scenes. Most often they portray buffalo hunts, as Zotom has rendered here, but some depict hunts for a variety of other animals, from wild turkeys to antelope and bear. Scenes of hunters on horseback like this one resembled the Plains Indian representations of warfare that had dominated pre-reservation drawing and painting, but perhaps they were more acceptable than battle scenes to Saint Augustine audiences. Providing food for one's family would have been viewed as honorable by both the Plains men and their captors.

Zotom uses this hunt as an opportunity to suggest great speed, the hooves of horses and buffalo off the ground as they move from right to left across the page. All the animals and men are rendered in profile, with one exception: the buffalo farthest to the right has turned its head outward, toward the viewer. Both horns are visible, and the buffalo's head angles downward between its front legs.

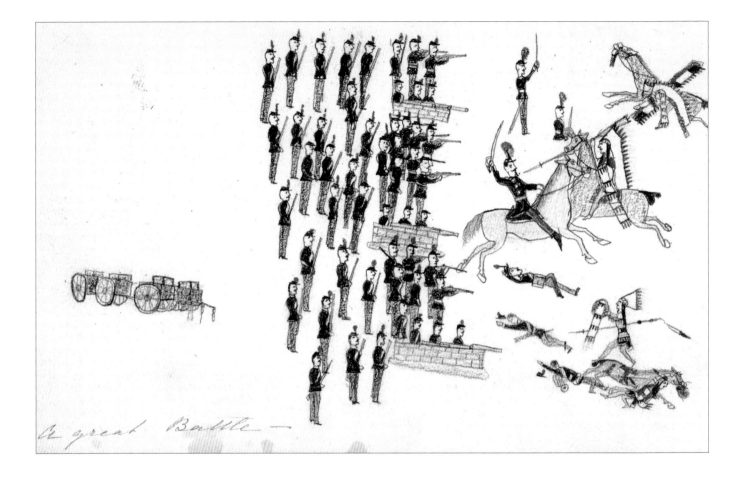

A great Battle —

Plate 27.
BRL, 4100.G.1.27A.

Plates 27 and 28. "A great Battle"

In the only two-page composition in Zotom's drawing book, the Kiowa artist rendered a battle between Plains warriors and the United States military. Soldiers fire from behind gray stone barriers, perhaps a fort, and what may be cannons appear in yellow. Other soldiers stand to fire at the warriors who charge toward them, and still more wait to relieve the troopers in the front line.

The warriors dominate the right-hand drawing page and almost half of the facing page; they are the men on horseback who charge the soldiers, moving in various directions. One warrior near the bottom of the left-hand page has fallen, his horse wounded, as the blood on its hindquarters attests. A soldier has been either killed or wounded there as well. Above those figures, a war-bonneted man uses his lance and shield to fight; he has apparently been victorious over the fallen soldier in front of him. One mounted soldier—an officer, judging from his plumed cap—engages a warrior whose full feathered headdress makes his accomplishments apparent. The two high-ranking men meet one on one as the officer holds his saber high and the warrior holds his lance. Above them, two officers battle another war-bonneted figure, and this time it is the warrior who appears to be falling.

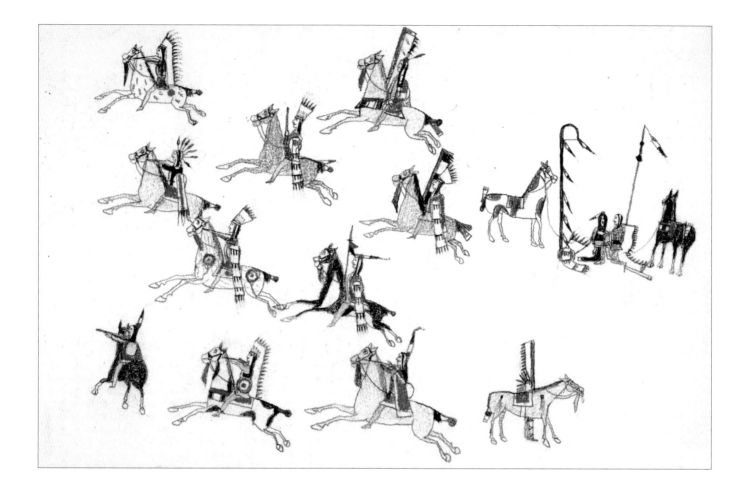

The right-hand page has allowed Zotom wide range to render the actions of the mounted warriors, whose headdresses, shields, and lances denote individual variation and achievements within their culture. A centrally placed warrior rides a horse that has been painted in a way similar to that of Zotom's horses elsewhere in Eva Scott's book. Two warriors sit or kneel on the ground to the far right, their horses and differing lances positioned nearby. Below them, a warrior stands behind his wounded horse, blood dripping from two bullet holes in the horse's side. Several of the warriors wear red capes similar to those the artist depicted elsewhere in his book. Again, they may reference a specific warrior society. Several of the lances depicted here in miniature also appear in Zotom's larger-scale rendition in plate 4.

As in many of his other drawings, Zotom might well have been depicting a specific battle, but there is nothing here to tell contemporary viewers when or where this fight took place. That it involved Kiowa warriors firing on a fort and being fired on in return, however, is certain.

Plate 28.
BRL, 4100.G.1.27B.

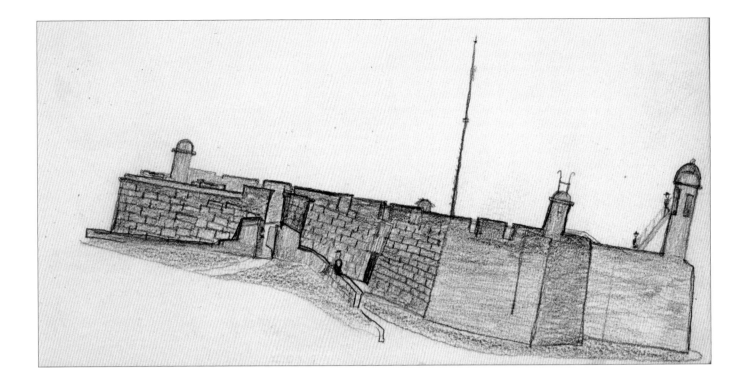

Plate 29.
BRL, 4100.G.1.28.

Plate 29. "Exterior view Fort Marion, St. Augustine, Fla. Where the Indians are confined—1877."

The last three drawings in Zotom's book are of Fort Marion and his life there. Each of them reads more like a postcard or snapshot of this strange place and its inmates. Such photographs were readily available, and Eva Scott herself collected many of them.

The sixteenth-century Spanish fort of San Marcos, by the nineteenth century called Fort Marion, is an imposing stone structure with turrets and casements.[32] Zotom has located the fort on a patch of green grass, but even that small suggestion of a natural setting does little to lighten the building's oppressiveness. The only open entryway, appearing in the middle left half of Zotom's drawing, provides little relief from the bulk of the massive gray walls. One tiny figure, apparent only from the blue area of his uniformed legs, stands guard at the entryway, and two other figures climb the stairway to the highest tower. These men may all be Fort Marion inmates, for by the time Zotom filled his book with drawings for Eva Scott, the men had become their own guards. Early during their captivity, Pratt had their chains removed and developed an internal guard system. Many of the prisoners were already established leaders, accustomed to taking responsibility for maintaining order. Their fellow warriors were equally accustomed to obeying the leaders' directions. This sort of culturally congruent policing was probably more effective than US military guards would have been.

Figures 43 and 44.
Details of plate 29.

By far the most important of the figures rendered in miniature is the man sitting on the outer wall of the fort just to the left of the drawing's horizontal and vertical midpoints. Behind him appears a darkened doorway. The figure is so tiny that understanding what he might be doing, beyond sitting there, gazing outward, is difficult. But when one examines a detail of the drawing closely, the man appears to hold a small white rectangle. At first this rectangle blends in with the courses of stone composing the fort itself, but it is in fact smaller and angled differently from the stones. Zotom may have rendered the seated figure holding something, possibly a book.

The only known representation of a Fort Marion artist in the act of drawing that has come to light is a photograph that was subsequently copied by the artist Frank Hamilton Taylor. Taylor's image was published in the *New York Daily Graphic* in April 1876 and has been reproduced in various publications on the Fort Marion period, as has the original photograph. The similarity between the position of the seated figure in Zotom's drawing and that of the artist depicted in both the photograph and Taylor's rendition is striking. The two differ in that the photograph suggests that the artist is looking inside the enclosed space of the fort, whereas Zotom's figure looks outward. Fort Marion artists did draw internal views of the fort, but they often rendered the view *from* the fort toward the world outside their confinement. Many drawings exist of what the prisoners saw beyond the walls of their prison, from the city of Saint Augustine to Anastasia Island and its lighthouses. If Zotom indeed intended this tiny figure to be an artist drawing, then it is the only image by a Fort Marion artist to have come to light so far that is a self-conscious view of a prisoner-artist creating art there.

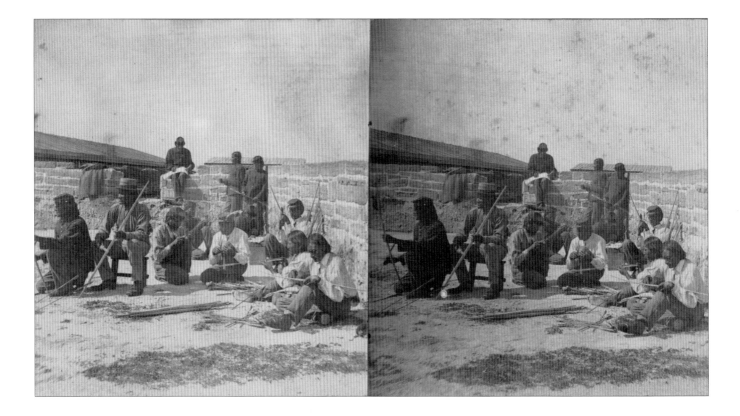

Figure 45.
*Unknown photographer, "The Prisoners
making bows and arrows for visitors."
A man drawing sits on the wall at
upper left. Richard Henry Pratt Papers,
Yale Collection of Western Americana,
Beinecke Rare Book and Manuscript
Library, 1167274.*

Plate 30. "Interior View Fort Marion—and light-house on Anastasia Island"

Plate 30.
BRL, 4100.G.1.29.

The opposite side of the crenellated walls of the old fort from that shown in plate 29, and the stairway leading to the wall, gave Zotom the opportunity to explore systems of perspective. The curving arches, the doorways to spaces farther inside the fort, the cannons, and the small windows opening within openings all suggest the depths of the fort and the darkness within.

From the upper platform of the fort, the men could see across Matanzas Inlet to Anastasia Island, which stood between the fort and the Atlantic Ocean. At the time of their imprisonment, the island had two lighthouses. The one Zotom rendered was the newer of the two and by far the more visually interesting, with its bold, black-and-white striping. He depicted the towering structure and the lighthouse keeper's house at ground level. The men not only saw the lighthouse from a distance but also visited the island various times. Pratt took them there by boat, away from the sweltering summer heat in Saint Augustine, so that they could fish and camp. Many of the Fort Marion artists rendered the island and the lighthouse, which undoubtedly represented to them the times when they felt freest from the dark confines of the fort and their lives in forced exile.

Plate 31.
BRL, 4100.G.1.30.

Plate 31. "A class of Indians in Fort Marion, with their teacher (Mrs. Gibbs) -original autographs-"

Seven of the Fort Marion men appear in Zotom's drawing of their classroom, and their teacher stands at the left. All the figures hold open books and apparently are reading. The men, in their uniforms, sit on a long yellow bench with a table in front of them. What may be a slate or another book or paper appears in front of the prisoner closest to the teacher. Zotom has suggested a wooden floor on which the desk and bench stand. The teacher, identified as Mrs. Gibbs, is rendered in great detail, wearing a dark, bustled dress and an elaborate floral or ribbon-embellished hat.

Zotom and his fellow prisoner Making Medicine, a Southern Cheyenne, each signed their names on the drawing. The signatures do not indicate that both men made the drawing but identify the figures that represent the two. Each name is connected to a single man's head by a line, echoing the way in which artists on the plains often placed name signs or glyphs on their drawings to identify protagonists (see plate 33, chapter 4). Here, the two most important people for Zotom to have identified were himself and Making Medicine.

It might be asked why the second figure identified in Zotom's drawing is a Southern Cheyenne rather than another Kiowa. That this is the case may indicate the uniqueness

of the Fort Marion environment, where new friendships were made out of necessity and new cultural norms were developing. If extant drawings are any indication, Zotom and Making Medicine were among the most active of the Fort Marion artists.

Both men rendered images in the drawing book that Richard Pratt presented to Commissioner of Indian Affairs John Quincy Smith in 1877, the same year Zotom made Eva Scott's drawings. That Pratt wanted to present the two men's work to high-ranking officials who could help further the cause of Native education might have brought Zotom and Making Medicine together as artists with some frequency. Making Medicine's work differs markedly from Zotom's. Although both created multiple views of activities at Fort Marion, Making Medicine, like his fellow Southern Cheyenne inmate-artist Howling Wolf, often rendered views of his life on the plains before prison. Making Medicine and Howling Wolf gave free expression to their longing for their homes and a return to their lives there. Zotom, as is readily apparent in his drawings for Eva Scott, worked more consistently as a historian, detailing specific incidents in his life, particularly those associated with his imprisonment in Florida.

Figure 46.
Detail of plate 31.

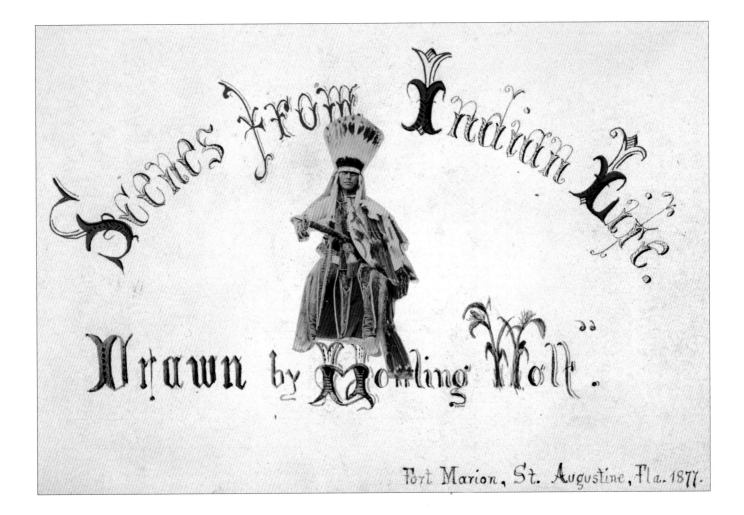

Plate 32.
Title page created by Eva Scott for Howling Wolf's book of drawings. BRL, 4100.G.2.1. All of Howling Wolf's drawings in the book are in some combination of ink, colored pencil, graphite, and possibly crayon. All pages measure 6 inches high by 10 inches wide.

Howling Wolf

Cheyenne Artist as Ethnographer

Plate 33. "Howling-Wolf in Indian Costume. A Howling-Wolf 'Honennisto'—
Cheyenne for 'Howling Wolf'"

Howling Wolf's first page in his book for Eva Scott is a signature page in various ways. He
has presented a standing self-portrait, his name sign, and his handwritten signature. Eva
Scott, or perhaps Richard Pratt or the interpreter, George Fox, has offered yet another
identifier by writing the Cheyenne word for "Howling Wolf." In four ways—three of them
primarily Cheyenne—Howling Wolf is identified here.

Many examples of Howling Wolf's name sign appear in other drawings he made, both
at Fort Marion and on the Great Plains. His pre–Fort Marion ledger, now at Oberlin Col-
lege in Ohio (see fig. 27, chapter 2), and the twelve drawings postdating his return to Indian
Territory from Florida use the image of a standing or running wolf with lines emanating
from its mouth to indicate howls. Like the name signs of many other protagonists, Howl-
ing Wolf's is most often placed in the space above the self-portrait and connected by a line
to that figure in the drawing. Here the artist has instead drawn a seated wolf in profile. The
howl lines have been carefully rendered, for they are an integral part of his identification.
The name sign is not connected to the standing self-portrait but sits in a space of its own.
The artist's handwritten name is identified as "his autograph," but the wolf name sign, the
Cheyenne word for Howling Wolf, and the handwritten name are his autographs, for the
name sign was the traditional Cheyenne way of identifying protagonists in drawings on
the plains. Name signs are not the equivalent of artists' signatures, because warriors some-
times rendered the heroic actions of other men. But if the artist was drawing his own deeds,
then the name sign would be the identifier of the brave warrior, as well as the "autograph"
of the artist.

The self-portrait shows Howling Wolf in clothing and with accouterments indicating
the position he had achieved in Southern Cheyenne society before his incarceration at Fort
Marion. A similar self-portrait appears in a small autograph book filled with drawings by

Figure 47.
*Detail of figure 27 (chapter 2). Howling
Wolf's name sign, at the top of the page,
is connected by a line to his self-portrait
in the drawing. From page 32 of a
ledger by Howling Wolf, circa 1874
to mid-1875. Allen Memorial Art
Museum, Oberlin College, Oberlin,
Ohio. Gift of Mrs. Jacob D. Cox,
19.04.1180.9,21.*

The drawing shows a standing figure in full Indian regalia holding a flag, with handwritten captions including "Howling Wolf in Indian Costume," "a Howling-Wolf," "Honennisto — Cheyenne for 'Howling-wolf,'" "Howling Wolf," and "His Autograph."

Plate 33.
BRL, 4100.G.2.2.

Figure 48.
Detail of plate 33.

twenty or twenty-one Fort Marion artists, apparently made for Richard Pratt.[1] The men who rendered self-portraits in Pratt's book presented themselves as they would have appeared on the plains, not as they did in Florida, dressed in blue military uniforms and with their hair shorn. Many drawings in the small book represent hunting scenes and village life, and none illustrates life at Fort Marion. Four Cheyenne men and one Kiowa prisoner provided self-portraits without additional figures; another Kiowa man rendered a three-quarter-length view of himself next to the lodge to which his family held the rights.

Not only was Howling Wolf an established warrior who had counted coup on several occasions, but he also had risen to become a secondary-level leader in his warrior society, the Bowstrings.[2] In plate 33 he has drawn himself wearing a full feathered war bonnet, something with which he depicted himself in battle in other drawings (fig. 49). A brightly colored bird is attached to his headdress. His shield and its full feathered trailer are visible, as is the otter-skin-wrapped and feather-embellished saber in his left hand. In his right hand, Howling Wolf holds a United States flag. He wears a combination of Native and US military clothing; his trousers or leggings are blue with yellow stripes, clearly military attire, and his coat bears military epaulets. Yet, he also wears long, red

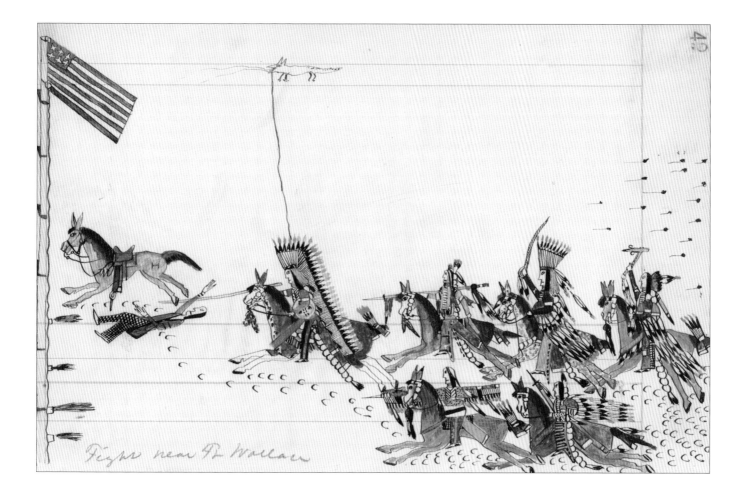

cloth strips from a loincloth and a hair-pipe breastplate. One of his red-and-white-wrapped braids is visible, as are the German silver hair plates that hang down his back.

This self-portrait raises questions about why the Fort Marion prisoner-artist presented himself in this combination of ways. Men on war parties did capture flags and uniforms from their military foes and often wore or carried them, or parts of them, in their everyday lives, as well as making them part of their war clothing.[3] Although Cheyenne men sometimes borrowed shields, headdresses, and warrior society paraphernalia from fellow warriors, Howling Wolf owned his own protective shield and had significant achievements as a warrior. Here his full feathered headdress, military uniform, flag, and saber confirm his status. He presents himself confidently, detailing his achievements in ways that fellow prisoners would have understood. The American flag might also indicate the multiple roles he has now assumed as a Plains Indian man forced to live in Saint Augustine. As a page of self-portraits and signatures, Howling Wolf's initial drawing in Eva Scott's book is a strong statement of the combination of influences he felt and realities he faced.

Figure 49.
Howling Wolf, drawing labeled "Fight Near Ft. Wallace," circa 1874 to mid-1875. Page 42 of a ledger in the Allen Memorial Art Museum, Oberlin College, Oberlin, Ohio. Gift of Mrs. Jacob D. Cox, 1904.1180.9,21.

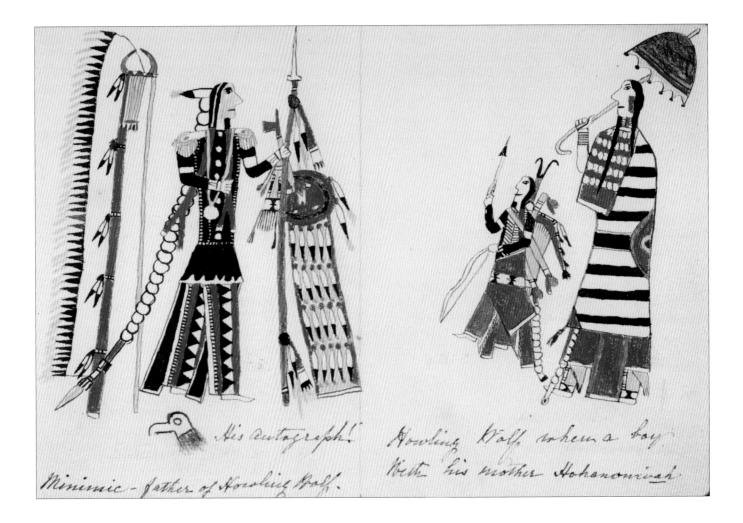

Plate 34.
BRL, 4100.G.2.3.

Figure 50.
Detail of plate 34.

Plate 34. "His autograph. Minimic—father of Howling Wolf. Howling Wolf when a boy with his mother Hohanowivah"

Howling Wolf's father, Eagle Head, or Minimic, was one of the highest-ranking men imprisoned in Florida (see fig. 26, chapter 2). A member of the Council of Forty-Four, the chiefly leadership of the Cheyenne people, Eagle Head had, like others before him, achieved his position through bravery in battle and demonstration of the calm, reasoned leadership necessary for council membership.[4] Although the position of chief was not inherited among the Cheyennes, Howling Wolf was following in his father's footsteps as a recognized war leader before the Fort Marion incarceration.

If Eva Scott's caption for this drawing is accurate, then the image is unique in the history of nineteenth-century Plains drawing and painting as it is currently known. In rendering not only his father but also his mother, together with an image of himself as a child, Howling Wolf drew a family portrait of a type familiar to Eva Scott and other visitors to the fort but not to pre-reservation cultures on the plains.

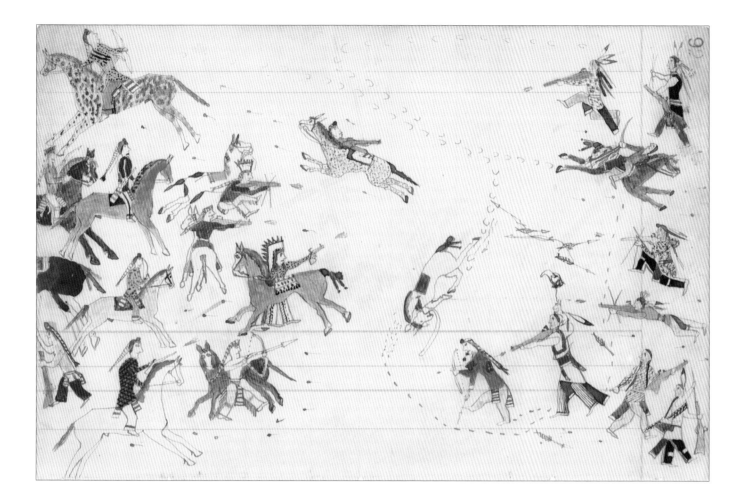

Eagle Head is clearly identified by his name sign, here placed beneath the figure of the standing chief rather than above his head. Howling Wolf provided the same type of name glyph for his father when he recorded some of Eagle Head's battle exploits in the Oberlin drawing book. On this page in Scott's volume, neither Howling Wolf nor his mother has such an identifier.

Eagle Head is a leader, and his position in Cheyenne society is made readily apparent by his dress and what he carries. The full feathered and horned war bonnet standing behind him is that of an established warrior, one whose bravery and capabilities have been recognized by men he has led into battle; this recognition would have been necessary to make him a member of the Council of Forty-Four. His lance and shield also attest to his achievements. He has fought under the protection of power granted him through a vision associated with the shield, and the lance indicates his leadership in the Cheyenne Bowstring Society. His pipe and pipe bag may also be indicators of his role in leading war parties, because leaders carried pipes.[5] Pipes had other

Figure 51.
Howling Wolf, drawing labeled "A Battle Between the Crow and Cheyenne Tribes," circa 1874 to mid-1875. Eagle Head's name sign appears in the lower right-hand portion of the drawing. Page 92 of a ledger in the Allen Memorial Art Museum, Oberlin College, Oberlin, Ohio. Gift of Mrs. Jacob D. Cox, 1904.1180.9,21.

Figure 52.
Detail of figure 51.

uses, of course, but Howling Wolf may have included this one not only because it was an important personal possession but also because it underscored his father's status.

Like his son as depicted on the previous page of Scott's book, Eagle Head wears arm bands, a long line of hair plates, and a military-style jacket with epaulets. His leggings bear the distinctive triangular pattern that Howling Wolf rendered on many figures. The chief also wears a circular disk suspended from a yellow cord around his neck. Although no image is apparent on the disk, it is undoubtedly a peace medal of the type given to Native leaders who met with US government delegations or who traveled to Washington, DC, to meet with federal officials there.[6] As a member of the Council of Forty-Four, Eagle Head probably received his medal sometime between the mid-1860s and his imprisonment, when the federal government was trying to maintain peace on the plains through various means, including treaties such as that of Medicine Lodge.

According to the captions Eva Scott provided, the two figures who face Eagle Head are Howling Wolf himself (as a young boy) and his mother. Howling Wolf wears a blanket with beaded decoration and carries a small bow in one hand and an arrow in the other. An intricately embellished mountain-lion-skin quiver is suspended from his back. Boys learned to hunt by practicing with small bows and arrows, and as they grew and became more skilled, they advanced to full-size weapons.[7] The young Howling Wolf is dressed elaborately, with hair plates, a bone breastplate, and arm bands, in addition to his blanket. Children were showered with such signs of the love their families and their people felt for them.

The artist's mother wears a dress decorated with elk teeth or shells, and she holds an umbrella. Each of these items of apparel, as well as the circular silver disks that hang from beneath her blanket and are undoubtedly part of a belt, are indicators of position in Cheyenne culture. Male elk have only two milk teeth per animal, so dress yokes embellished with such teeth signaled an extremely successful hunter. By the reservation period, shells were often adhered to dress bodices in place of teeth. These, too, carried messages of achievement, regarding both the family member who provided the shells or teeth, such as a father or husband, and the woman, who was held in high regard.

Eagle Head's wife also wears a Diné (Navajo) blanket of the type known as a third-phase chief blanket, probably received in trade through Comancheros, or Mexican traders. Although Southern Plains people were often at war with the Navajos, they held Navajo textiles in high regard for the extreme tightness of their weave, which made the blankets nearly waterproof. Chief blankets were very popular among Plains peoples; the title *chief* was a reference to Plains Indian leaders who sought such blankets, frequently as gifts for their wives and daughters. The third-phase blanket style is distinctive with its bold dark and light stripes, the middle stripe broader than the others, as well as a centrally placed diamond and smaller triangular forms at each corner. The contrasting color of the diamond and corner triangles was most often red, with other colors sometimes woven into the pattern.[8] The dark and light stripes and the large red areas made the blankets desirable for aesthetic reasons, as well as practical ones.

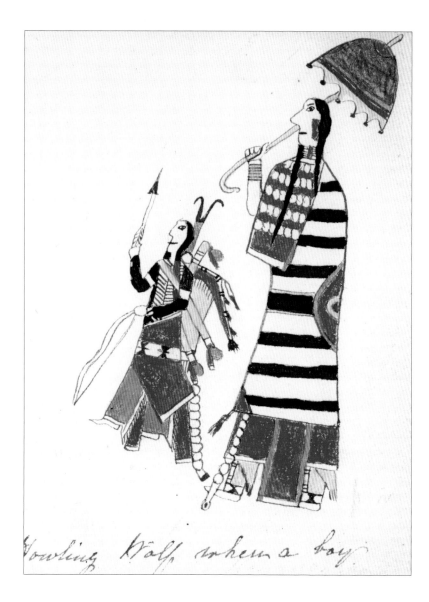

Howling Wolf when a boy

Figure 53.
Detail of plate 34.

The umbrella Howling Wolf's mother carries is another item of foreign manufacture. Many Plains drawings from the reservation period include umbrellas, which were practical as sunshades but also were signs of social position, given the necessity of trading for them. They were often colorful additions to one's attire as well. Even in Florida, the Fort Marion men recognized their value, and umbrellas appeared frequently in drawings, especially in courting scenes. Umbrellas were among the most popular items the prisoners purchased in Saint Augustine with some of the money they earned. The Southern Cheyenne artist Buffalo Meat created an often reproduced price list indicating what various objects cost the prisoners, and umbrellas, available for a dollar apiece, held a prominent place.[9]

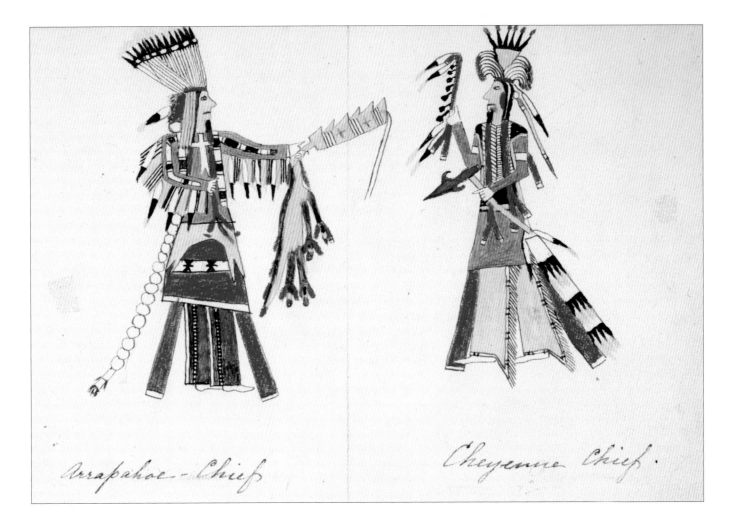

Arrapahoe-Chief

Cheyenne Chief.

Plate 35.
BRL, 4100.G.2.4.

Plate 35. "Arrapahoe Chief. Cheyenne Chief"

Howling Wolf's detailed representations of two chiefs, or leaders, provides a wealth of information about the two men. Although not identified as such in Eva Scott's caption, the Cheyenne man, positioned on the right, is a member of the Dog Soldier warrior society. His distinctive headdress—a circle of raven or crow feathers with central, upright eagle feathers—indicates that he is an officer of the society. Only two men in the society wore black headdresses; two other officers wore red ones, and two others, yellow. Howling Wolf depicted each of these headdresses in a drawing collected in 1876 that illustrates a Dog Soldier Society gathering (see fig. 55).[10] The curved deer hoof rattle with attached deer dewclaws, carried by each member and visible in the Cheyenne chief's right hand, is also a sign of the society. In plate 35 the warrior carries a tomahawk as well, possibly a pipe tomahawk of the type presented to chiefs and leaders by federal officials or one obtained through trade. By the time of Howling Wolf's imprisonment, tomahawks were far more important as signs of social position than as weapons or, in the case of pipe tomahawks, pipes.

Dog Soldiers were renowned as extremely brave warriors and strong fighters. By the 1860s they had become the most vocal advocates of war among the Cheyenne people. The society, which had actually become a separate residence unit after one of its leaders was banished for murdering a fellow Cheyenne, lost a large number of its members at the battle of Summit Springs in 1869. Following this major defeat, the Bowstring Society, to which Howling Wolf and his father, Eagle Head, belonged, became the most powerful Southern Cheyenne war faction.[11]

The Arapaho leader, standing on the left, is dressed in a far different manner. He wears an elaborately embellished shirt with beaded bands, feathers, and what may be horse or human hair. Often erroneously called a scalp shirt, such a shirt was more often embellished with horse hair.

A notched, wood-handled quirt, or riding whip, from which a kit fox fur is suspended, has been given a prominent position in Howling Wolf's drawing. The Arapaho holds it out toward the Dog Soldier, thus giving the quirt the central position in the composition. Around his neck the Arapaho chief wears a pendant of a type frequently associated with Arapaho leaders, made of so-called German silver, actually an alloy of copper, zinc, and nickel that was available in sheets ready to be cut into decorative forms. German silver crosses were popular among various tribes during the nineteenth century.[12]

Figure 54.
Detail of plate 35.

Figure 55.
Howling Wolf, drawing depicting a Dog Soldier Society gathering. Sketchbook, 1876. Yale Collection of Western Americana, Beinecke Rare Book and Manuscript Library, 1073190.

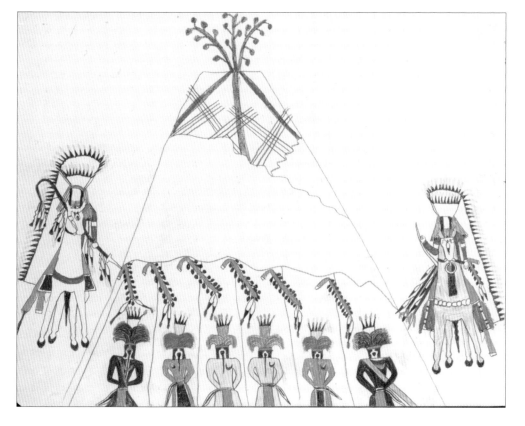

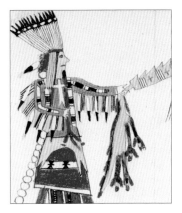

Figure 56.
Detail of plate 35.

Figure 57.
*Detail of figure 27 (chapter 2).
From page 32 of a ledger by Howling
Wolf, circa 1874 to mid-1875. Allen
Memorial Art Museum, Oberlin
College, Oberlin, Ohio. Gift of Mrs.
Jacob D. Cox, 1904.1180.9,21.*

Unlike the warrior societies of their Cheyenne allies, the Arapahos' warrior societies were age graded, with each grade acquiring greater knowledge. Young men entered the Kit Fox Society as their first formal step in the Arapaho system. Although early anthropologists reported different characteristic ages for the societies, the Kit Fox Society was for boys from their later teens to perhaps twenty-one. The Stars followed. Both groups were the means through which young men in Arapaho culture began to acquire the knowledge that would lead them to become fully Arapaho.[13]

The quirt, or club board, that the man in Howling Wolf's drawing holds was an insignia of the Clubboard or Tomahawk Lodge among the Arapahos. This society was far more formal than the preceding two. Not all members of the Tomahawk Lodge carried the same type of insignia. First- and second-degree members carried the flat board, whereas those of lower rank carried sticks culminating in effigies of horses' heads. The higher-ranking members were obligated to use their club boards to strike the enemy in battle.[14] As was the case in various warrior societies among the Plains tribes, "the regalia itself carried an obligation governing the movement or immobility of warriors in battle."[15]

In a drawing in the Oberlin ledger, which predates Howling Wolf's Fort Marion imprisonment, he rendered a view of himself in battle using a quirt of a type similar to the one depicted in plate 35. The markings on the quirt are the same as in the Scott book, as is the basic coloration of the animal skin suspended from it. The other quirts he rendered in the Oberlin ledger, however, are not notched like the one held by the figure in Scott's book.[16] Howling Wolf was a member of the Southern Cheyenne Bowstring Society, and quirts such as these were carried by its subchiefs, or secondary leaders. Although the so-captioned Arapaho chief in Eva Scott's book might actually be Arapaho, he might also be a Southern Cheyenne Bowstring Society leader, given Howling Wolf's self-portrait elsewhere with the same type of quirt.

Plate 36. "Shooting a Buffalo"

Howling Wolf's depiction of a soldier shooting a buffalo is one of only two instances in his book for Eva Scott in which he represented a non-Native person. Later in the book (plate 58), a single soldier appears in a drawing with a great number of other figures. The soldier shooting the buffalo here is quite different in that the man and the animal have equal prominence in the drawing. Unlike Zotom, who often provided views of his contact with soldiers, Howling Wolf drew his life on the plains in many different ways without including clear evidence of the increasing presence of non-Native people in the region. The appearance of this single drawing that breaks from his other images in the book is striking. It might have been the artist's way of indicating that other people were hunting buffalo on the plains and endangering the supply of this vital animal.

Howling Wolf rendered the soldier far differently from the way he drew Native men. The soldier has an overlarge nose, a heavy, dark eyebrow, and a visible ear. Ears rarely appear in Howling Wolf's other drawings, because the way he represented the hairstyles

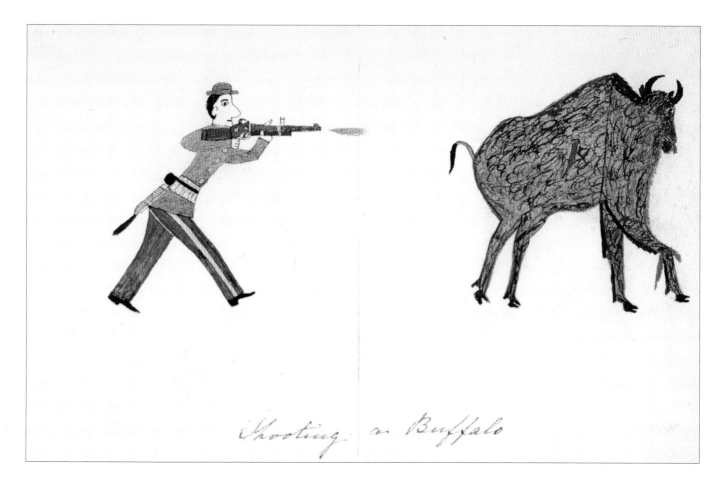

Shooting a Buffalo

Plate 36.
BRL, 4100.G.2.5.

of his Plains men and women obscures them. Eyebrows, too, are infrequent; he may have put one on this figure as a way of suggesting that the soldier had more facial hair than many Plains men did. Whether or not he intended it as such, the soldier's large nose lends a quality of caricature to the figure.

This is not the active kind of hunt that Howling Wolf portrayed later in the drawing book, where Native hunters race across the page in pursuit of horses or game (plates 47, 52, and 60). Here, a single soldier, perhaps moving forward, judging from the position of his feet and legs, fires at an already severely wounded buffalo. The massive body of the animal and the texture of its fur have been effectively suggested. Even in its dying moments, the buffalo's strength is apparent. Howling Wolf turned the buffalo's head slightly so that both horns are visible. In this drawing, as in several others in his book, Howling Wolf drew initial outlines in a color different from that composing the form itself. The blue outline is clearest along the tail and rear portions of the animal, on the legs and head, and in the line dividing the differing textures of the animal's fur vertically from its hump to just behind the front legs.

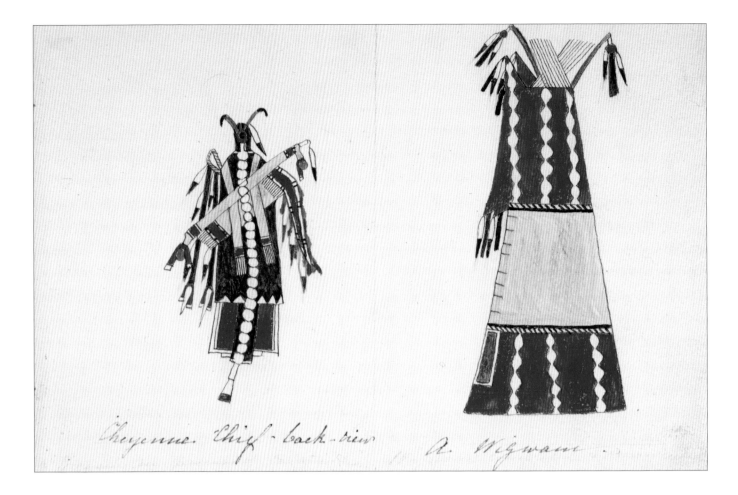

Cheyenne Chief—back-view

A wigwam

Plate 37.
BRL, 4100.G.2.6.

Plate 37. "Cheyenne Chief—back-view. A wigwam"

In this interesting pairing of a well-dressed man shown from behind and a lodge rendered in great detail, Howling Wolf gave full rein to his sense of design and abstraction. The chief's clothing and accouterments create vivid patterns of dark and light, circles and rectangles, verticals, horizontals, and diagonals. The same is true for the slightly simpler elements that compose the tipi, from the three-part division of its painted cover to the horizontal bands that separate the central field from the upper and lower levels. The vertical lines of connected white diamonds placed against the red field of the upper and lower parts of the cover unify the design. The lodge's crossed support poles and the feathers attached to the two larger poles, as well as the upper and lower areas of the tipi flaps, add diagonal elements. Two larger, green poles are visually balanced by the green rectangle on the lower level, which indicates the covering of the tipi's entryway.

The identity of the chief is unimportant in Howling Wolf's drawing. Although the artist might well have been depicting someone in particular, the figure remains anonymous to viewers today, as it must have been to Eva Scott and her contemporaries. There is no doubt,

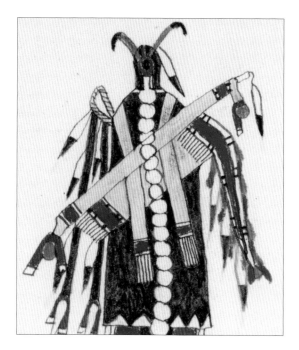

Figure 58.
Detail of plate 37.

however, that this is a man of some accomplishment. The yellow hilt of his saber appears above his left shoulder, and the saber's otter-skin, feathered pendants hang beside his body. A long line of German silver hair plates trails down the figure's back and behind him. The part in his hair has been painted, and feathers have been attached to his hair.

By far the most visually complex element of the warrior's attire is the elaborately embellished quiver that crosses from his right shoulder to his left side at mid-body. Such combination quiver-bow-lance cases are dramatic examples of the union of functionality and aesthetics. This one's yellow cougar skin is embellished with bands of beadwork, trade cloth, fringe, and feathers. The triangular red cloth insert that comes from the top of the quiver and bends to the right side of the man adds another element of distinction. Even while the figure stands with the case on his back, the kinetic qualities of the case are apparent. When worn while the owner rode or walked, the movement of the appendages, feathers, and fringe on such a case would have created a visual dynamic unequaled by any other single item of Plains Indian clothing.

The composition of this drawing resembles that of many others in Eva Scott's book in which Howling Wolf visually divided the page in half, placing figures or figures and objects in each half of the drawing. Here he has placed the man slightly higher on the picture plane than the tipi, which is referred to in the caption as a "wigwam." The placement may indicate that the man is farther back in space, or it might have been a result of Howling Wolf's deteriorating eyesight. In either case, the difference between the placements of the figure and the lodge on this page is more exaggerated than it is in the artist's other images in the book.

Medicine - Man. Cheyenne brave.

Plate 38.
BRL, 4100.G.2.7.

Plate 38. "Medicine-Man. Cheyenne brave."

That the man positioned on the left of the drawing page here is a person of great spiritual power is unmistakable. Howling Wolf presented him with elaborate body paint that includes celestial symbols, zigzag lines indicating lightning, and perhaps animals associated with his visionary powers. His horned headdress is unlike that of a chief or war leader, and the objects he holds and the owl depicted above his head are additional indicators of the role he plays in Cheyenne life. He carries signs suggesting association with lightning, from the zigzag lines of the snake to the undulating edge of his lance and the wavy line attached to its opposite side.

George Bird Grinnell, who worked extensively among the Cheyennes in the early years of the twentieth century, related that two or three men among the tribe, known as Contraries, might hold great supernatural power at any one time.[17] Their power came specifically from Thunder, and the main sign of that strength and ability was the thunder bow or lance that they carried in their left hand. Brave Wolf, a Contrary known to

Figure 59.
Detail of plate 38.

Grinnell, was always painted red when he carried the bow. When the thunder bow was not in use, it was wrapped in buffalo hide:

> *Lashed to the lance outside of the buffalo-hide wrapper was a short, forked stick, sharpened at the butt, painted red, and with two prongs of unequal length. When the lance was unwrapped for use in a fight, or for other purpose, the sharpened end of the forked stick was thrust in the ground, and the lance was rested on it, the point up, so that the point should not touch the ground. When the Contrary took up his lance to go into the fight, he might hand this stick to any young man to carry. It was supposed to give the young man good luck in battle, because it was one of the belongings of a great medicine.*[18]

Contraries lived apart from the Cheyenne village, pitching their red-painted tipis at some distance from the camp. They did not marry, for abstinence from sexual activity was required for them to maintain their strength. Contraries held not only power but also great obligations, including that of being extremely brave in battle. In addition, a Contrary had to observe certain taboos in order to preserve his abilities. As the name suggests, these men behaved in a contrary fashion, doing exactly the opposite of what they said they were doing and responding, for example, "yes" to indicate "no."[19]

Howling Wolf's "Medicine-Man" may well be a Contrary. Some aspects of the objects the man carries and the way in which he is dressed and painted conform to that

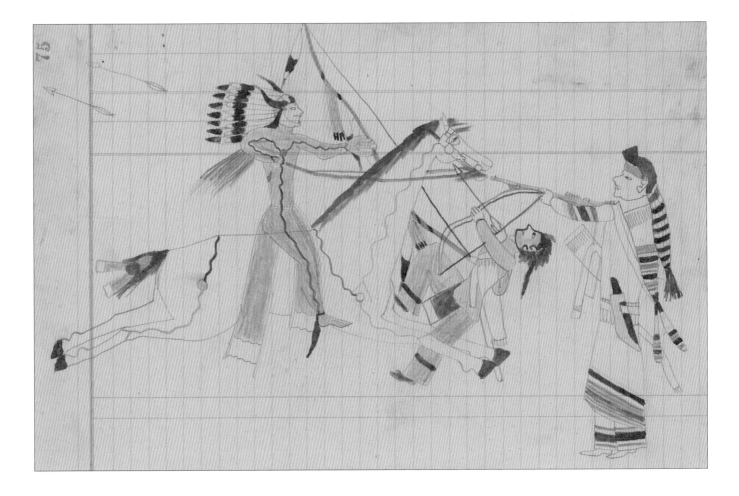

Figure 60.

Yellow Nose, drawing labeled "Yellow Nose drawing of warrior in full body paint using bow lance to strike two enemies whose horses are tethered nearby," about 1889. Page 75 of the Yellow Nose–Spotted Wolf ledger, National Anthropological Archives, Smithsonian Institution, 166032.

suggestion; others do not. No other Fort Marion drawing that might depict one of these powerful men has come to light, but several Northern Cheyenne drawings offer comparisons. The best-known one is from the ledger known as the Yellow Nose–Spotted Wolf book, now in the collections of the National Anthropological Archives of the Smithsonian Institution. On pages 55 and 75 of that book, for example, a man wearing red clothing and body paint rides in battle carrying a red, double-curved bow to which feathers are attached. One of the drawings offers a view of the Contrary with his chest placed frontally and his leg in profile. A zigzag line has been painted from each wrist to a circular form on the man's chest and then down his visible leg. His horse carries the same painted design. The Contrary is using his thunder bow to count coup on the enemy and will survive the gunshot being fired at him almost point-blank, provided he has not violated his taboos.

Howling Wolf's figure, too, wears red face paint, and the design on his face and the zigzags on his arms and legs are similar to those seen on the warrior in the Yellow Nose–Spotted Wolf ledger. His body paint, however, is yellow, not red like that of the

Contrary in the latter book. An owl appears above the figure's head in Howling Wolf's drawing, and both Grinnell and George Dorsey recorded that owls were attached to the heads of Contraries. Father Peter Powell noted that the night, or screech, owl was used because it provided "power to move silently through the night and attack at great speed."[20] The bow that Howling Wolf's figure carries is red and is held in the man's left hand, but otherwise it differs markedly from other known representations of Contraries' bows.[21] It does not conform to ethnographic descriptions of thunder bows as being double curved; Howling Wolf's figure holds a lance that has jagged or serrated edges. Such an edge, however, is similar to the lines that appear as part of the figure's body paint and suggest thunder. The forked stick he carries matches Grinnell's description of this part of a Contrary's powerful objects.

Grinnell's discussion of the thunder bow includes a description of a stuffed oriole that was tied to the end of the bow. Among the Northern Cheyennes, the bird would have been a Louisiana tanager, which has some red on its head, but the oriole used among the Southern Plains tribes was yellow. Grinnell wrote that both the painting of the Contrary and his clothing imitated the colors of the bird. Thus, a Southern Cheyenne Contrary might well have appeared more the way Howling Wolf depicted the man here than like the red-painted figures in Northern Cheyenne drawings.

Despite the differences in details, it seems likely that Howling Wolf rendered an image of a Contrary in Eva Scott's book. The caption "Medicine-man" may be misleading to non-Native viewers unfamiliar with the details of Cheyenne culture; it can be read as a stereotypical way of referring to Native men with healing powers. Nonetheless, the figure depicted here possesses great medicine, and the caption is an apt one.

The Cheyenne man facing him is undoubtedly a member of the Elk Warrior Society, also known as the Crooked Lance Society because of the type of bent lance associated with it, a type that the man holds here. Elk warriors were found among both the Northern and Southern Cheyenne peoples, whereas Howling Wolf's own warrior society, the Bowstrings, existed only among the Southern Cheyennes. The Bowstrings' northern counterparts were the Crazy Dogs. When the entire Cheyenne people gathered as a whole, the Bowstrings and Crazy Dogs worked together, as did the Elk warriors from both regions.[22]

Two members of the Elk Warrior Society carried the distinctive bent lances, and two others carried straight lances; these four men were the bravest warriors of the group.[23] Both types of lances had eagle feathers attached to them at four different positions along their shafts. Strips of otter skin were connected to the lances, along with the feathers. Howling Wolf carefully detailed these attachments to the lances, including the deer dewclaws that hang from the otter skin, two at each of the four feathered clusters. The artist also suggested different colors for the otter fur; a portion of the attached pendants is black, and a portion yellow. As Mike Cowdrey has discussed in relation to another Cheyenne artist's work, the otter fur was painted yellow on one side, bringing together black and yellow, colors associated with thunder and lightning. The otter skin was twisted

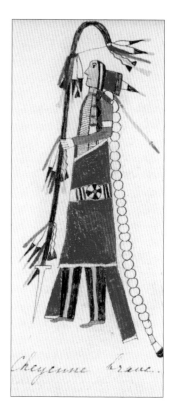

Figure 61.
Detail of plate 38.

when wet to make the pendants suggest zigzags and thus lightning, attesting to the Elk Society's association with these powerful forces.[24]

Like other warriors in Howling Wolf's book, this man wears a bone pipe breastplate, as well as long dentalium shell earrings. Such shells were traded onto the southern plains from the Northwest Coast, where they were abundant off Vancouver Island. Vast trade networks existed throughout Native North America from the archaeological past into the historic period. As he did repeatedly elsewhere, Howling Wolf rendered the Elk Society warrior wearing a red trade-cloth blanket with beadwork designs that include a beaded medallion. Such medallions were frequent additions to Cheyenne beadwork, especially on cloth blankets. The man's arm band and the long row of German silver disks he wears suspended along his back also appear frequently in Plains Indian drawings. Along with the earrings and breastplate, they indicate the man's stature and the fact that he is dressed for a special occasion. Because he holds his warrior society lance, he may be ready to take part in a warrior society gathering. Most Cheyenne men also dressed in their finest as they went into battle. A man so dressed was prepared to die.

Plate 39. "Chief singing and drumming, Chief dancing"

Song and dance were important parts of the life from which Howling Wolf had been exiled. Men sang and danced at their warrior society gatherings and on important occasions when the larger community was gathered. Often, songs and dances accompanied a man's recital and reenactment of his battle deeds or his narration of the accomplishments of those who had come before him, a way of honoring both recent and distant past bravery. Even at Fort Marion the prisoners sang and danced on various occasions, some of them arranged by Richard Pratt for public view.

Here Howling Wolf has drawn two men in different postures representing their roles as a singer-drummer and a dancer, respectively, in a celebration. Eva Scott, in her caption, labeled them "chiefs," a word she used often in Zotom's and Howling Wolf's drawing books. The drawings themselves do not always bear out her identifications. In this drawing, each man wears clear signs of his important position. The drumming and singing man, on the left, has an otter-skin turban with feathers and red trade cloth visible. Such headdresses were also embellished with oval or circular beaded disks, as suggested here. A saber with its otter-skin and feathered pendants is beside him, Howling Wolf's way of further emphasizing the man's standing in Cheyenne culture. The dancing figure to the right holds a feathered lance, a sign of his rank in one of the Cheyenne warrior societies. Various feathered lances were associated with different fraternal warrior societies and levels of leadership in each society. The lances differed in many ways, but primarily in the types of feathers affixed to them and the patterns or arrangements of those feathers.

Both men have bone pipe breastplates, metal arm bands, and long strings of German silver disks suspended down their backs. From the breastplate of the dancing man

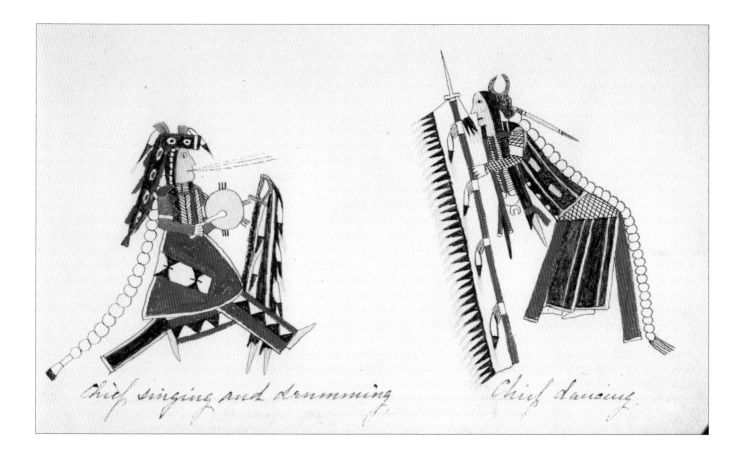

Chief singing and drumming

Chief dancing.

hangs an elaborate German silver pendant. This combination of curved silver pectoral and attached horseshoe-shaped *naja* was a frequent one and is also found on many horse headstalls on the southern plains. Introduced by Spaniards, najas are Moorish symbols referencing the hands of Fatima, daughter of the Prophet Muhammad, who dipped her hands in blood during battle and then imprinted her hands on a flag.[25] The form of the naja, without its connection to Islam, eventually became a key component of the squash-blossom necklace in southwestern Native jewelry, particularly among the Navajos, or Diné.

The drumming figure also wears a red trade-cloth blanket that has been embellished with a beaded blanket strip in a bold black-and-white pattern. The man's leggings, although showing large triangles of black-and-white beadwork, have a slightly different pattern.

Plate 39.
BRL, 4100.G.2.8.

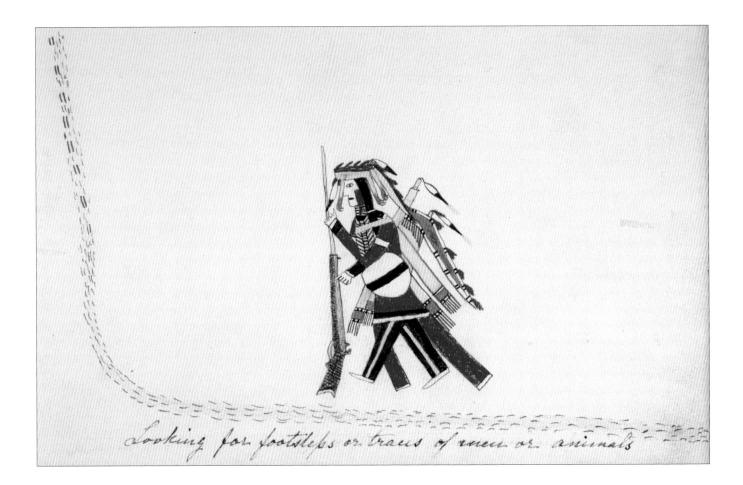

Looking for footsteps or traces of men or animals

Plate 40.
BRL, 4100.G.2.9.

Plate 40. "Looking for footsteps or traces of men or animals"
A hunter or scout wearing a headdress created from a kit fox skin stops to prepare his gun. The line of prints he has followed from the right side of the drawing page angle upward to the left, indicating that the man's prey, whether animal or human, has moved beyond the visual boundaries of the page. In ways such as this, Plains artists suggested that action continued and that the single, fixed view that could be presented on a small piece of paper was insufficient to relay the entire story.

Here the hunter or advance scout for a war party appears in profile, allowing a different view of a cougar-skin quiver and case of the type that Howling Wolf presented in full view two pages earlier in the drawing book. The way in which the quiver is held on the man's chest and the manner in which the long fringed tabs, the pendant feathers, and the triangular covering angle out from the hunter's body clearly suggest the kinetic qualities of the complex quiver. The man carries a shield in addition to his gun, indicating his preparedness for tackling the different kinds of prey he might encounter.

On war parties, young men generally served as scouts, or, as they were known, wolves, to seek the location of enemy camps. Grinnell suggested that typically one or

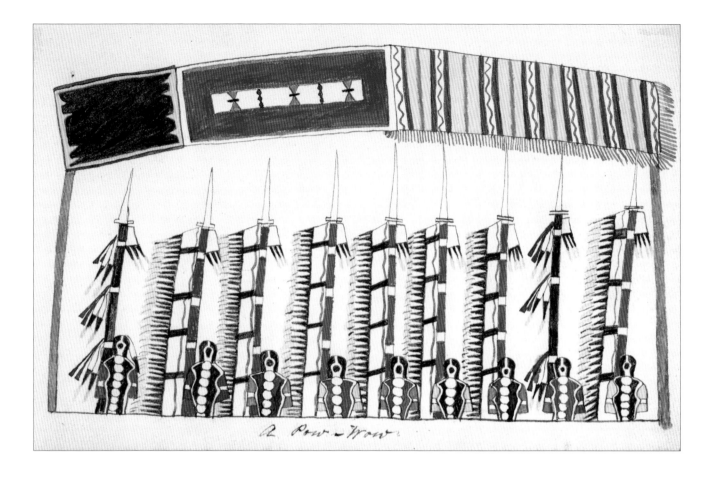

a Pow-Wow

a pair of scouts traveled alone to ascertain the locations of camps, particularly from which the war party could plunder horses. In looking for enemy locations, scouts moved cautiously and observed the behavior of animals in the area through which they traveled. Running buffalo or leery wolves, for example, signaled that scouts needed to exercise extreme caution. If the animals were quiet and no signs of smoke indicated a camp, then the scouts returned to their fellow warriors and urged them forward. In Howling Wolf's drawing, the scout is tracking what may well be both animal hoofprints and human footprints, for each was part of the scout's responsibility.[26]

Plate 41. "A Pow-Wow"

In a type of scene that Howling Wolf represented various times during his Fort Marion confinement, men have gathered under the shade provided by textiles attached to wooden poles. The artist has turned the blankets outward, toward the viewer, flattening them rather than presenting them in profile. In this way the vivid patterns of the striped fringed blanket and the red blanket with beaded strip become more visually dramatic and assume a larger role in creating the dynamic pattern of the composition.

Plate 41.
BRL, 4100.G.2.10.

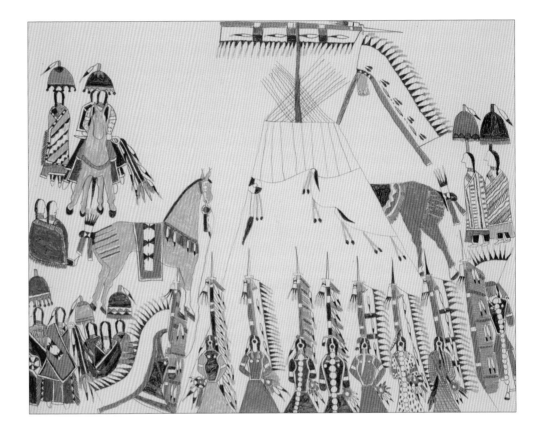

Figure 62.
Howling Wolf, drawing depicting
a Bowstring Warrior Society
Gathering. Sketchbook, 1876.
Yale Collection of Western Americana,
Beinecke Rare Book and Manuscript
Library, 1073191.

Beneath the sunshade, the men are shown from the back. Howling Wolf drew them only from the waist upward; our view of their elaborate dress is truncated by a line at the bottom of the pictorial space, connecting the two support posts of the sunshade. Each man is dressed similarly in shirt, vest, arm bands, and hair plates; the parts in their hair are also the same. Although the artist carefully rendered the repetition of form, the colors of the clothing differ. Red, purple, green, blue, yellow, black, and white provide a rhythm that suggests the vibrancy of the gathering.

Comparing this drawing with others that Howling Wolf made of warrior society gatherings, the identification of this one as a gathering of the artist's own society, the Bowstrings, becomes likely. Known as the "noisiest and gayest" of the Cheyenne warrior groups, according to the anthropologist George Dorsey, the Bowstrings had no truly uniform dress style, whereas some other Plains warrior societies did.[27] Rather, each member dressed as he wished. Gatherings such as the ones Howling Wolf represented in this drawing and in one from a book bearing the date 1876, now in the Pratt Papers of the Western Americana Collections of Yale University, emphasize the diversity of colors (see fig. 62). The great similarity in the way the artist represented the warriors in the two drawings is clear. Scott's book has smaller pages, and this might have been at least the partial impetus for Howling Wolf's rendering the men from the waist up rather than full

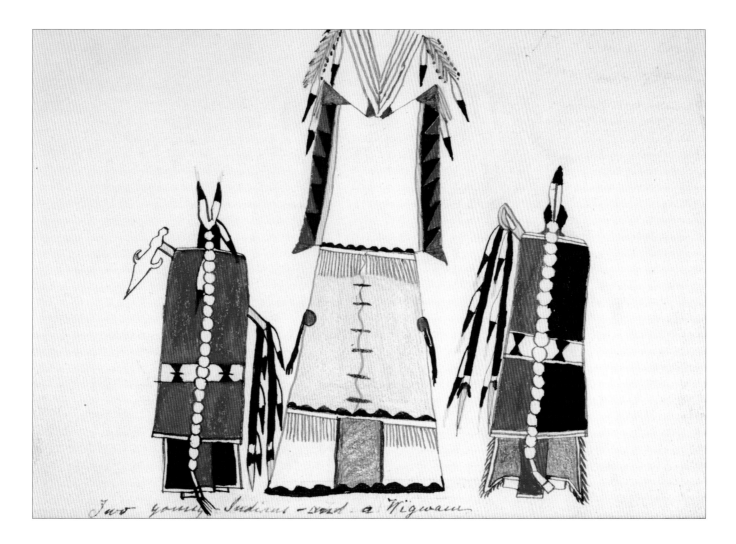

Two young Indians – and a Wigwam

Plate 42.
BRL, 4100.G.2.11.

length, as he did in the Yale book. The earlier image includes many other observers and the warrior society lodge itself, whereas the drawing in Scott's book employs the patterning of the sunshade as auxiliary evidence of the festiveness of such gatherings, which Dorsey suggested. But the portions of the men visible in the Scott book, and the lances they hold, are strikingly similar to the Yale drawing.

Plate 42. "Two young Indians—and a Wigwam. One of these Indians holds a Tomahawk, the other a sword. The string of disks down their backs, is composed of silver-dollars beaten out thin. The Wigwam is presented in a different position from that given in the first picture of one."

Two men stand flanking a painted lodge in another drawing in which Howling Wolf focused intently on the creation of bold patterns. The man to the left of the lodge, as Eva Scott's caption indicates, holds a tomahawk, its elaborate head visible, as well as

the fur wraps, decorated with feathers, that hang from its handle. To the right of the tipi, a warrior holds a saber, from the yellow hilt of which hang the same types of fur and feathered pendants found on the tomahawk.

Both men wear blankets with beaded strips at their centers. The man on the right wears what is often referred to as a courting blanket, which consisted of pieces of red and black or dark blue trade cloth sewn together vertically where the blanket fell along the man's spine. Such two-colored blankets were particularly prominent among the Lakota people. A female relative would make one for a young man as a sign of affection but also as an article of apparel important in courting practices. A young man would ask a young woman in whom he was interested if she would share his blanket with him, and, if she returned his interest, she might join him under cover of the blanket for private conversation. Any blanket would do, but the two-colored ones with wide, beaded blanket strips are especially prominent in representations of courting scenes from the plains.

Each man in the drawing wears a long line of hair plates, which the caption indicates were made from hammered coins. Early silverwork by Diné, or Navajo, artists in the Southwest, as well as by the Mexican smiths from whom they learned the art, was made from hammered coins. Although Plains Indian smiths, who probably also learned to work silver from Mexican smiths, did hammer coins, by the latter part of the nineteenth century they more often employed sheets of German silver, cutting it into forms such as disks for hair plates and belts and pectorals for breastplates.

The lodge in the picture, as the caption indicates, is oriented in a manner distinctly different from the tipis that Howling Wolf represented on some of the other pages in Eva Scott's book. Here a full frontal view is provided, with the pegs that hold the lodge together visible along the center front and the door cover below. The smoke flaps, or ears, as they are frequently called, have been pulled back to allow air to circulate more freely through the interior of the lodge. The white space between the two red-and-black-patterned edges is actually the interior space of the upper portion of the lodge. Circular forms or disks that appear in the middle portion of the cover undoubtedly represent the beaded or quilled medallions that were prominent on both Cheyenne and Arapaho lodges.

Scott's comparatively detailed caption for this drawing differs significantly from most of the other captions she wrote on Howling Wolf's and Zotom's drawings. Her identifications of the tomahawk and sword and her note about how the silver disks were made can be explained as records of information she gathered. Her note about the position of the lodge is the result of her interest as an artist who observed Howling Wolf's creative variations in representation.

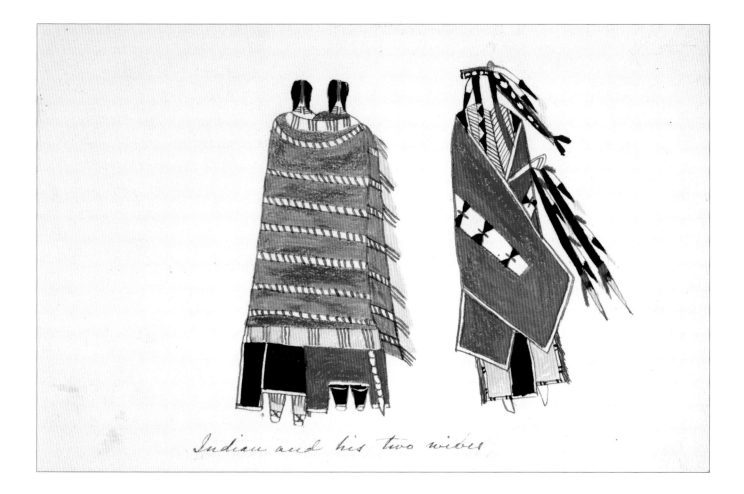

Indian and his two wives

Plate 43. "Indian and his two wives"

Continuing a practice that he used in earlier pages of Eva Scott's drawing book, Howling Wolf has again divided the page into two zones. The left half of the pictorial space is filled with a representation of two women viewed from the back, sharing a blanket. They have red paint in the parting lines of their hair, and each appears to wear a bone choker. Their dress colors differ, as do their leggings, which appear below the edges of the dresses. The woman on the right wears a line of silver plates, again undoubtedly connected to a belt that is hidden under the fringed green blanket.

On the right side of the page, a man appears in full frontal view, but Howling Wolf has not rendered his facial features. The artist excluded facial features several times in Scott's book, something that might have been due in part to his having developed severe vision problems.[28] Indeed, Howling Wolf's drawings in Scott's book, although boldly patterned and expertly composed, are generally far less complex and detailed than the drawings he made earlier at Fort Marion and certainly less so than those he created before

Plate 43.
BRL, 4100.G.2.12.

his imprisonment, perhaps because of his failing eyesight. The bold details of color and pattern, the elements of saber and fur and feathered pendants, of beaded blanket strips and otter-skin turban are here, but additional fine-line details like those Howling Wolf provided in many of his other drawings are not. Some of the pages in the Scott book even have a vertical line visibly bisecting the page, suggesting that the artist needed to deal with smaller portions of the page at a time. The division also provided a way to balance the compositions, and it is this balance of halves that dominates in many of the drawings in the book.

The concept of a man with two wives would have been of great interest to non-Native audiences in Florida. Although the practice was far from universal, a Plains Indian man who could afford to might take a second wife. For harmony's sake, the second wife was often a sister of the first.[29] However, Eva Scott might have used the word *wives* without clearly understanding that this might be a representation of a man courting two women. Courting scenes were common in Fort Marion drawings, as they were in reservation-period drawings on the plains. If the woman was willing, a warrior who had proven himself in battle would wrap a blanket—like the one the man wears in Howling Wolf's image—around her for some privacy while they spoke. Here the two women are separate from the man. They could be waiting to take turns in the blanket with him, or they could be on an errand to fetch water, for example. Virtue was highly regarded in Cheyenne society, and women were often accompanied when their duties took them away from the interior of the village, to prevent any eager man from overstepping the bounds. For Cheyenne men, the rules were different from those for women in matters of courting.[30]

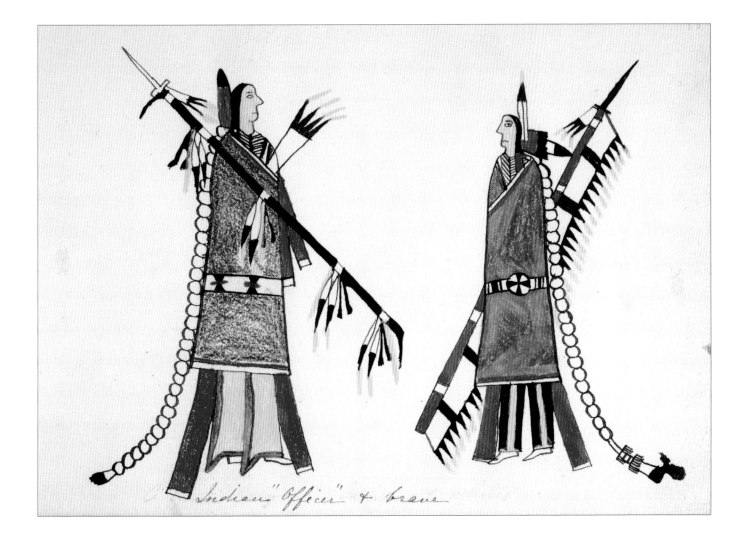

Indian "Officer" & brave

Plate 44. "Indian 'Officer' & brave"

Howling Wolf here depicted two warriors, each wearing a blanket with a beaded strip, a long line of silver hair plates, and a hair pipe breastplate. Both are members of warrior societies, as is indicated by the designs of their lances. The man on the left is an officer of the Elk Warrior, or Crooked Lance, Society because he carries an otter-skin-wrapped straight lance. Like the crooked lance of the same society that Howling Wolf rendered in plate 38, this warrior's sharply pointed lance has eagle feathers and strips of otter fur with deer dewclaws attached at four points along the shaft.[31] He faces a member of the Bowstring Society whose lance has feathers extending along its entire length, with the alternating groupings of white and black that are distinctive of some Bowstring lances.[32] Leaders of the Bowstring Society had lances such as this, and with the position of leadership and the accompanying lance came great responsibility for leading their fellow

Plate 44.
BRL, 4100.G.2.13.

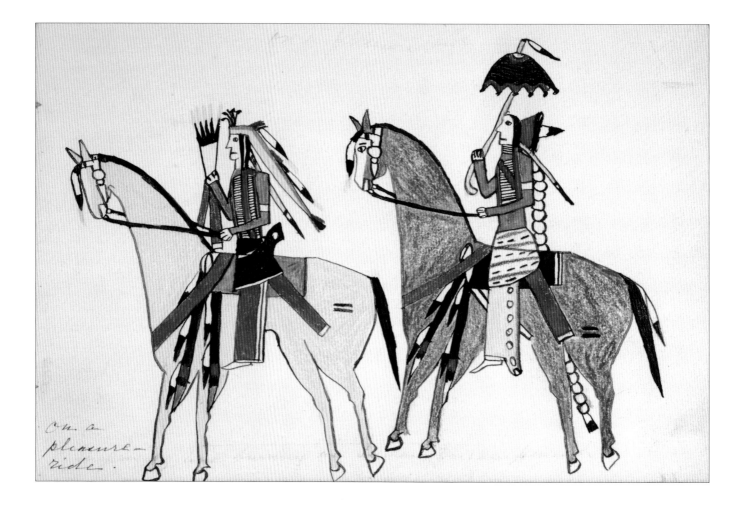

On a pleasure-ride.

Plate 45.
BRL, 4100.G.2.14.

warriors in battle.[33] Distinctive feathered lances like this were visible not only to other Cheyenne warriors but also to enemies, and they often drew enemy fire toward the men carrying them.[34]

Because these men appear to be from different warrior societies, their ranks may not be comparable. Without knowing for certain which warrior had the higher position, the viewer relies on the difference suggested by Eva Scott's caption, which labels one an officer and the other a brave—whether or not that information is correct. The man on the visual left has been rendered slightly larger than the man on the right. Although this might have been a way to suggest position in space, the difference in scale might also have differentiated comparative rank.

Plate 45. "On a pleasure-ride."
Two well-dressed men ride from right to left across the drawing page on what Eva Scott labeled a "pleasure-ride." Considering their dress and the fan carried by one man and the

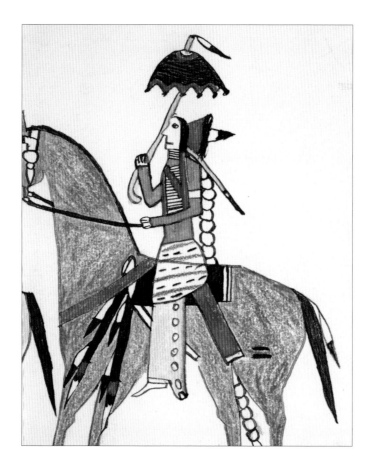

umbrella by the other, the pleasure probably has to do with a social visit, perhaps to court young women. Both men have what appear to be sabers with otter-fur and feathered pendants. Neither horse has its tail tied for war, and each has a headstall, probably fashioned from German silver.

 This drawing provides clear evidence of a practice followed by many Plains artists, that of rendering the horse first, then placing the rider astride the animal. The upper outline of the horse's body is visible as it passes through the striped blanket worn over the lap of the rider on the right. It is also apparent in the rendering of the other rider, although not as distinctly under his black blanket. In neither case, though, did Howling Wolf draw the entire outline of the horse's underbody; no such outlines are visible behind the two men's legs.

 Each horse is marked with two short, parallel lines on its rear flank, a common feature in drawings of Cheyenne horses. Plains warriors stole horses from members of other tribes and from US soldiers whenever possible, and brands are evident in some Plains drawings. Here the two lines are probably painted. Cowdrey suggested that they might be symbols of speed, expressing the wish that the horse move swiftly in battle and on

Figure 63.
Detail of plate 45.

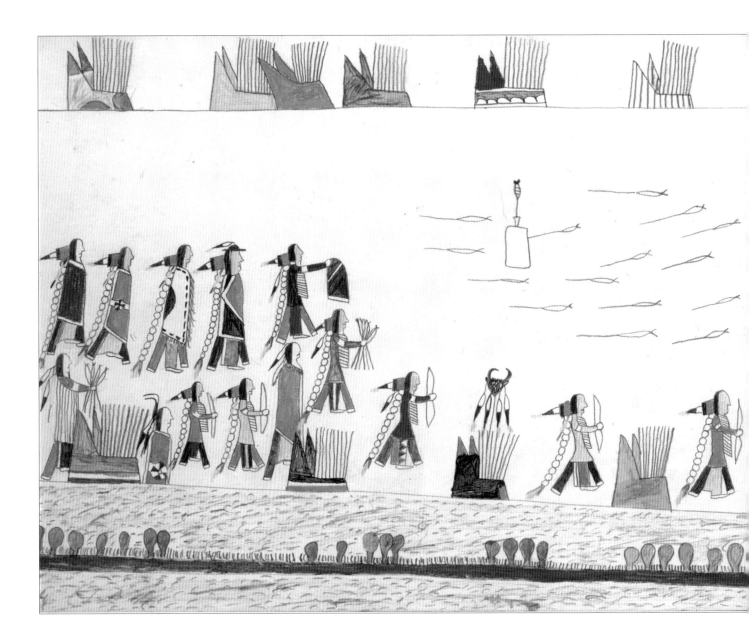

Figure 64.
Howling Wolf, drawing depicting target practice. Sketchbook, 1876. Yale Collection of Western Americana, Beinecke Rare Book and Manuscript Library, 1073199 and 1073557.

the hunt.[35] The horses appear to be walking during this pleasure ride, however. Unlike representations in which Howling Wolf depicted all four legs of the animals off the ground to suggest rapid movement, here the horses stand firmly on ground that is understood if not represented.

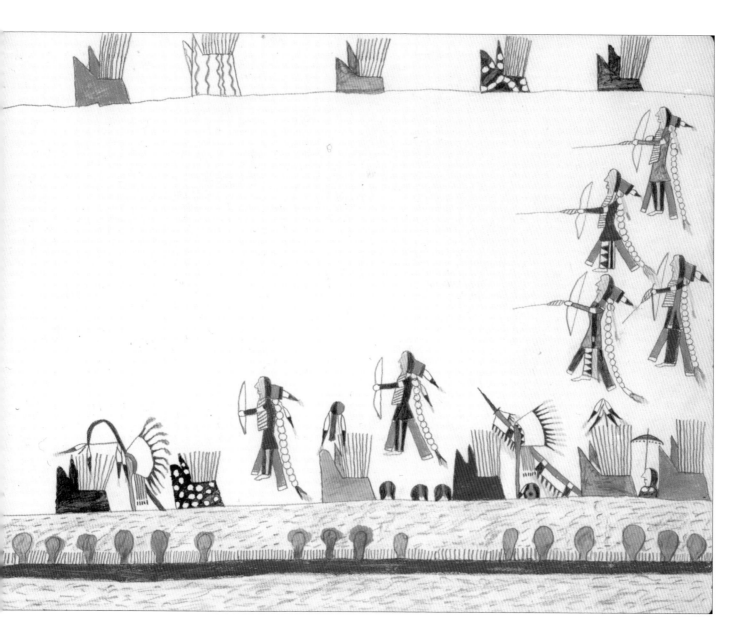

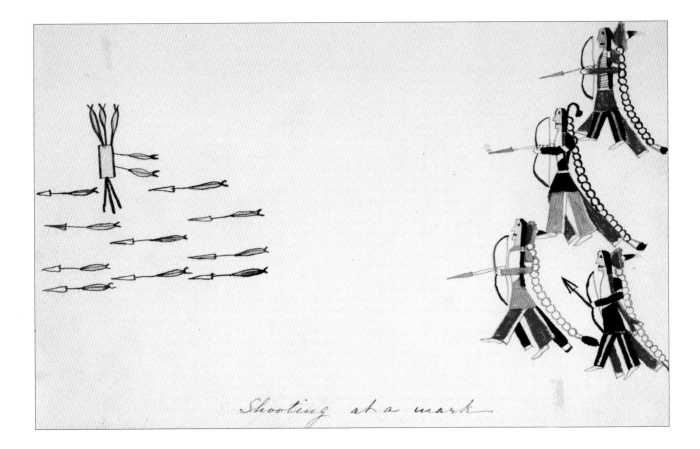

Shooting at a mark.

Plate 46.
BRL, 4100.G.2.15.

Plate 46. "Shooting at a mark."

Four men, each with a long line of silver hair plates, stand at the right in Howling Wolf's drawing, shooting at a target placed on the left of the pictorial space. Many arrows have been shot; two are stuck in the tripod-supported target. Three of the men hold their bows with arrows ready to be released while the fourth observes, holding his bow and arrow in a relaxed position, perhaps awaiting his turn. In a sketchbook dated 1876, Howling Wolf created a similar drawing illustrating men on the plains engaged in target practice. There he used facing pages of the drawing book to gain greater space, allowing the marksmen to shoot their arrows across the seam of the book toward targets rendered on the opposite page (see fig. 64).

Plains Indian men honed their hunting and fighting skills through practice, and friendly contests were part of their lives. Even at Fort Marion the men used bows and arrows, as several drawings make apparent. They manufactured miniature bows and arrows for sale to tourists, but they also used full-sized bows and arrows for target practice. Pratt arranged to have some of the prisoners demonstrate their prowess with bows and arrows for visitors to the fort.[36] Some of the men even gave archery lessons to women and children who were resident in Saint Augustine, at least for the winter.

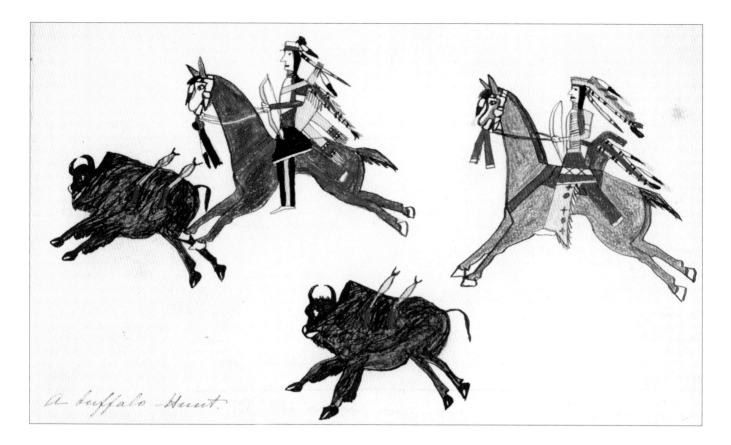

A buffalo-Hunt.

Plate 47. "A buffalo-Hunt"

Buffalo hunting was a subject that Howling Wolf portrayed in many different ways throughout his Fort Marion confinement. From a single hunter facing a lone buffalo or one man stalking a herd in a dense landscape to hunting parties racing after many animals, Howling Wolf relayed both the excitement of the hunt and various stages in achieving success. Here he has presented two mounted hunters pursuing two buffalo. Both bulls have already been struck with arrows, and blood runs from the two wounds in each body.

Both riders hold their bows and the reins of their horses. Neither man is ready to shoot again, perhaps sensing that the arrows that have already hit their marks will bring the animals down. The hunters are dressed well, and each carries an elaborate quiver, one rendered in yellow and the other in blue. Unlike horses prepared for war or those ridden during warrior society gatherings, where war honors were celebrated, these two horses do not have their tails tied. Rather, the tails stretch out behind the animals' bodies, adding to the sense of motion created by the positions of the horses' hooves and the flying appendages of the hunters' headdresses and quivers. The variation on a circular composition that Howling Wolf employed here further suggests the action of the hunt as horses and riders move in close to the wounded buffalo.

Plate 47.
BRL, 4100.G.2.16.

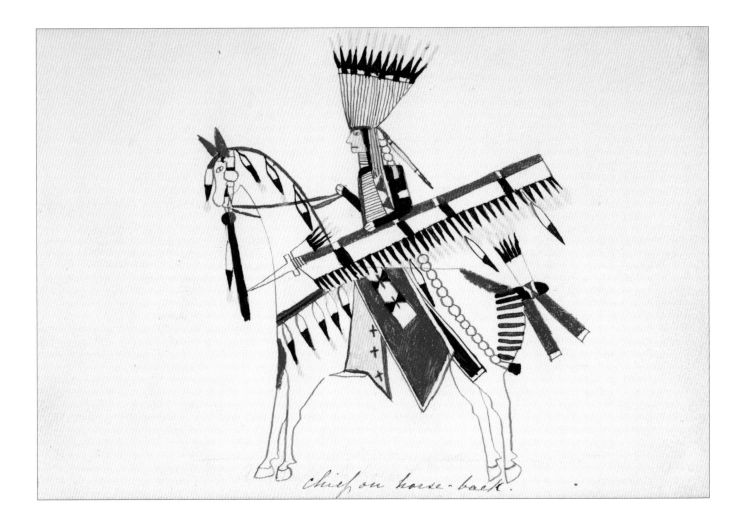

chief on horse-back.

Plate 48.
BRL, 4100.G.2.17.

Plate 48. "Chief on horse-back"

An elaborately dressed man on horseback fills the drawing page here, as does the renowned warrior presented in the following drawing in Eva Scott's book (plate 49). Although Scott may have used the term *chief* too frequently, here the rider's social rank is signaled by his upright feathered war bonnet and the feathered lance he carries, which indicates a position in the Bowstring Society. The distinctive, alternating black and white bands of feathers attached to the wooden shaft of the lance are a characteristic of that society.[37] The chief's horse is painted with black stripes referencing either an aspect of the rider's visionary powers or, more likely here, a record of his war exploits. It might also be an expression of the owner's desire that the horse move swiftly, as was suggested for the horses in plate 45. Either way, this is a highly valued war pony whose tail is tied as if for battle. Feathers are attached to the horse's mane, and a scalp lock, indicated by the circular form painted half red and half black, hangs from the horse's bridle.

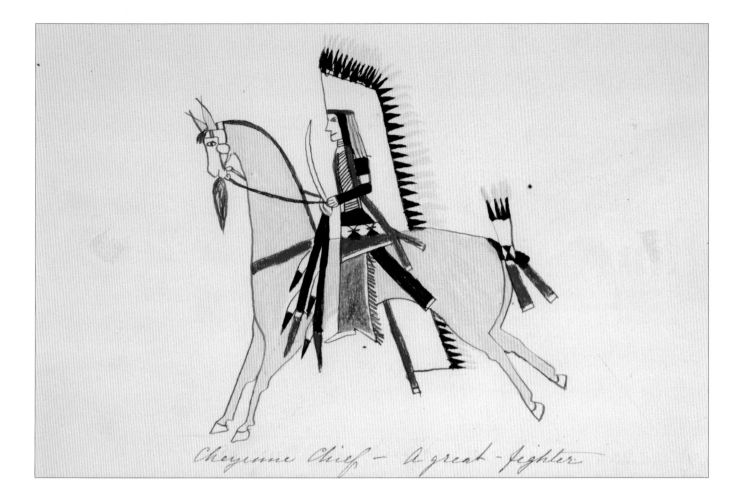

Cheyenne Chief — A great-fighter

Plate 49. "Cheyenne Chief—A great-fighter"

A full feathered war bonnet with long feathered trailer suggests that this warrior is a great leader who has achieved prominence in his culture, whether or not he is an actual chief. He holds his saber upright, allowing the feathered and fur-wrapped pendants to hang alongside his horse. As in plate 48, the horse's tail is tied as if for war. The man depicted here, like the preceding one and those in other drawings in Howling Wolf's book, might have borrowed such signs of achievement from others to help him in battle, but Scott's caption, at least, suggests otherwise.[38]

In various drawings in Eva Scott's book, Howling Wolf adjusted the way in which he rendered horses' bodies, particularly the way he suggested the animals' four legs. Although the horses he depicted in plate 45—the view of two warriors on a pleasure ride—are well proportioned, they appear awkward in comparison with the horse ridden by the Cheyenne man here. In plate 45, the artist clearly had difficulty rendering the way the back legs overlap each other. Although portions of the front legs are obscured

Plate 49.
BRL, 4100.G.2.18.

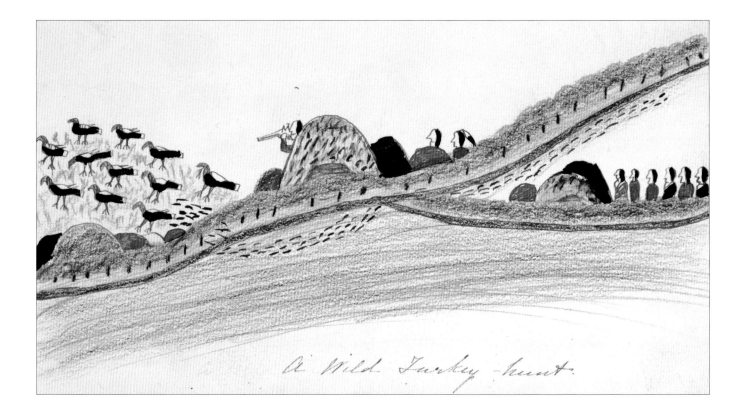

A Wild Turkey-hunt.

Plate 50.
BRL, 4100.G.2.19.

by the pendants attached to the riders' sabers, those legs, too, are anatomically incorrect. In this image of the great fighter, the artist has been more effective in suggesting the unity of the yellow horse's body and legs. Drawings made at different times or on different days reflect changes in the ways in which many artists work, and Howling Wolf was no exception.

Plate 50. "A Wild Turkey-hunt"

Departing markedly from the compositions on the three preceding pages, Howling Wolf used this page to draw a detailed hunting scene. The prey here are wild turkeys, which appear at the far left of the landscape the artist provided for the scene. A river flows from two positions on the right side of the drawing page, joining in mid-page. Howling Wolf has carefully rendered the lush vegetation nearest the water in a darker green to indicate its ready access to moisture. The landscape toward the bottom of the drawing is variegated in color, suggesting drier ground. The marks of the crayons he used are visible, overlapping one another to create the landscape. To the right, just before the two streams join, small hills are apparent, again rendered in a variety of colors. A larger grouping of hills occupies the center of the pictorial space. One hunter aims his gun, safely hidden from his prey by the large, multihued hill, which offers cover. Behind him, portions of two other figures are visible, as is a group of six figures along the lower stream.

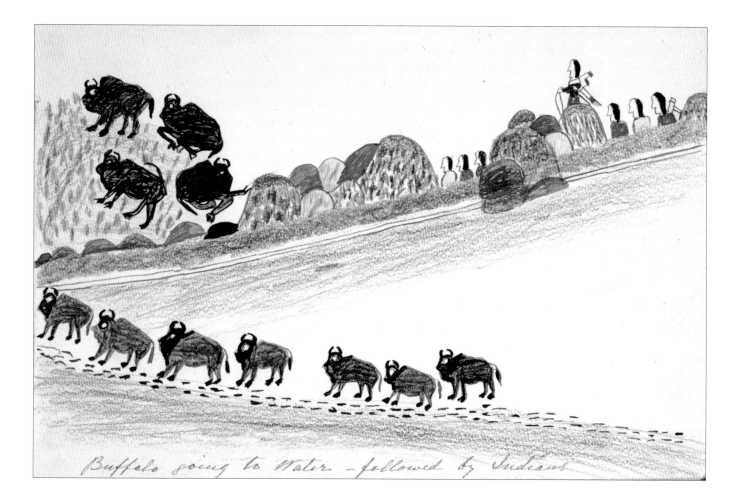

Buffalo going to Water - followed by Indians

Plate 51.
BRL, 4100.G.2.20.

The hunters have apparently been tracking the birds for some distance, because the birds' tracks follow the water, cross a portion of the variegated landscape, and again ford the river. They stand amid the short grass suggested by vertical green hatch marks at the far left, above yet another grouping of hills and perhaps stones. The artist has taken care to render the distinctive aspects of the turkeys: their small heads, red beaks, large bodies, and lighter tail and wing markings.

Plate 51. "Buffalo going to water—followed by Indians"

In a composition much like that of the turkey hunt in plate 50, Howling Wolf here uses two diagonal lines to organize his pictorial space and renders a variegated landscape as cover for hunters and habitat for the buffalo they are stalking. Rather than two streams that join, here the path taken by the buffalo in the lower portion of the drawing meets the line formed by the green shrubbery, rocks, and hills of the upper level. The multiple hues the artist employed to suggest the plains underscore the V-shaped arrangement of the drawing. Like the turkeys in plate 50, a group of buffalo appears in the

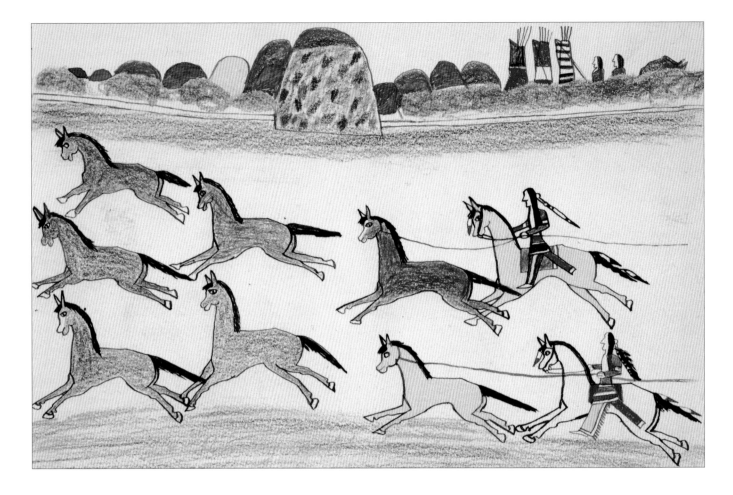

Plate 52.
BRL, 4100.G.2.21.

upper left corner, in short green grass. Hunters stand or sit amid the hills, with one man, holding his bow, standing higher than the others. Both he and the hunter at the far right have quivers.

The buffalo on the lower level appear as if they are resting momentarily from their movement. Hoofprints mark their passage and the path that others before them have followed. Of the four buffalo at upper left, two are clearly sitting. Howling Wolf's renditions of their sitting positions appear a bit awkward, but of course he had no buffalo to observe in Saint Augustine and he drew from memory. Although artists on the plains occasionally drew hunting scenes before the Fort Marion period, among them two by Howling Wolf himself,[39] positioning a resting or fallen buffalo was more difficult to master than suggesting the animals standing in a herd and grazing or racing from pursuing hunters.

Figure 65.
Detail of plate 52.

Plate 52. "Hunting Wild horses"

In a dramatic scene of much faster-paced action than that of stalking wild turkeys or buffalo, two mounted hunters ride in pursuit of wild horses, hoping to add new mounts to their herd. Although the wild horses are clearly racing at top speed, the hunters' steeds keep pace, and each man has successfully lassoed a horse.

In the three-part division of space for this hunt, Howling Wolf used a compositional scheme that he used many times elsewhere. An upper band of landscape with variously colored hills and green shrubbery is the location for the Indians' camp. Three tipis have been pitched in the upper right corner. Given the subject of the drawing, this might be a temporary hunting encampment rather than a larger village. Two figures appear behind the lodges, partially obscured by the green landscape. Behind them, a red form with ears is visible, which may be a dead buffalo from which the largest portion of the hide has been removed to be treated, before the meat is prepared. If so, then the hunters have been in pursuit of other prey, too.

A second horizontal band of variegated colors marks the lower boundary of the pictorial space. This surface acts as the ground on which the bottommost row of horses and one rider move. The central expanse of the page is left without representation of landscape. The viewer understands that the action is set in real space, but the artist has not filled in—or felt it necessary to give all the horses—visible ground on which to stand. The extremely detailed landscape that Howling Wolf recorded here and in other drawings shows him moving from the older Plains device of organizing figures in an allover pattern covering a hide or piece of paper, without the use of ground lines, to closely depicting settings to differentiate locations. Such experiments and the subsequent combination of means of suggesting both action and space are repeatedly visible in Fort Marion art.

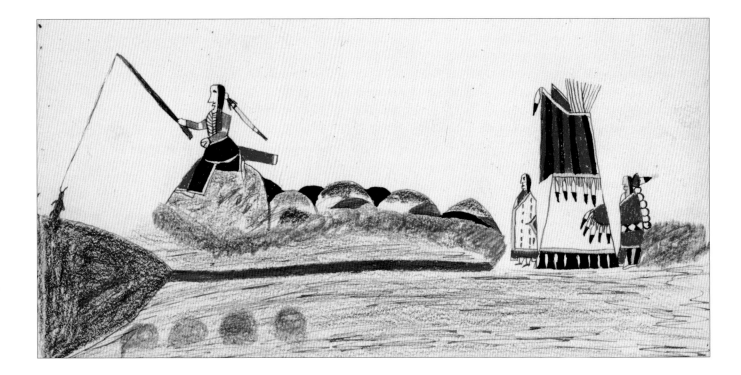

Plate 53.
BRL, 4100.G.2.22.

Plate 53. "Fishing"

Some Plains Indian peoples ate fish, and others did not.[40] In either case, fish rarely became the subject of art for internal use, whether in painted or sculpted form, unless they had an association with spiritual power or with powerful supernatural beings about whom narratives were told. The men at Fort Marion, however, were taken to Anastasia Island, and at least some of them went fishing. Undoubtedly, the most memorable trips were excursions to hunt "water buffalo," as the men referred to the sharks for which they fished.[41] These fish were unlike any the men had seen in lakes or rivers on the Great Plains, although sharks might have had some characteristics similar to those of powerful underwater supernatural figures.

Here Howling Wolf has rendered a single man seated on rocks near a body of water. He has just caught a fish and is pulling it from the water, the diagonal line of his pole mirrored by the slant of the line to which the fish is hooked. The pool of water in which he is fishing connects to a small stream, beside which a tipi has been raised. A man and a woman stand on either side of the elaborately decorated lodge. The woman wears either a Navajo blanket or a textile of a similar pattern from Mexico. The man wears the frequently represented red trade-cloth blanket with beaded blanket strip. The tipi is one of the most vividly patterned ones that Howling Wolf depicted in Eva Scott's book, the bold red and black stripes of the upper portion contrasting strongly with the central white band and lower black one with pendant feathers. A red shieldlike design appears on the back of the tipi's cover.

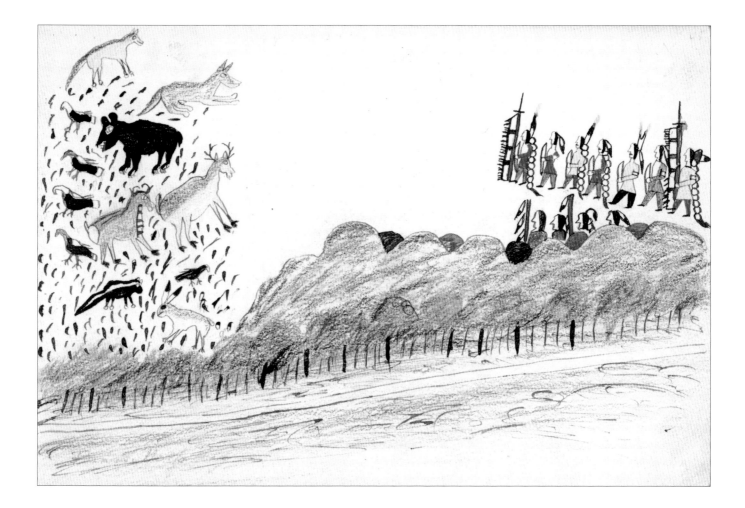

Plate 54.
BRL, 4100.G.2.23.

Once again Howling Wolf has painstakingly detailed the landscape in which the scene takes place. Variegated colors compose the foreground, and rocks and dense green vegetation appear alongside the stream. Howling Wolf's repeated representations of place can readily be interpreted as far more than his merely adjusting to non-Native forms of landscape representation. Rather, it seems that in at least some cases, specifying the setting for the memories he drew was vital for himself and for conveying a sense of his homeland to people he met in the strange world of Florida.

Plate 54. "Various Wild Animals"

Not only did Howling Wolf feel it important to render detailed landscapes, but he also wanted to relate to viewers some of the diversity of animal life he knew from the plains. A bear, a rabbit, a skunk, an antelope, a deer, a fox, a coyote or cougar, and various birds appear here amid hoof- and pawprints and bird tracks. Two lines of men, some with lances and bows, approach the animals from the right. Rolling hills of different colors

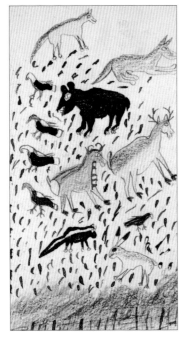

Figure 66.
Detail of plate 54.

provide a middle ground and a barrier behind which some of the men can move more effectively toward their prey. Impressionistically rendered trees and sketchy suggestions of the foreground complete the representation of place where this hunt occurs.

The grouping of animals, many of them either too large or too small relative to one another, might well have been meant as a type of inventory of mammal and bird life on the plains, which Howling Wolf illustrated to make his home and his culture's practices more understandable to people in Saint Augustine who were unfamiliar with the region and its inhabitants. Why he selected these particular animals is unknown, but many of them were important to Plains people for their power, cunning, or other unique characteristics that made them exceptional in the animal world. Plains people recognized the abilities of animals and were keen observers of nature. They knew the bear, for example, as a strong animal able to stand on two feet, like humans, as well as to move on all fours. The bear was important as a source of protective power to humans, especially warriors. At a very different scale, the skunk has a defensive power unlike that of any other animal depicted here; there was no mistaking that kind of power either.

Cheyenne people categorized animals in different ways, and Howling Wolf may have expressed some aspects of those categories here. As John Moore explained, animals considered to be game animals, or those that could be eaten, were said to "have no paint," whereas those with bright coloration were not eaten. Game animals, then, included most of the ones Howling Wolf depicted here, such as the deer, antelope, rabbit, skunk, and fox. Birds such as wild turkeys and prairie chickens were edible, but brighter-colored ones such as flickers and eagles were not. Some birds, such as magpies and ravens or crows, were not eaten even though they were not brightly painted, because they were considered holy birds.[42] Whether the men on the right in Howling Wolf's drawing are on a hunting expedition for game animals or appear as a kind of balanced presentation of belief and appropriate behavior, the artist was cognizant of the categories of animals in Southern Cheyenne society and presented some of the important animals in his drawing for Eva Scott.

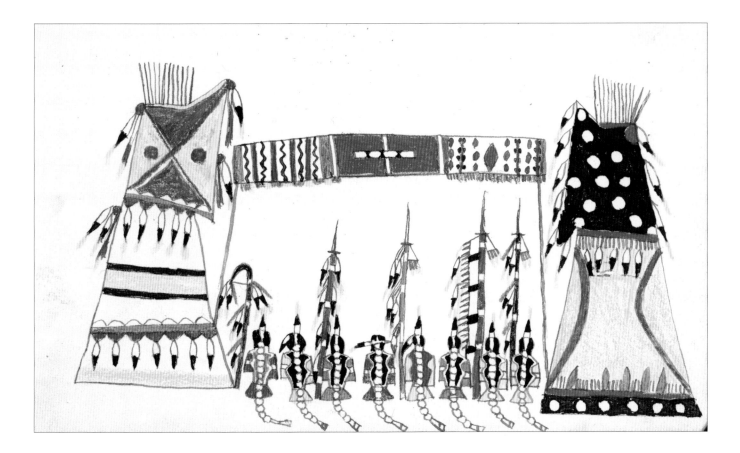

Plate 55. "Council of War."

Plate 55.
BRL, 4100.G.2.24.

In a variation of the type of warrior society gathering that Howling Wolf presented in plate 41, the artist here offers rear views of eight warriors, from just below the waist or else in seated positions. The feathers on their heads and their lances, pushing toward the vivid textiles from which the sunshade is built, add a repeated vertical rhythm to the drawing. At least one of the lances is a Bowstring lance with its alternating bands of black and white feathers. Crooked Lance, or Elk Warrior, lances are here as well; they are the bent lance at the far left and perhaps the green middle lance and the one on the far right, with feathers attached at various points along the wooden shafts. The red lance placed next to the bent lance of the Elk Warrior at the far left differs from the other lances.

If this is a war council, as the caption suggests, rather than a gathering of an individual warrior society or warriors from different societies for other reasons, then men from different warrior societies may have met to negotiate an agreement concerning battle. Men from different Cheyenne warrior societies fought alongside one another in many instances, especially in the years immediately preceding the Fort Marion exile. Sometimes warriors from one society were invited to take part in gatherings of other societies,

and occasionally, members of one group lent society paraphernalia to warriors from another.[43] Alternatively, the men depicted here might be gathered to engage in a kind of contest over battle exploits in which men from the various Cheyenne warrior societies tried to outdo their fellow warriors as they recounted their heroic actions. Adherence to truth prevailed in these kinds of gatherings, just as they did in less formal storytelling among the Cheyenne people.[44]

The varied colors of the men's shirts and vests, together with their arm bands and long lines of hair plates, create a rhythmic repetition of shapes, similar to that seen in Howling Wolf's drawing of a Bowstring Society gathering in plate 41. Slight additional variation is provided by the placement of feathers in the men's hair, as well as by the diverse lances.

The two lodges that flank the gathering bear extremely colorful patterns. Although portions of the designs represented here might have been associated with specific lodges in Southern Cheyenne culture, in all likelihood Howling Wolf was giving full freedom to his design sense as he developed the representations. The textiles of the sunshade are either Navajo or Hispanic variations of striped and central diamond designs. Blankets from Mexico and what would become the US state of New Mexico came onto the southern plains from the 1860s forward.

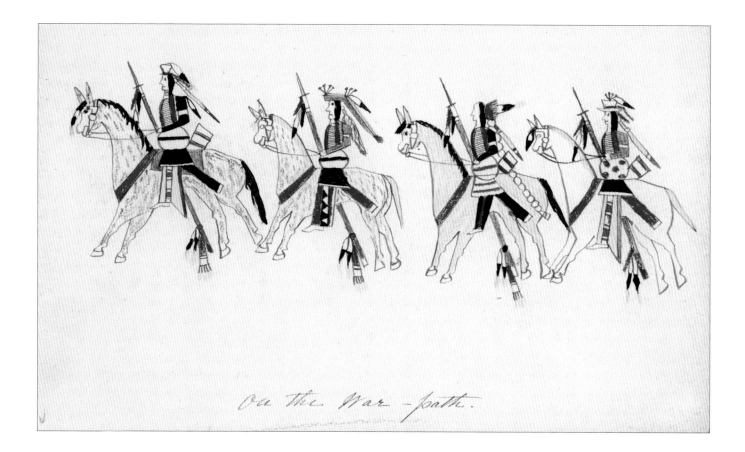

On the War-path.

Plate 56. "On the War-path"

Four men on horseback form a single line as they travel from right to left across the drawing page. Each man carries a shield and a lance, and each is dressed well for war. Headdresses and hats vary, but the men are probably all from the same warrior society, given the similarity of their lances. They appear to be just beginning their journey; none of the horses has its tail tied for battle. The men and their mounts may have to travel a great distance to find their enemies.

In various drawings in Eva Scott's book, Howling Wolf experimented with ways to suggest a larger color palette than was available to him with the pencils and crayons he used. In some cases he placed colors on top of one another to produce variegated effects. Here he may have tried another approach. Although the last two horses in the line have basically solid-colored bodies, in the first two Howling Wolf has used the pencil or crayon unevenly, creating dashed lines that suggest texture. He did this again, slightly differently, on the next page. Considering his attention to animals and their physical characteristics, the artist probably suggested more than artistic variety with these textures. Younger red and blue roan horses sometimes have flecks of color on their bodies, giving them a mottled appearance.[45]

Plate 56.
BRL, 4100.G.2.25.

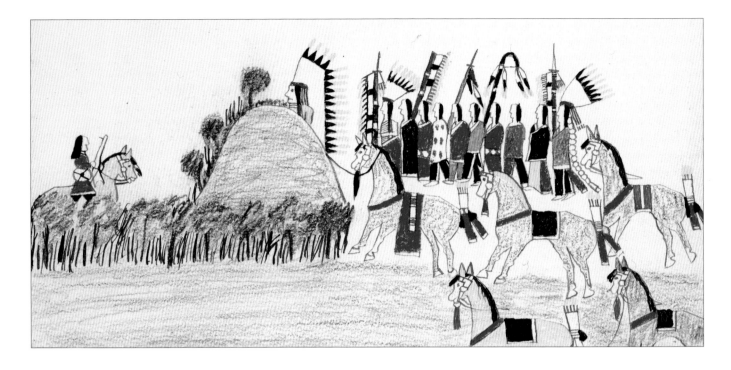

Plate 57.
BRL, 4100.G.2.26.

Figure 67.
Detail of plate 57.

Plate 57. "Cheyennes in Ambush—lying in wait for a Yute-Warrior"

Here, Cheyenne warriors wait to ambush a Ute man. The Utes were one of the Cheyennes' most frequent enemies. The Cheyenne war party includes members of at least two warrior societies, or at least men who carry lances from different societies. The curved lance of the Elk Warrior Society is here, as are two Bowstring lances with their black and white feathers.

The Cheyenne men have dismounted. Their horses, with their tails tied for war, stand nearby. A line of men, many of them carrying lances of various types and two wearing upright feathered war bonnets, stands just above the horses in the pictorial space. One man, clearly the leader of the war party, given his full feathered headdress with trailer, waits behind a hill and some trees to attack his enemy. War parties were undertaken for various reasons, but avenging the death of a relative or fellow warrior society member was a frequent cause.[46] Perhaps the warrior leading this party does so for revenge. If so, then he has the right to make the first attack on a member of the enemy tribe responsible for the death he seeks to avenge.

Howling Wolf has taken his representation to the edge of the drawing page here, as he did in several of his richly landscaped images. Not only is colorful ground apparent, but the artist has also placed two horses low in the pictorial space, so their bodies are only partially visible. Above them, three other horses stand either on or above the variegated ground. Variation in the placement of figures in space and the incorporation of the full page in the scene again demonstrate the experimental ways in which artists such as Howling Wolf worked at Fort Marion.

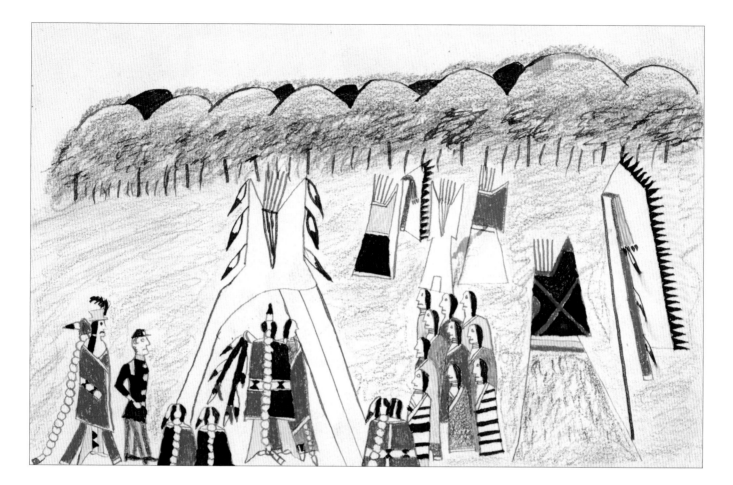

Plate 58. "A Wedding—Chief taking his bride to his Wig-wam"

Plate 58.
BRL, 4100.G.2.27.

As Zotom did in his book for Eva Scott (see plate 12, chapter 3), Howling Wolf drew what is labeled a wedding. Whereas Zotom chose to concentrate solely on the man and woman, apparently identifying himself as the groom by writing his name next to the man's head, Howling Wolf rendered a detailed narrative set in a specific landscape with hills or mountains in the distance and trees in the middle ground. Several lodges indicate the village, and many people, including one soldier, observe the couple. The warrior and his new wife are about to enter the lodge that has been prepared for them. The sides of the tipi have been rolled back, and Howling Wolf provides a view into the space of the lodge.

If this is a view of a marriage, then the event is taking place after the man has made his intentions known and has successfully courted the woman, determining that both are in agreement to the marriage. An exchange of gifts between the man or his family and the intended bride's relatives will also have preceded the couple's moving in together, as Howling Wolf has depicted.

That other members of the village appear in Howling Wolf's drawing is unsurprising, but the presence of the soldier is puzzling. He stands next to a man of apparent high

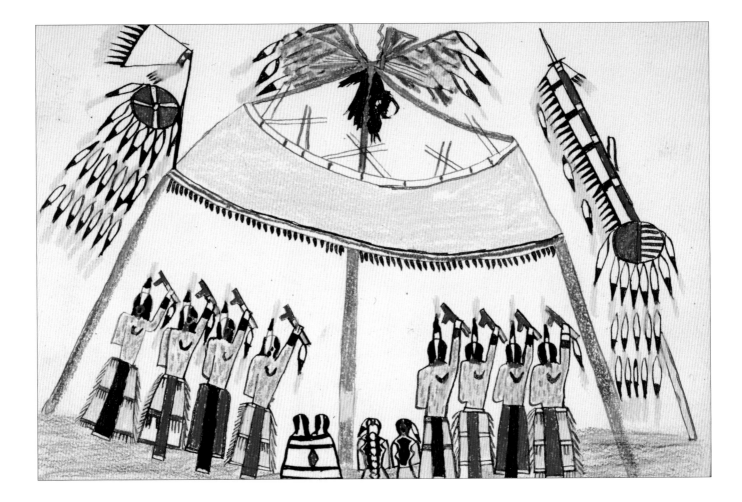

Plate 59.
BRL, 4100.G.2.28.

status, judging from the man's height and position as the only obviously standing Native man in the drawing other than the new husband. As discussed previously, the caption designating this as a wedding may be a fanciful title applied to the drawing by Eva Scott. If it is indeed accurate, then this might have been a specific subject Howling Wolf chose to draw in his effort to impart information about his culture to the young woman.

Plate 59. "Medicine Tent. 'Medicine men fasted four days—Lift pipes to the sun'—(Howling Wolf's explanation)."

Various artists at Fort Marion depicted the annual renewal ceremony of the Sun Dance, some in greater detail than others. Howling Wolf's representation shows eight men who have pledged to take part in the solemn ceremony, their bodies painted in the prescribed manner. The pledgers, called medicine men in the caption, raise their pipes upward as they stand inside the Sun Dance lodge, the sides of which have been rolled up to allow

Figure 69.
Detail of plate 59.

Figure 68.
Detail of plate 59.

the interior space to be viewed. These pledgers are involved in a sacred ceremony that will benefit the entirety of the Cheyenne people. In this way they are true medicine men, even if they are not in the stereotypical manner in which that phrase was, and is, frequently used by non-Native people.

The lodge for the ceremony would have been erected days before, with specially selected cottonwood trees for supports.[47] Howling Wolf included the foliage above the forks of the support poles at the very top of the drawing. There, offerings of green brush, cloth, and buffalo hide appear.

The lance, shields, and war bonnet to the sides of the lodge may indicate who has sponsored the renewal ceremony. The Sun Dance of 1874, the last one that Howling Wolf attended before the Fort Marion incarceration, had been sponsored by his own warrior society, the Bowstring Society, and its Northern Cheyenne counterparts, the Crazy Dogs.[48] Howling Wolf played a prominent part in that Sun Dance, although he does not identify himself in this drawing. That this may be a Sun Dance sponsored by the

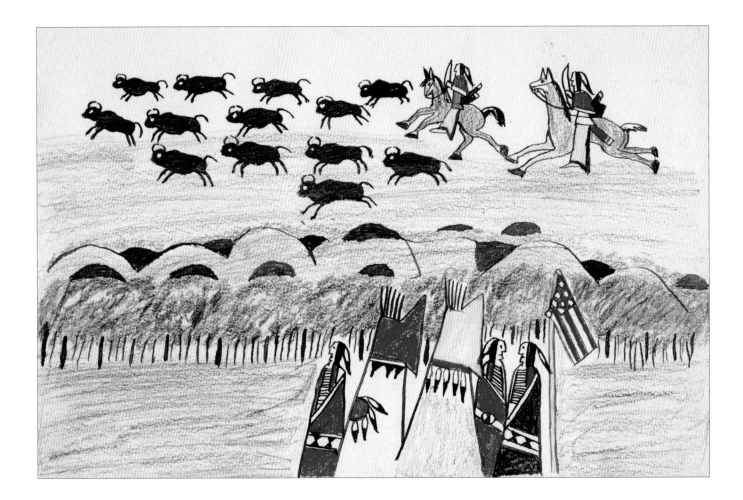

Plate 60.
BRL, 4100.G.2.29.

Bowstrings is supported by the rendering of that warrior society's lance to the right of the ceremonial lodge.

Eva Scott recorded that Howling Wolf provided the caption stating that the men taking part in the ceremony had fasted and were lifting their pipes to the sun in his representation. Such a notation indicates Howling Wolf's continuing role as an autoethnographer, here providing not only a drawing of the vital sacred ceremony but also an explanation of at least that portion of the Sun Dance he felt he could reveal to Scott.

Plate 60. "Chasing the Buffalo."

Here, Howling Wolf has again used a three-part organizational scheme as the foundation for his composition, a picture of a buffalo hunt set in a landscape. Unlike his drawing of the hunt for wild horses (plate 52), the middle zone of this composition is not the blank white space of the drawing page. In this scene Howling Wolf has described undulating low hills and rocks behind a line of trees in the middle ground, a village in the foreground, and two riders pursuing a herd of buffalo in the distance. The two lodges,

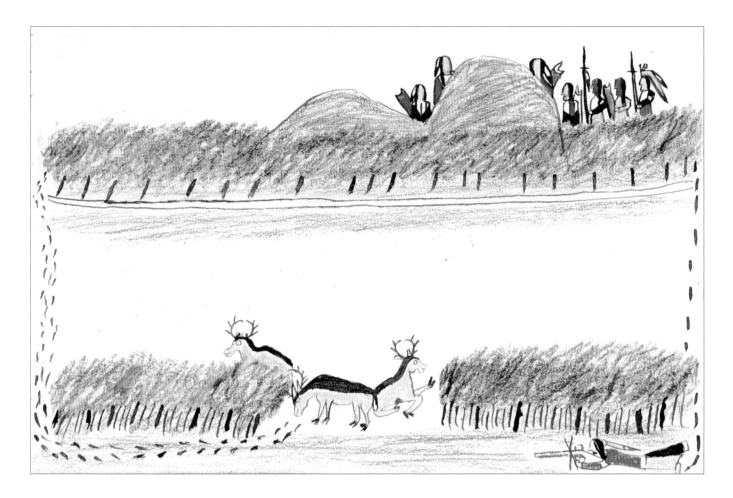

flag, and three men in the foreground appear larger than the buffalo and the two men on horseback, probably conveying the spatial distance between foreground and background. Some buffalo at the upper left of the drawing are positioned above the ground the artist has rendered. The artist has used the entire page to present a fully detailed landscape in which the Plains people who are his subjects interact, hunt, and live their daily lives. This and the so-captioned wedding scene in plate 58 are Howling Wolf's most fully developed landscapes in the Scott book.

Plate 61. "Antelope hunt."

In yet another attempt to effectively represent the action of a hunt, this time one for what may be antelope, elk, or even deer, Howling Wolf has used the three-banded composition in a different way. Here the middle zone, like that in plate 52, is left uncolored, and the top and bottom registers depict landscapes in which people and antelope move. The upper area holds seven hunters, their lances and quivers sketchily rendered. Judging from the lances and the headdress of the man at the far right of the upper register,

Plate 61.
BRL, 4100.G.2.30.

the party may be going to or coming back from a raid. Some of the men peer from behind one of the two hills that Howling Wolf has placed in his wooded setting. The lower portion of the drawing shows one hunter, his gun held firmly on a crossed-stick brace, taking aim at the three antelope positioned in the central portion of the register. Two antelope stand while one sits, all in a clearing between two wooded areas.

The two registers of the composition are united not only by the repetition of landscape and color but also by the artist's use of hoofprints and footprints. These connecting prints tie the registers together and make it apparent that the hunter who is on the ground in the lower level has moved there from the upper level, where his fellow hunters still wait. In like manner, the animals were earlier in the upper level but have moved along the left side of the representational space to the position they now occupy. Such conventions indicating former and future actions were part of the vocabulary of Plains Indian drawing and painting, with which many of the Fort Marion men were familiar before their imprisonment. Like name signs, these elements of pictorial shorthand were used less frequently in Florida than they were in drawings on the plains. A significant part of the audiences for whom drawings were made in Saint Augustine was unfamiliar with Plains pictographic shorthand, so the artists made many representations that were more readily understandable, eliminating a visual language that the artists understood but non-Native viewers did not.

Identifying the mammals the hunters seek is less easy than the caption suggests. These could be male pronghorn antelope, especially considering the way Howling Wolf has rendered some of the hoofprints along the left side of the pictorial space. He has emphasized the way the split hoofprints narrow from the rear to the front, as those of antelope do. On the other hand, the multiple tines of the animals' antlers suggest that these are more likely elk. Even the ubiquitous deer might be depicted. Male deer, too, have multipronged antlers, and whitetail deer have the telltale coloring suggested by their name. Mule deer have a partially white tail and a white patch on the rump. The animal that stands in full view in Howling Wolf's drawing has a tail with its underside left uncolored, suggesting white. Mule deer also have a dark stripe down their backs during the summer, as Howling Wolf has depicted here. Like antelope hooves, deer hooves narrow distinctly in the front.[49]

An experienced hunter, the artist knew which animal he drew, whether or not Eva Scott did and whether or not viewers do in the twenty-first century.

Conclusion

Eva Scott was in her early twenties when she met the two Southern Plains prisoners from whom she would commission drawing books at Fort Marion. Indeed, she was close in age to both Howling Wolf and Zotom, although their experiences were vastly different from hers. Despite those differences, all three were artists, and the lives of all three intersected, at least briefly, in Saint Augustine during the second half of the 1870s.

Coming from a wealthy family and, thanks particularly to her far-sighted father, filled with a sense of her ability to handle her personal and financial affairs, Eva Scott was not a typical young woman of the day. Zotom and Howling Wolf were not the expected norm in Saint Augustine in the 1870s, either. Although the two men were prisoners, taken against their will, without benefit of trial, and exiled to a place far from home and family, their positions in Florida were different from those of some of the other prisoners, because both were well-established warriors. During their three years at Fort Marion, each man made many drawings, undoubtedly for diverse reasons: among others, to satisfy his desire for self-expression, to record history, to describe visually the life from which he had been exiled, to memorialize the trip to the strange new world in which he now found himself, and to illustrate the prisoners' activities in Florida. Eva Scott commissioned each artist to fill with drawings a book that she provided. Each man approached this task in his unique way. Howling Wolf and Zotom both had relationships with Eva Scott that allowed the commission to take place and encouraged their creation of detailed drawings.

We can never know the full extent of those relationships. Scott was a volunteer teacher at the fort. As a non-Native, she occupied a position of limited power over the men—limited because she was a woman. At least three of the younger prisoners at Fort Marion, if not more, developed strong feelings for young women they met in Saint Augustine. Richard Pratt recorded that one prisoner, unnamed in his account, was

influenced by one of the women he met: "One of the prominent young ladies of St. Augustine was a special friend to the youngest Cheyenne."[1] While the prisoners were camping on Anastasia Island, she persuaded the young man to sail across the bay with her and a group of others. Because he had not obtained permission to make the trip and returned late to camp, Pratt disciplined him by having him carry a "light stick of wood" on his shoulder until midnight. In the morning the young man was still carrying the stick. The sergeant of the guard, also a Southern Cheyenne, had decided that the punishment Pratt had ordered was insufficient for such a "very bad thing" and had extended the time.[2]

Making Medicine, a Southern Cheyenne prisoner-artist who was a sergeant of the guard, rendered a drawing showing two of the men doffing their caps to two women in Florida, one of whom has been identified, in a caption supplied by someone unknown, as Jennie Pendleton.[3] She was the daughter of George and Alice Pendleton, who took a great interest in the men and, following the end of the Fort Marion imprisonment, provided tuition for Making Medicine to remain in the East for three years to study. Making Medicine became an Episcopal deacon and took the name David Pendleton; he was canonized by the Episcopal Church in 1986.[4] Making Medicine also drew an image of an outing to Anastasia Island in Florida, and among the figures he represented was a prisoner walking arm in arm with a young woman. It is intriguing to suggest that this might be the artist himself with Jennie Pendleton, or it might be the youngest Cheyenne prisoner with his friend, about whom Pratt wrote.[5]

Another Southern Cheyenne man, Buffalo Meat, expressed his feelings of friendship and love for a Miss Ellerhausen, a woman he met in Florida. He promised to remember her if he went home and assured her that he was attending church.[6] Bear's Heart, again a Southern Cheyenne prisoner, inscribed a small autograph book of drawings that included work by several Fort Marion prisoners with the following words: "A long time ago I soldier of Indian Soldier & the Cheyennes of Howling Wolf and Miss Alice This Book not forget."[7] Although more than one Alice could certainly have been in repeated contact with the prisoners, Alice Pendleton remains one possibility. No matter who she was, Bear's Heart pledged to remember her, as Buffalo Meat did for Miss Ellerhausen.

Whether or not a fondness such as that expressed in these examples developed between Eva Scott and the men she asked to fill her drawing books is unknown. Zotom, however, for whatever reasons, felt comfortable asking her for subjects or accepting suggestions from her for his drawings. That Howling Wolf approached his drawings more independently is unsurprising, considering the stature he had achieved before his imprisonment and his previous work as a warrior-artist. Zotom's apparent acquiescence may be what requires explanation, for he was, as Pratt recorded, a headstrong young man who required discipline in the early part of his three-year exile. Scott's commission came toward the end of that period, and the prisoners, including Zotom, had adjusted, at least to some extent, to the startling situation in which they found themselves. By the time of Eva Scott's commission, the men had created many drawings to be sold or given to visitors to the fort.

Zotom and Howling Wolf were prisoners, even if they had greater freedom at Fort Marion under Pratt's relatively open practices than under conditions a more staunch military man might have imposed on his Southern Plains charges. In many ways Pratt made the prisoners' three years of exile far more bearable than they might have been. One way was by encouraging the men to create drawings that, whether or not he intended them to do so, served many purposes. The prisoner-artists made drawings for themselves, for their families, to sell, and to give as gifts.

Unlike Eva Scott, Richard Pratt held significant power over the Fort Marion prisoners. He was the army officer placed in charge of them, and he used various means to bend them to his will. Removing Plains Indian signs of identity such as clothing and long hair and requiring military drills, marching, and daily inspections were only parts of the regime that developed at the prison. Men went to church services, and the younger prisoners attended classes to learn to read and write in English. On several occasions when discipline broke down, Pratt instituted harsher measures. At one point, for example, several of the Kiowa prisoners made plans to leave Fort Marion and travel back to their homes. When one of the younger Kiowa men was questioned, the scheme was discovered. Pratt had the two organizers of the plot shackled, initially drugged, and kept in confinement at the nearby military barracks for several weeks before being returned to Fort Marion.[8]

At least some of the Fort Marion men responded well to Pratt. He made the daily inspection a more positive experience by giving the man deemed worthiest extra privileges for the day, and a contest arose among some of the men for this position. The Cheyenne and Arapaho chiefs pledged their support and that of their men to Pratt at the time of the Kiowa prisoners' plot to escape. Later in life, Etahdleuh Doanmoe remembered Pratt fondly. These instances, among others, suggest some of the complexity of the three-year exile in Florida. Pratt remains a contested figure who never wavered in his view that assimilation was the best goal for Native American people.

Like our view of Pratt, the view we have of Eva Scott as a patron of Fort Marion drawings is incomplete, deriving only from the way in which she provided captions, titles, or subjects for at least some of Zotom's and Howling Wolf's drawings and the way she presented each artist on her title page for his drawing book. One thing is certain: Scott does not fit into an easy category of someone focused solely on Native people, nor was she involved in some early "Indian craze," as Elizabeth Hutchinson has described for the United States in the last decade of the nineteenth century and early years of the twentieth. Eva Scott was not an ethnographer, either, even while an increasing number of ethnographers, exclusively men at first, sought contact with Native people in order to study them and collect ethnographic objects from them.

Scott does, however, fit securely into the paradigm of the benevolent Victorian woman concerned with social issues. Later in her life, one of those issues would be the American prison system, as it was for many other women, and that concern might well have begun with her time at Fort Marion. Above all, she was an artist, and throughout her life she commissioned works from diverse artists. A few of them were, like

Howling Wolf and Zotom, Native Americans, particularly during the time she lived in Santa Fe and knew the primary non-Native people involved in Indian art education there. In New Mexico she also knew people such as Edgar Lee Hewett who were patrons of Native American artists, including Crescencio Martinez, from whom Scott obtained a drawing. But Eva Scott Fényes commissioned works from such well-known American artists as William Merritt Chase, too, and she opened her Pasadena home to many additional artists, turning it into an artists' salon while she resided there. Her artistic connections in Santa Fe were equally strong. Her Santa Fe home is filled with art she "commissioned," most endearingly the collection of small self-portraits to which she asked each visiting artist to contribute a view of himself or herself.

That she saw Zotom and Howling Wolf as artists is without doubt. That she was a person of her era, complete with some of its romantic notions, is also clear. The way in which she framed the title pages for her drawing books is the strongest indicator of this. Along with photographic portraits of each man in Native clothing, she embellished the title page of Zotom's book with Indian signifiers and written identifiers that firmly position him as a red man, a Kiowa, a brave, and an artist. These pages, which might well have been added after the two men put their drawings in the books, conceptually but permanently frame the manner in which the books have subsequently been viewed. Now, separated from their covers, the drawings are no longer physically bound to these virtual and theoretical frames, but they are still tied to them through the original manner in which they were conceived.

The captions to the drawings remain, even if the covers are loose. They will always be a part of the entirety of each set of facing pages, detracting from the primacy of the visual images. Eva Scott's voice is the authoritative one here. Some of the captions may be in error; the drawing may not actually depict what the caption indicates it does. Contemporary viewers, like viewers in Scott's time, can seldom determine which captions are accurate and which are not.

Thus, although it was impossible for Eva Scott to exert the same kind of power over Zotom and Howling Wolf that Pratt could, she, too, had power. Her power remains clearest in her elevation of the written word over the visual. Whether or not she intended her captions to outweigh the men's drawings, they do so now and probably always have. In any case it would be impossible to know all the reasons Howling Wolf and Zotom rendered the images they did for Scott or even to recognize on a basic level the specific subject matter of some of them. But to come at least closer to experiencing what the prisoner-artists intended, it is necessary to divorce the drawings from the text, visually and mentally.

As Michel Foucault has written, the exercise of power over others brings with it a wide range of potential reactions and results.[9] Drawings created at Fort Marion were among the many possible responses to the situation in which the prisoner-artists found themselves. Visual images have the power to communicate in ways the written word cannot, even across cultural divides. As William Diebold wrote in relation to medieval manuscripts

and the nationality of their creators, "visual culture is a matter of training the eye and the hand, not of having the right blood."[10] Zotom's and Howling Wolf's drawings have great communicative power if they are allowed to stand on their own, without written captions. On some levels, at least, the drawings were accessible and readable to everyone who viewed them in the nineteenth century, and they remain so today.

Both Zotom and Howling Wolf had power as well, although theirs was far more limited than Eva Scott's or, certainly, Richard Pratt's. Yet, the Fort Marion prisoners could and did make choices in many ways. Some of them chose, for example, to compete to become orderly of the day; they were under no duress to cooperate with Pratt in that way. The men could have chosen not to make objects for sale, but many of them did so. They then had the freedom to choose how to spend the money they earned, as is made clear, among other ways, by the price list for popular items that Buffalo Meat drew. He reproduced it many times during his years in Saint Augustine, where it apparently became a much requested item. Zotom and Howling Wolf exercised choice in selecting ways in which to record the subjects they drew. In many cases—notwithstanding the doubt raised by Scott's inscription in Howling Wolf's book—they must have chosen the very subjects of their art.

It seems likely that Eva Scott met Howling Wolf and Zotom in the classroom at Fort Marion where she worked as a volunteer teacher and there became acquainted with their interest in art and their abilities as artists. It is tempting to see her, as an artist and a teacher, selecting two of the most prolific of the Fort Marion artists to fill her drawing books as a way of encouraging them. She might also have selected these two men because of the differences in the ways they approached their art in Florida, even though their subject matter overlapped at times.

Eva Scott Fényes's drawing books reveal men who were confident of their abilities as artists, just as they were confident of the positions they had earned on the plains as established warriors. Zotom's renderings of the actions leading to the Kiowa surrender at the end of the Southern Plains war and of steps along the journey to Florida provide a staggering amount of information on relatively small pages. Howling Wolf generally provided larger-scale figures with detailed clothing and paraphernalia. Both men incorporated landscapes in many of their drawings, though not in all of them. Each experimented with the placement of figures in carefully defined spaces, no matter where those spaces were. The spaces are locations in which specific actions take place, and thus they are places of significance. Place is space made important by what has happened there.

Although hundreds of drawings still exist from the Fort Marion period, many more were undoubtedly destroyed. Of those remaining, many show the effects of time, suggesting the lack of care they have received over the past 130 years. Eva Scott Fényes's books are among the rare drawings from the Florida period that survive in good condition. Fényes herself was concerned with their preservation, as her descendants have been. The Southwest Museum and subsequently the Autry National Center have been long aware of their good fortune in having drawings of this quality in their collections, and

those of us who have the opportunity to view them share in their beauty and power. We also recognize their importance as creative works by two men held captive in Florida in the 1870s who used art as a means of remaining connected to their homeland and of understanding the new circumstances in which they found themselves.

Zotom may have developed his historical sense of representing scenes of importance to the Fort Marion prisoners as an extension of the Kiowa practice of maintaining calendars. The cryptic icons on those calendars jogged people's memories about certain events and therefore about specific years, enabling them to remember other actions that occurred around the same time as those suggested by the twice-yearly notation. Zotom's drawings from Fort Marion, however, are fully representational scenes, many of them filled with detailed landscapes that pinpoint locations. New places and new experiences in foreign places appear in detail, though often on an extremely small scale. Not only was Zotom among the most prolific of the Fort Marion artists, but he also emerges as the single artist who most frequently drew panoramic scenes with multitudes of figures. The Scott books are small, measuring only six by ten inches, so the sweeping representations Zotom provided are all the more impressive.

Howling Wolf generally rendered fewer figures on each page but provided far more intricate details for those figures than Zotom did. The exceptions in his work, where figures appear as blocks of color with blank faces, may have been due to his diminishing vision, a problem that had him travel to Boston in 1877 for treatment. But even in the drawings that are less detailed, Howling Wolf carefully rendered patterns and colors, as well as vital information about warrior society membership and position within Southern Cheyenne society.

Both men drew many scenes of life on the plains, including aspects of lives in their villages and of hunting expeditions for various prey. Of the two artists, only Zotom rendered battle images. From a one-on-one encounter to a major fight between mounted warriors and massed soldiers, spanning two pages of the drawing book, each scene is the type of image that recalls heroic deeds in combat—subjects that are comparatively rare in Fort Marion art.

Zotom (chapter 3) was also more experimental in rendering interior spaces than Howling Wolf was in his book for Eva Scott. Some of the soldiers in Zotom's "A great Battle" (plate 27) fire from inside structures or battlements; the prisoner-students depicted in plate 31 exist within the interior area marked for their desks; and Fort Marion itself appears as a structure enclosing complex spaces in plates 29 and 30.

Even when Zotom was not suggesting architectural settings, he investigated the placement of figures in ways that enclosed space. The men gambling in his "Gambling with hair pipe" (plate 6) and those making bows and arrows in plate 7 assume varied positions that define their relationships to one another and to the places they inhabit. Women taking down lodges (plate 14) and a complex village scene involving many people engaged in diverse activities (plate 10) carry these explorations of composition even further. Figures move and act within these clearly defined spaces.

Howling Wolf's major compositional experiments in Eva Scott's book (chapter 4, this volume) are those in which he placed hunters and a variety of animals in detailed landscapes.[11] His are often tiered arrangements that suggest locations from which figures have moved to reach the positions in which they appear in his drawings. The inclusion of footprints and hoofprints underscores the narrative function of Howling Wolf's drawings; the images, in a self-contained way, expand the information offered to the viewer. He used landscape in many drawings that detail aspects of life on the plains, including fishing (plate 53), the Sun Dance (plate 59), and a wedding (plate 58). Unlike Zotom, he presented single figures on a few pages of his drawing book. In plates 48 and 49, the men on horseback are established warriors, as their headdresses, saber, and lance attest. The warrior in plate 48 may indeed be a self-portrait. Howling Wolf rendered views of himself, complete with name sign, astride horses marked similarly and, in some cases, bearing the same paint on their rear flank. The warrior in plate 48 also carries a Bowstring Society banner lance, and Howling Wolf was a member of that society.[12]

Zotom and Howling Wolf experimented widely in their books for Eva Scott. They drew images unknown in the rest of their currently recognized work from Fort Marion, and they rendered unique topics. That they felt able to explore subjects freely for their patron is readily apparent. The multiple battle scenes that Zotom provided are but one suggestion of this.

Patronage is a long-studied phenomenon in art from many parts of the world. It is a less prominent topic in the study of Native American art. Some might assume that, given the position of Zotom and Howling Wolf as prisoners, they felt it necessary to draw only certain subjects for the young Eva Scott. The drawings they created, however, cover a breadth of imagery that makes it impossible to view them as having been made only to please the woman who commissioned them. Each prisoner-artist rendered his images as he chose in ways that allowed experimentation in composition and subject. Each used his drawings as a way to relay information to Eva Scott, primarily about the life from which he had been exiled and, for Zotom, the passage from Indian Territory to Saint Augustine. Some views of life at Fort Marion appear, but they are far from dominant. Zotom and Howling Wolf focused their energies on other stories, on other narratives and histories they wanted their drawings to help portray. Even though the men were learning English, orally and in written form, the drawings they made must have been a more concrete way of communicating.

Howling Wolf and Zotom, like many other artists at Fort Marion, used the art supplies available to them in ways that called on their previous experiences on the plains, but they made the resulting drawings something far more vital. Eva Scott, Zotom, and Howling Wolf were engaged in cross-cultural exchanges of information, and drawings played important roles in that ongoing communication. Despite the different contexts in which the drawing books now appear, they continue to communicate a multiplicity of messages today.

Notes

Introduction

1. Joyce M. Szabo, *Art from Fort Marion: The Silberman Collection* (Norman: University of Oklahoma Press, 2007) also includes many details of the drawings under examination there. The kind of publication support that made both that book and this one possible is rare.

Chapter 1. The Southern Plains Wars, Fort Marion, and Representational Art

1. James Mooney, *Calendar History of the Kiowa Indians*, Seventeenth Annual Report of the Bureau of American Ethnology, 1895–1896 (Washington, DC: Government Printing Office, 1898), 314–17; Candace S. Greene, *One Hundred Summers: A Kiowa Calendar Record* (Lincoln: University of Nebraska Press, 2009), 89–90.

2. Greene, *One Hundred Summers*, 97.

3. Mooney, *Calendar History*, 320–22.

4. Ibid., 103.

5. J. Brett Cruse, *Battles of the Red River War: Archaeological Perspectives on the Indian Campaign of 1874* (College Station: Texas A&M University Press, 2008), 14–15.

6. Ibid., 17.

7. See the accounts in Wilbur S. Nye, *Carbine and Lance: The Story of Old Fort Sill* (Norman: University of Oklahoma Press, 1937), 276–82; Mooney, *Calendar History*, 210–11; and Cruse, *Battles of the Red River War*, 76–79. Cruse notes that Lyman provided two reports concerning how many Natives were killed. One indicated that the number was thirteen, while the other recorded twenty-seven Indian casualties.

8. Maurice Boyd, in *Kiowa Voices: Myths, Legends and Folktales* (Fort Worth: Texas Christian University Press, 1983), 228, spelled his name *Manan'-te* and referred to him as Owl Prophet. Candace S. Greene, in *Silver Horn: Master Illustrator of the Kiowas* (Norman: University of Oklahoma Press, 2001), 37, spelled it *Mamante* and translated the name as Screaming Above. She also illustrated the miniature shield collected by James Mooney that was Mamante's design (*Silver Horn*, plate 37). It was known as the Owl Shield and has a painting of a spotted

owl in the upper center field. Greene noted that Mamante was "a powerful and much feared medicine man."

9. Cruse, *Battles of the Red River War*, 107.

10. See the discussion in Richard Henry Pratt, *Battlefield and Classroom: Four Decades with the American Indian, 1867–1904* (New Haven, Conn.: Yale University Press, 1964), 93–97.

11. George E. Hyde, *Life of George Bent Written from His Letters* (Norman: University of Oklahoma Press, 1968), 365.

12. For a discussion of some of the factors leading to the Fort Marion imprisonment, see Pratt, *Battlefield and Classroom*.

13. Carlisle opened in 1879.

14. Pratt, *Battlefield and Classroom*, 108–9.

15. Ibid., 112–13.

16. Ibid., 114–15.

17. Boyd, *Kiowa Voices*, 254.

18. Ibid.

19. Karen Daniels Petersen, *Plains Indian Art from Fort Marion* (Norman: University of Oklahoma Press, 1971), 172, 225. Zotom might have been inspired to become a bugler by incidents in recent Kiowa history. Set-tainte, or White Bear (Satanta), a Kiowa leader, had a bugle that he carried during warrior society dances and at the Sun Dance. Several Kiowa calendars record the winter of 1869–70 as "the winter they were frightened by the bugle" and present the image of a bugle as a marker for the year. When a bugle was blown around daylight one morning, by either Set-tainte or another young warrior who also had a bugle, the Kiowa village, then camped near Fort Supply, became alarmed, thinking that the army was about to attack. See the calendar entries and the discussion of them in Mooney, *Calendar History*, 326–27, and Greene, *One Hundred Summers*, 97, 212, 228. Greene also quotes General Hugh Scott's papers, now in the Fort Sill Museum archives, concerning the winter of 1869 and the bugle incident. According to Hugh Scott, "Satanta carried this trumpet (which he had gotten at some Army Post) for many years using it in the Sun Dance and in the dance of the 'Rattle soldiers' of which he was the chief." Greene, *One Hundred Summers*, 212. Michael Jordan recounts that Set-tainte also used the bugle in battle with US forces by playing it in opposition to what the army actually wanted its men to do. For example, he would play retreat when the soldiers were supposed to be charging. Michael Jordan, "On Intellectual Property Rights and Historical Consciousness in Kiowa Society: An Overview" (paper presented at the Sixteenth Biennial Conference of the Native American Art Studies Association, Norman, Okla., October 22, 2009). Set-tainte's prominent position and cunning use of his bugle, as well as the position of bugler itself at Fort Marion, might have made Zotom associate the instrument with leadership.

20. Pratt, *Battlefield and Classroom*, 118–20.

21. Ibid., 124–27.

22. Floyd Rinhart and Marion Rinhart, *Victorian Florida: America's Last Frontier* (Atlanta, Ga.: Peachtree, 1986), 112.

23. Pratt listed those who died and their death dates as the Cheyennes' Heap of Birds, Oct. 9, 1877; Grey Beard, who died during the trip to Fort Marion; Big Moccasin, Nov. 4, 1875; Lean Bear, July 24, 1875; Starving Wolf, Dec. 5, 1876; Spotted Elk, Jan. 2, 1877; and the Kiowas'

Straightening An Arrow, Oct. 5, 1875; Sun, May 24, 1875; and Man-who-Walks-above-the-Ground, July 29, 1875. He also noted that Coming To The Grove, a Kiowa warrior, was "released by order of the Secretary of War, April 18, 1877." Pratt, *Battlefield and Classroom*, 138–44.

24. Donal F. Lindsey, *Plains Indians at Hampton Institute, 1877–1923* (Urbana: University of Illinois Press, 1995), 30.

25. See the discussion of Pratt's views about assimilation as summarized in Linda M. Waggoner, *Fire Light: The Life of Angel de Cora, Winnebago Artist* (Norman: University of Oklahoma Press, 2008), 33–34.

26. Ibid., 129–34.

27. Ibid., 133.

28. Ibid., 166–67.

29. Linda F. Witmer, *The Indian Industrial School, Carlisle, Pennsylvania, 1879–1918* (Carlisle, Pa.: Cumberland County Historical Society, 1993); Joyce M. Szabo, "Drawing Life's Changes: Late Nineteenth-Century Plains Drawings from Hampton Institute and Carlisle Indian School," *European Review of Native American Studies* 18, no. 1 (2004): 41–51.

30. Pratt, *Battlefield and Classroom*, 120–21; Brad D. Lookingbill, *War Dance at Fort Marion: Plains Indian War Prisoners* (Norman: University of Oklahoma Press, 2006), 88–89, 90–95.

31. Silvia Sunshine, *Petals Plucked from Sunny Climes* (1880; reprint, Gainesville, Fla.: University Presses of Florida, 1976), 231.

32. Waggoner, *Fire Light*, 166–67.

33. Pratt, *Battlefield and Classroom*, 116–35, 154–66; Petersen, *Plains Indian Art*, 15–16; Joyce M. Szabo, *Howling Wolf and the History of Ledger Art* (Albuquerque: University of New Mexico Press, 1994), 67–68.

34. William T. Sherman to Richard Pratt, January 10, 1876, box 8, folder 281, Richard Henry Pratt Papers, Beinecke Rare Book and Manuscript Library, Yale University; Herman J. Viola, *Warrior Artists: Historic Cheyenne and Kiowa Indian Ledger Art Drawn by Making Medicine and Zotom* (Washington, DC: National Geographic Society, 1998), 13–14; Petersen, *Plains Indian Art*, 65; Lookingbill, *War Dance*, 87.

35. For a recent, detailed summary of Garrick Mallery's career, see Christina E. Burke, "Waniyetu Wówapi: An Introduction to the Lakota Winter Count Tradition," in Candace S. Greene and Russell Thornton, eds., *The Year the Stars Fell: Lakota Winter Counts at the Smithsonian* (Lincoln: University of Nebraska Press, 2007), especially 6–10.

36. Garrick Mallery, *Pictographs of the North American Indians*, Fourth Annual Report of the Bureau of American Ethnology, 1882–1883 (Washington, DC: Government Printing Office, 1886), 13.

37. Ibid., 17.

38. See, for example, Petersen, *Plains Indian Art*, 269–308, and Karen Daniels Petersen, "Pictography: A Useful Folk Art," in *The Edwards Ledger Drawings: Folk Art by Arapaho Warriors* (New York: David A. Schorsch, 1990), xvii.

39. James Mooney, *The Ghost Dance Religion and the Sioux Outbreak of 1890*, Fourteenth Annual Report of the Bureau of American Ethnology, 1892–1893, Part 2 (Washington, DC: Government Printing Office, 1896).

40. James Mooney, "Kiowa Heraldry Notebook, 1891–1904: Descriptions of Kiowa Tipis and Shields," Manuscript 2531, Anthropological Archives, National Museum of Natural History,

Smithsonian Institution, Washington, DC. See also John C. Ewers, *Murals in the Round: Painted Tipis of the Kiowa and Kiowa-Apache Indians* (Washington, DC: Smithsonian Institution Press, 1978).

41. Mooney, *Calendar History*, 145; italics added.

42. See the discussion of Silver Horn's paintings on hide depicting the Sun Dance in Greene, *Silver Horn*, 80–84.

43. Ibid., 80.

44. E. Adamson Hoebel and Karen Daniels Petersen, *A Cheyenne Sketchbook by Cohoe* (Norman: University of Oklahoma Press, 1964).

45. John C. Ewers, *Plains Indian Painting: A Description of an Aboriginal American Art* (Palo Alto, Calif.: Stanford University Press, 1939).

46. Karen Daniels Petersen, *Howling Wolf: A Cheyenne Warrior's Graphic Interpretation of His People* (Palo Alto, Calif.: American West, 1968).

47. John C. Ewers, "Introduction," in Petersen, *Howling Wolf*, 13.

48. John C. Ewers, "Plains Indian Artists and Anthropologists: A Fruitful Collaboration," *American Indian Art* 9, no. 1 (1983): 36–44.

49. Petersen, *Howling Wolf*.

50. Helen H. Blish, *A Pictographic History of the Oglala Sioux* (Lincoln: University of Nebraska Press, 1967).

51. Dorothy Dunn, *American Indian Painting of the Southwest and Plains Areas* (Albuquerque: University of New Mexico Press, 1968).

52. Howard D. Rodee, "Stylistic Development of Plains Indian Painting and Its Relationship to Ledger Drawings," *Plains Anthropologist* 10, no. 30 (1965): 218–32.

53. See, for example, Joyce M. Szabo, "Howling Wolf: An Autobiography of a Plains Warrior-Artist," *Allen Memorial Art Museum Bulletin* 46, no. 1 (1992): 4–87; Janet Catherine Berlo, *Spirit Beings and Sun Dancers: Black Hawk's Vision of the Lakota World* (New York: George Braziller, 2000); Robert G. Donnelley, *Transforming Images: The Art of Silver Horn and His Successors* (Chicago: David and Alfred Smart Museum of Art, University of Chicago, 2000); and Phillip Earenfight, ed., *A Kiowa's Odyssey: A Sketchbook from Fort Marion* (Seattle: University of Washington Press, 2007).

54. See, for example, Szabo, *Howling Wolf*, and Greene, *Silver Horn*.

55. See Evan M. Maurer, *Visions of the People: A Pictorial History of Plains Indian Life* (Minneapolis: Minneapolis Institute of Arts, 1992); Szabo, *Howling Wolf*; and Janet Catherine Berlo, ed., *Plains Indian Drawings 1865–1935: Pages from a Visual History* (New York: Abrams, 1996).

56. An important example of a culture- and period-focused study of representational imagery is L. James Dempsey's *Blackfoot War Art: Pictographs of the Reservation Period, 1880–2000* (Norman: University of Oklahoma Press, 2007), as is Donnelley's *Transforming Images*.

57. See James D. Keyser, *The Five Crows Ledger: Biographic Warrior Art of the Flathead Indians* (Salt Lake City: University of Utah Press, 2000); Craig D. Bates, Bonnie B. Kahn, and Benson L. Lanford, *The Cheyenne/Arapaho Ledger Book from the Pamplin Collection* (Portland, Oreg.: Robert B. Pamplin Jr., 2003); and Scott M. Thompson, *I Will Tell My War Story: A Pictorial Account of the Nez Perce War* (Seattle: University of Washington Press, 2000).

58. Jean Afton, David Fridtjof Halaas, and Andrew E. Masich, with Richard N. Ellis, *Cheyenne Dog Soldiers: A Ledgerbook History of Coups and Combat* (Niwot: University Press of Colorado, 1997).

59. These include but are not limited to *The Edwards Ledger Drawings* (New York: David A. Schorsch, 1990); Mike Cowdrey, *Arrow's Elk Society Ledger: A Southern Cheyenne Record of the 1870s*

(Santa Fe, N.M.: Morning Star Gallery, 1999); and *American Pictographic Images: Historical Works on Paper by the Plains Indians* (New York: Alexander Gallery, and Santa Fe, N.M.: Morning Star Gallery, 1988).

60. See, for example, *American Pictographic Images* and *Edwards Ledger Drawings*.

61. The accompanying catalogue—Berlo, *Plains Indian Drawings 1865–1935*—provides an excellent record of the exhibition in New York City (organized by the Drawing Center and the American Federation of Arts), along with essays and narrative captions for the drawings that explore diverse issues associated with Plains representational imagery. The title of the book and the show underscores the single-page approach required by such exhibitions.

62. See www.plainsledgerart.org.

63. Sandra Hindman, Michael Camille, Nina Rowe, and Rowan Watson, *Manuscript Illumination in the Modern Age: Recovery and Reconstruction* (Evanston, Ill.: Mary and Leigh Block Museum of Art, Northwestern University, 2001).

64. See, for example, Szabo, "Howling Wolf," fig. 68.

65. Donald J. Berthrong, *The Southern Cheyennes* (Norman: University of Oklahoma Press, 1963), 329.

66. Petersen, *Howling Wolf*; Szabo, *Howling Wolf*; Greene, *Silver Horn*.

67. Berlo, *Plains Indian Drawings*; Maurer, *Visions of the People*. The more recent traveling exhibition of works from the Trout Gallery at Dickinson College in Carlisle, Pennsylvania, and related drawings from the Beinecke Rare Book and Manuscript Library at Yale University was an extremely important addition to the study of the works of individual artists from Fort Marion. Earenfight, *Kiowa's Odyssey*. Other extensive examinations of complete books have included Berlo, *Spirit Beings*.

68. For two examples in addition to those already cited, see Burton Supree with Ann Ross, *Bear's Heart: Scenes from the Life of a Cheyenne Artist of One Hundred Years Ago with Pictures by Himself* (Philadelphia: J. B. Lippincott, 1977); and Moira F. Harris, *Between Two Cultures: Kiowa Art from Fort Marion* (St. Paul, Minn.: Pogo Press, 1989).

69. See, for example, Earenfight, *Kiowa's Odyssey*, and Szabo, *Art from Fort Marion*.

70. Pratt, *Battlefield and Classroom*, 147–49; Petersen, *Plains Indian Art*, 176.

71. Pratt, *Battlefield and Classroom*, 144; Lookingbill, *War Dance*, 42.

72. Sunshine, *Petals Plucked from Sunny Climes*, 229.

73. Dempsey, *Blackfoot War Art*.

74. Ibid., 274–78.

75. Lynne Sprigs, quoted in Dempsey, *Blackfoot War Art*, 280.

76. Dempsey, *Blackfoot War Art*, 281.

77. This exhibition is discussed in many places, but a particularly thorough examination can be found in W. Jackson Rushing, "Marketing the Affinity of the Primitive and the Modern: Rene d'Harnoncourt and Indian Art of the United States," in Janet Catherine Berlo, ed., *The Early Years of Native American Art History: The Politics of Scholarship and Collecting* (Seattle: University of Washington Press, 1992), 191–236.

78. See National Museum of the American Indian, *The Changing Presentation of the American Indian: Museums and Native Cultures* (Seattle: University of Washington Press, 2000).

79. See the discussions in Mariet Westermann, ed., *Anthropologies of Art* (Williamstown, Mass.: Sterling and Francine Clark Art Institute, 2005).

80. William Rubin, ed., *"Primitivism" in 20th Century Art* (New York: Museum of Modern Art, 1984).

81. Few colleges and universities offer courses in Native American art history on either the undergraduate or the graduate level, whereas Native American archaeology and ethnology remain strong components of anthropology departments. As more survey texts on Native American art become available, this dearth of art historical courses will change, allowing the canon of art history to expand beyond its restrictive borders. Even the extant survey texts on Native American art, however, have struggled with how to present the work of more than five hundred Native nations in multiple mediums from the archaeological past to the present. Such texts, with their narrative structure, were preceded by visual surveys of collections of Native American art, most of it held by relatively large institutions such as the Denver Art Museum and the forerunner of the National Museum of the American Indian, the Heye Foundation's Museum of the American Indian, in New York. Such visual presentations provided little contextual information but generally organized the works by geographical region, recognizing, for example, the similarities among works by Plains Indians from different cultures or by people from the Northwest Coast. What might be viewed as a stepping stone to the more widely distributed, visual and narrative surveys of the very late years of the twentieth century and early years of the twenty-first is at least one volume, Christian F. Feest's *Native Arts of North America* (New York: Oxford University Press, 1980), that approached the daunting task of writing such a survey by organizing works according to medium rather than geographical origin. Although the author took an interesting approach, it is difficult to gain from the book a broad understanding of the cultures in which artists created the multitude of works in specific historical settings.

82. Maximilian, Prince of Wied, *Travels in the Interior of North America*, vol. 23 of Reuben Gold Thwaites, ed., *Early Western Travels, 1748–1846* (Cleveland, Ohio: A. H. Clark, 1906), 352–53.

83. The most famous example of a book's being carried into battle is the Little Fingernail Ledger, now in the collection of the American Museum of Natural History in New York.

84. See, for example, Szabo, *Howling Wolf*, 40–41.

85. Ibid., n. 25; Fanny Kelly, *Narrative of My Captivity among the Sioux Indians* (Cincinnati, Ohio: Wilstach, Baldwin, 1871), 143–45.

86. See, for example, Serge Guilbaut, "Preface: The Relevance of Modernism," in Benjamin Bulloch, Serge Guilbaut, and David Solkin, eds., *Modernism and Modernity* (Halifax: Press of the Nova Scotia College of Art and Design, 1983).

87. Arjun Appadurai, *Modernist at Large: Cultural Dimensions of Globalization* (Minneapolis: University of Minnesota Press, 1996), 9.

88. Joyce M. Szabo, "Medicine Lodge Treaty Remembered," *American Indian Art* 14, no. 4 (1989): 52–59, 87.

89. Edwin L. Wade and Jacki Thompson Rand, "The Subtle Art of Resistance: Encounter and Accommodation in the Art of Fort Marion," in Berlo, *Plains Indian Drawings*, 45–49.

90. Szabo, *Howling Wolf*, 99–102; Szabo, "Medicine Lodge Treaty Remembered."

91. See Lookingbill, *War Dance*, 58.

92. See Szabo, *Art from Fort Marion*, 153–63.

93. Candace Greene has published three Comanche drawings on paper from the 1860s. These may have been made at the request of the man who collected them, Edward Palmer,

who may also have supplied the drawing materials. Candace S. Greene, "Southern Plains Graphic Art before the Reservation," *American Indian Art* 22, no. 3 (1997), 44–53.

94. Petersen, *Plains Indian Art*, 240–41, 254.

95. Szabo, "Drawing Life's Changes," 45. Various drawings in the collections of Hampton Institute bear the name Packer. They are in a style distinctly different from that evident in the two drawings that have both Packer's and White Bear's names on them. If the drawings at Hampton are by Packer, then the other two might well have been made by White Bear.

96. Mooney, *Calendar History*, 312, 326.

97. William L. Merrill, Marian Hansson, Candace Greene, and Frederick Reuss, *A Guide to the Kiowa Collections at the Smithsonian Institution* (Washington, DC: Smithsonian Institution Press, 1997), 7–8, 90.

98. Greene, "Southern Plains Graphic Art."

99. Ibid., 46. Greene suggests, again, that the paper on which the drawing was made might have been given to the Kiowa artist by the man who collected both the hide and the paper. The drawing is not a battle exploit image; it illustrates a single standing man. Vanessa Jennings, a contemporary Kiowa artist, notes that Kiowa men were not allowed to "brag on themselves." Although her comments refer to the celebration of heroic actions in the scalp dance, they might also apply to drawings of brave actions in battle. She indicates that other men might ask to render or celebrate a warrior's war exploits, and if the warrior agreed, then the action could be depicted. Vanessa Jennings, "Clothed in Valor: A Kiowa Dress with Battle Pictures" (paper presented at the Sixteenth Biennial Conference of the Native American Art Studies Association, Norman, Okla., October 22, 2009). This cultural restriction might have affected the number of Kiowa drawings and paintings of battle encounters.

100. Ewers, *Murals in the Round*, 14–17.

101. Sunshine, *Petals Plucked from Sunny Climes*, 195, 196.

102. The Wohaw drawing appears in the following publications, among others: Petersen, *Plains Indian Art*; Harris, *Between Two Cultures*; Donnelley, *Transforming Images*; Lookingbill, *War Dance*; and Berlo, *Plains Indian Drawings*. It is the only Plains ledger-style drawing included in Janet Catherine Berlo and Ruth B. Phillips, *Native North American Art* (Oxford: Oxford University Press, 1998), the primary textbook on Native American art history. It also appears on the cover of Hertha Dawn Wong's *Sending My Heart Back across the Years: Tradition and Innovation in Native American Autobiography* (Oxford: Oxford University Press, 1992).

103. D. Aaron Fry, "What Was Wohaw Thinking? Double Consciousness and the Two Worlds Theory in Native American Art History" (paper presented at the 93rd Annual College Art Association Meeting, Atlanta, Ga., February 2005); Candace S. Greene, "Pictures of Home: Being Indian at Fort Marion" (paper presented at the symposium "A Kiowa's Odyssey: A Sketchbook from Fort Marion," Trout Gallery, Dickinson College, Carlisle, Pa., October 20, 2007).

Chapter 2. On Collecting and Being Collected

1. Carmella Padilla, *El Rancho de las Golondrinas: Living History in New Mexico's La Cienega Valley* (Santa Fe: Museum of New Mexico Press, 2009), 76.

2. Quoted in Heidi Applegate, "A Traveler by Instinct," in Kevin J. Avery and Franklin Kelly, eds., *Hudson River School Visions: The Landscapes of Sanford R. Gifford* (New Haven, Conn.: Yale University Press, 2003), 63.

3. Padilla, *Rancho de las Golondrinas*, 76.

4. Ibid., 77.

5. Ibid.

6. See Molly H. Mullin, *Culture in the Marketplace: Gender, Art, and Value in the American Southwest* (Durham, N.C.: Duke University Press, 2001). Mullin's discussion of Amelia Elizabeth White and her sister Martha, two wealthy, single women who moved to Santa Fe from New York, purchased property there, and continued to live their lives as they chose, offers parallels in some ways to Fényes's experience. Although Eva Scott Muse Fényes married twice, she was not a woman whose life simply followed those of her husbands. After she began spending more time in Santa Fe, Fényes must certainly have known the Whites and many other independent-thinking women and men. Fényes was involved in various artistic activities developing in northern New Mexico, joining forces, for example, with Edgar Lee Hewett, the first director of the Museum of New Mexico, in his attempts to revive Santa Fe's annual fiesta. Padilla, *Rancho de las Golondrinas*, 83.

7. Padilla, *Rancho de las Golondrinas*, 78.

8. Michael Allen Divic, "Eva Scott Fenyes: Windows to an Adobe Past," *Southwest Art* 23 (March 1994), 60; Padilla, *Rancho de las Golondrinas*, 78.

9. The most famous Orientalist expression in an artist's home in the United States was Olana, designed by the Hudson River school artist Frederic Edwin Church between 1870 and 1872. Holly Edwards, *Noble Dreams, Wicked Pleasures: Orientalism in America, 1870–1930* (Princeton, N.J.: Princeton University Press, 2000), 30–31, 177–81. Orientalism was not unique to the United States; European countries, especially France and England, were among the other nations drawn into the spell of this exotic fantasy world.

10. Jennifer Hardin, *The Lure of Egypt: Land of the Pharaohs Revisited* (St. Petersburg, Fla.: Museum of Fine Arts, 1996), 12.

11. Edwards, *Noble Dreams*, 27.

12. Ibid., 27, 35.

13. Among those who repeatedly gathered at the Fényeses' home were William Keith (1838–1909), Benjamin Chambers Brown (1865–1945), John W. Nicoll (1865–1943), and Carl Oscar Borg (1879–1947). See the discussion of Fényes's influence in Jane Dini, "A Salon of Her Own: The Art Patronage of Eva Scott Fenyes," in *California Art Club, 91st Annual Gold Medal Juried Exhibition* (Pasadena, Calif.: Pasadena Historical Museum, 2001).

14. Charles F. Lummis Manuscript Collection, MS1. Diary for 1899, Braun Research Library, Autry National Center.

15. Ibid.

16. Listed on both the California and the National Register of Historic Places, the building was the Finnish consulate from 1947 to 1964, when Y. A. Paloheimo, the husband of Eva Fényes's granddaughter, Leonora, served as the Finnish consulate (Pasadena Museum of History website, www.pasadenahistory.org). The museum was founded in 1924 as the Pasadena Historical Society and was subsequently renamed the Pasadena Museum of History. The building and grounds were a gift from the Fényes descendants.

17. A close study of Eva Scott Fényes, her daughter, Leonora Muse Curtain, Leonora's daughter, Leonora Frances Curtin, and the development of their home in Santa Fe can be found in Virginia Scharff and Carolyn Brucken, "The House of Three Wise Women: A Family

Legacy in the American Southwest," *California History* 86, no. 4 (2009).

18. See, for example, Robert G. Hays, *A Race at Bay: New York Times Editorials on the "Indian Problem," 1860–1900* (Carbondale: Southern Illinois University Press, 1997), 271–76.

19. Steven Noll, "Steamboats, Cypress, and Tourism: An Ecological History of the Ocklawaha Valley in the Late Nineteenth Century," *Florida Historical Quarterly* 83, no. 1 (2004):9.

20. Rinhart and Rinhart, *Victorian Florida*, 107–22; Phillip Earenfight, "Introduction: Images from Fort Marion" and "From the Plains to the Coast," in Earenfight, *Kiowa's Odyssey*, 3–29.

21. Curtain-Paloheimo Collection, Acequia Madre House, Santa Fe.

22. DeHuff Family Papers, Center for Southwest Research, Zimmerman Library, University of New Mexico, Albuquerque.

23. J. J. Brody, *Pueblo Indian Painting: Tradition and Modernism in New Mexico, 1900–1930* (Santa Fe: School of American Research Press, 1997), 82–83.

24. Elizabeth DeHuff to Mother, March 15, 1930, DeHuff Family Papers, Center for Southwest Research, Zimmerman Library, University of New Mexico, Albuquerque.

25. Padilla, *Rancho de las Golondrinas*, 82–83.

26. Brody, *Pueblo Indian Painting*, 56.

27. Ibid., 55–56.

28. Ibid., 37–47. Brody discussed the early artists who worked at San Ildefonso with Hoyt and titled his chapter on that era "A Tradition Is Born." Although Hoyt was hired to teach students twelve years of age and under, her influence and that of her students affected many older artists as well, including Crescencio Martinez.

29. Ibid., 46–47.

30. The work that Eva Scott Fényes purchased from Crescencio Martinez is part of the collections of the Indian Arts Research Center at the School for Advanced Research in Santa Fe (IARC 1989.28.130). It is illustrated in Brody, *Pueblo Indian Painting*, 58, plate 15.

31. Ibid., 31, 123–25.

32. Ibid., 124, fig. 42. Hewett's painting by Kabotie is now in the collection of the Museum of New Mexico. Its official title is *Sun Dance–Santa Clara*, but it in fact depicts a Havasupai or Coconino dance, as is made clear by a comparison with plate 53, above it on the same page in Brody's book, and his discussion of the two images. Fényes's "close copy" of this work is now in the collection of the School for Advanced Research, AC17:54.2.

33. Ibid., 123–126; Fred Kabotie to Mrs. Eva L. Fényes, December 22, 1921, School for Advanced Research, AC17:54.2.

34. For a painting by Fred Kabotie depicting a Hopi buffalo dance, see Brody, *Pueblo Indian Painting*, 125, plate 54. The letter from Kabotie to Fényes cited in the preceding note explains the objects inside the kiva as follows: "These two men are preparing for Buffalo dance and the shield that you see on the wall and another below are only used in Buffalo dance. They are representing the sun. In the dance they are worn by the ladies only on their back. These sun shields are fashion some way on their backs so that parret's feathers on the shields behind their heads projecting out a little above their heads. (2) These feathers on the floor are suppose to be parret's feathers with a stick to which they will be attached and place on the other shield. (3) These disks near the bowl are colors and are used on the shields and some others. (4) These two crooked stick with the eagle feathers laying against the wall are used by two men dancers and these sticks are suppose to represent the lightning. (5) These 🪇🪇 are rattles

used by the two men dancer. I am sorry I do not know the meaning of these designs ⱱⱱⱱ on the lightning sticks but they are more like bird's tracks. (6) The blanket is used in thi dance, worn by the ladies but it can be used in other ceremonial dances. (7) The men formerly when working in the kiva gennerally took off their clothes provided the heat is plentiful. (8) In the kivas the fire-places are different from those in the houses. The ceremonial kivas are large rooms, so I order to keep the heat in balance the fire-place must be right in the center of the room. The entrance from the top by which the people go down into kiva can also be used as a chimney, (9) I don't know the name of the stone used on the floor. They are flats and are only found on the adobe hills."

Kabotie then briefly explained his other painting, *Havasupai Dance*. "This dance of four dancers is not a Pueblo. That's a Coconina dance. A tribe around Grand Canyon. These peo-ple are very clever in making baskets. These two men are wearing baskets on their heads, and the deer's skin of different colors worn by each man around the waist. The womens gowns are made of deer skin and their head dress of turkey feathers and fine eagle feathers. The paint-ings on their faces are suppose to be tattoos. I have been told that these people used to tattoo their faces with different coloring matters and I don't know whether it is still existed among them down to this day. They can dance this and Buffalo dance, any time in the fall, if they wish." School for Advanced Research, AC17:54.2.

35. Brody, *Pueblo Indian Painting*, especially 70–103.

36. Viola, in *Warrior Artists*, reproduces a drawing book that Pratt gave to Commissioner of Indian Affairs John Quincy Smith, probably in 1877. Two artists contributed works to the vol-ume: Zotom and the Cheyenne Making Medicine. Zotom's drawings repeat many of the sub-jects found in Eva Scott's book, specifically those detailing the events leading to the surrender of the Kiowa people, the prisoners' journey to Fort Marion, and their activities in Florida.

37. Stowe had her Florida home, Mandarin, built in the late 1860s on a plot of land facing the sea on one side and the St. Johns River on the other. Joan D. Hedrick, *Harriet Beecher Stowe: A Life* (Oxford: Oxford University Press, 1994), 330.

38. Petersen, *Plains Indian Art*, 221–22.

39. Ibid., 171–92.

40. Petersen, *Howling Wolf*; Szabo, "Howling Wolf"; Szabo, *Howling Wolf*.

41. See, for example, Maurer, *Visions of the People*; Berlo, *Plains Indian Drawings*; Donnelley, *Transforming Images*.

42. For detailed discussions of Howling Wolf's achievements, see Szabo, "Howling Wolf," and Szabo, *Howling Wolf*. Howling Wolf was interviewed by James Mooney while Mooney was on the Great Plains conducting field research. See Mooney, Field Notes, 2531, V, Anthropological Archives, National Museum of Natural History, Smithsonian Institution, Washington, DC.

43. Howling Wolf suffered from pterygium, a growth over the white part of the eyes, prob-ably caused by extended exposure to harsh sunlight on the plains. See the brief discussion of his disease and treatment in Robert Taylor, "The Journey of Howling Wolf," *Boston Globe Magazine* (April 11, 1993).

44. Petersen, *Plains Indian Art*, 221–24; Szabo, *Howling Wolf*, 90–91; Taylor, "Journey of Howling Wolf."

45. Charles Snyder, former librarian of the Massachusetts Eye and Ear Infirmary, to Joyce M. Szabo, May 23, 1983; Szabo, *Howling Wolf*, 188.

46. Petersen, *Howling Wolf*, 30.

47. Petersen, *Plains Indian Art*, 171, 189.

48. "Indian War Dance," Richard Henry Pratt Papers, Western Americana Collections, Beinecke Rare Book and Manuscript Library, Yale University, New Haven, Conn.; Petersen, *Plains Indian Art*, 176.

49. Greene (*One Hundred Summers*, 3) notes that some Cheyenne families did maintain calendars.

50. Joyce M. Szabo, "Ledger Art in Transition: Late Nineteenth and Early Twentieth Century Drawing and Painting on the Plains, with an Analysis of the Work of Howling Wolf" (Ph.D. diss., University of New Mexico, 1983).

51. Wade and Rand refer to the dearth of battle images as a result of "censorship," although there is no evidence to support the existence of censorship imposed from the outside rather than self-imposed censorship. They also cite me as having indicated that Pratt and other military officers suggested that representations of encounters between Native warriors and non-Native forces be avoided, which I did not (Wade and Rand, "Subtle Art of Resistance," 47).

52. Representations of Navajo men engaged in battle with Kiowas can be found in Ronald McCoy, *Kiowa Memories: Images from Indian Territory, 1880* (Santa Fe, N.M.: Morning Star Gallery, 1987), plates 4 and 12. In both instances, the Kiowa men wear the distinctive hairstyle tied at the back of the head with red fabric. They also wear two-piece moccasin leggings and mountain lion hide war caps. See the discussion in McCoy, *Kiowa Memories*, 58, 60.

53. Gus Palmer Jr., *Telling Stories the Kiowa Way* (Tucson: University of Arizona Press, 2003).

54. Ibid., 12.

55. Ibid., 14.

56. Ibid., 42.

57. Ibid., 30–31.

58. Szabo, *Howling Wolf*, 161–88. Having conducted an extensive study of Howling Wolf's drawings in the Allen Memorial Art Museum of Oberlin College in Ohio, I firmly believe that these drawings predate Fort Marion, for various reasons. Most important among them is the state of Howling Wolf's eyesight when he returned to Indian Territory after his imprisonment. The only drawings he is known to have made after Fort Marion have thick outlines and lack the clarity of representation that the very fine-line Oberlin drawings have. Moreover, the Oberlin drawings are almost all battle oriented, with the exceptions of one courting scene, one view of the Sun Dance, a warrior society dance, and a buffalo hunt. I believe that these four exceptions to firmly established academic views of Plains representational drawing, which seem to deny that any experimentation was possible prior to Fort Marion, and the exceptional skill that Howling Wolf demonstrated in the Oberlin drawings are the basis for the refusal by some academics, both anthropologists and art historians, to accept that the drawings predate the Florida period.

59. Howling Wolf's pre–Fort Marion ledger is in the collection of the Allen Memorial Art Museum of Oberlin College in Oberlin, Ohio. It has been discussed in Szabo, "Howling Wolf," and Szabo, *Howling Wolf*.

60. George Bird Grinnell, *The Cheyenne Indians: Their History and Ways of Life* (New Haven, Conn.: Yale University Press, 1923), vol. 2, 33–34; George Bird Grinnell, *By Cheyenne Campfires* (New Haven, Conn.: Yale University Press, 1926), xxiii.

61. Szabo, "Medicine Lodge Treaty Remembered."

62. Heewon Chang, *Autoethnography as Method* (Walnut Creek, Calif.: Left Coast Press, 2008), 46.

63. Ibid., 47–48.

64. Carolyn Ellis and Arthur P. Bochner, "Autoethnography, Personal Narrative, Reflexivity: Researcher as Subject," in Norman K. Denzin and Yvonna S. Lincoln, eds., *Handbook of Qualitative Research*, 2nd ed. (Thousand Oaks, Calif: Sage, 2000), 740.

65. See, for example, Ruth B. Phillips, *Trading Identities: The Souvenir in Native North American Art from the Northeast, 1700–1900* (Seattle: University of Washington Press, and Montreal: McGill-Queen's University Press, 1998), 16–17; and Janet Catherine Berlo, "A Kiowa's Odyssey: Etahdleuh Doanmoe, Transcultural Perspectives, and the Art of Fort Marion," in Earenfight, *Kiowa's Odyssey*.

66. See, for example, Margaret Connell Szasz, ed., *Between Indian and White Worlds: The Cultural Broker* (Norman: University of Oklahoma Press, 1994).

67. Pratt, *Battlefield and Classroom*, 124, 126–27.

68. Howling Wolf's most inventive images of Eagle Head and Heap of Birds in various battles can be found in Szabo, "Howling Wolf," 63–64, 73.

69. Greene, *Silver Horn*, 158–59.

70. Ibid., 80–82.

71. Ibid., 159.

72. Sarah Burns, *Inventing the Modern Artist: Art and Culture in Gilded America* (New Haven, Conn.: Yale University Press, 1996).

73. Joyce M. Szabo, "From General Souvenir to Personal Memento: Fort Marion Drawings and the Significance of Books," in Joyce M. Szabo, ed., *Painters, Patrons, and Identity: Essays in Native American Art to Honor J. J. Brody* (Albuquerque: University of New Mexico Press, 2001), 66; Starr Ockenga, *On Women and Friendship: A Collection of Victorian Keepsakes and Traditions* (New York: Stewart, Tabori, and Chang, 1993), 31, 44. Other autograph books contain Plains Indian drawings. One is that of Walter Bone Shirt, a Lakota artist whose book, now in a private collection, was probably filled with images around 1895. Subjects include men on horseback and ceremonial subjects such as the Sun Dance and Buffalo Dreamers. See the brief discussion and reproduction of the volume's cover and two pages of drawings in Berlo, *Plains Indian Drawings*, 36–37, 194–95.

74. William C. Darrah, *Cartes de Visite in Nineteenth Century Photography* (Gettysburg, Pa.: William C. Darrah, 1981), 8–10; Richard Rudisill, *Mirror Image: The Influence of the Daguerreotype on American Society* (Albuquerque: University of New Mexico Press, 1971), figs. 17, 121.

75. Axel Bolvig and Phillip Lindley, eds., *History and Images: Towards a New Iconology* (Turnhout, Belgium: Brepols, 2003), xxiii–xxx.

76. Pratt, *Battlefield and Classroom*, 119, 125; Petersen, *Plains Indian Art*, 66–67; Sunshine, *Petals Plucked from Sunny Climes*, 230–31.

77. Sunshine, *Petals Plucked from Sunny Climes*, 231.

78. Phillips, *Trading Identities*.

79. Ibid., 134–42.

80. Elizabeth Hutchinson, *The Indian Craze: Primitivism, Modernism, and Transculturation in American Art, 1890–1915* (Durham, N.C.: Duke University Press, 2009), especially 11–50.

81. Mullin, *Culture in the Marketplace*.

82. See Szabo, *Art from Fort Marion*. Pratt wrote of the difficulties of communication between prisoners from five different cultures, and he hoped that the instruction the

prisoners received might enable them to use English as a lingua franca in Florida and after their release.

Chapter 3. Zotom: Kiowa Artist as Historian

1. Mooney, "Kiowa Heraldry Notebook." See also Ewers, *Murals in the Round*, 8.

2. Mooney, "Kiowa Heraldry Notebook"; also Ewers, *Murals in the Round*, 42–44.

3. Douglas C. McChristian, *The U.S. Army in the West, 1870–1880: Uniforms, Weapons, and Equipment* (Norman: University of Oklahoma Press, 1995), 45–46.

4. Boyd, *Kiowa Voices*, 71–76, 138 n. 6. Other signs of membership in the Black Leggings Society included painting one's legs black or, in more contemporary times, wearing black underwear or black stockings. Roach headdresses are prominent today. According to Boyd (p. 71), the Black Leggings Society was one of the six original Kiowa warrior societies developed in 1838. Chief Black Turtle was the society's first leader, Gulhei its second, and Sitting Bear, or Satank, its third.

5. William C. Meadows, *Kiowa, Apache, and Comanche Military Societies* (Austin: University of Texas Press, 1999). Other instances of capturing red capes from Mexican officers must certainly have occurred. One was recorded in a drawing currently in the collections of the National Anthropological Archives of the National Museum of Natural History, Smithsonian Institution, MS 1915. There, a red cape appears among a group of other important objects including a shield, a quiver, and a lance; all are outside the striped side of the famous Battle Picture tipi that belonged to Tohausen and his descendants. Tohausen I captured such a cape before the middle of the nineteenth century and gave it to his father, Padogai. Candace S. Greene, "Exploring the Three 'Little Bluffs' of the Kiowa," *Plains Anthropologist* 41, no. 157 (1996): 224, 237–38.

6. See, for example, Greene, *Silver Horn*.

7. McCoy, *Kiowa Memories*, 58, 60, and plates 4 and 12. Other captioned Kiowa drawings, however, identify Navajo enemies who look similar to the man Zotom rendered. See Berlo, *Plains Indian Drawings*, 146–47.

8. See the discussion in John C. Ewers, "Hair Pipes in Plains Indian Adornment: A Study in Indian and White Ingenuity," *Bulletin of the Bureau of American Ethnology* 164 (Washington, DC: Government Printing Office, 1957).

9. Robert P. Elmer, *Target Archery, with a History of the Sport in America* (New York: Knopf, 1946).

10. Josiah Gregg, *The Commerce of the Prairies: Or the Journal of a Santa Fe Trader during Eight Expeditions across the Great Western Prairies and a Residence of Nearly Nine Years in Northern Mexico* (New York: Henry G. Langley, 1844), 218–19; Forrest Dewey Monahan, "Trade Goods on the Prairie: The Kiowa Tribe and White Goods, 1794–1875" (Ph.D. diss., University of Oklahoma, 1965); Greta J. Murphy, "Chief Blankets on the Middle Missouri: Navajo Artists and Their Patrons," in Szabo, ed., *Painters, Patrons and Identity*.

11. See, for example, Szabo, *Art from Fort Marion*, figs. 6–8, 50, 55, 56, and 59.

12. Ewers, *Murals in the Round*, 6–12.

13. McCoy, *Kiowa Memories*, 61–63; Mooney, *Calendar History*, 169–70.

14. James H. Howard discusses these headdresses as having developed from earlier practices by Plains men who cut their hair with the exception of a narrow strip that remained from the back of the neck to the crown of the head. The term *roach* probably came from a

nineteenth-century practice of trimming or "roaching" a horse's mane. See James H. Howard, "The Roach Headdress," *American Indian Hobbyist* 6, nos. 7–8 (1960).

15. Mooney, *Calendar History*, 169–70.

16. Pratt, *Battlefield and Classroom*, 94.

17. Ibid., 96.

18. On the issue of these captions, see Marilee Jantzer-White, "Narrative and Landscape in the Drawings of Etahdleuh Doanmoe," in Berlo, *Plains Indian Drawings*, 50–55.

19. There is disagreement over the identity of the artist of the book illustrated in Earenfight, *Kiowa's Odyssey*. Both Candace Greene and I believe that Zotom was the artist, given the strong similarity of many of the drawings to others known to have been by Zotom, whereas Janet Catherine Berlo and Phillip Earenfight adhere to the Doanmoe attribution. The identification is difficult because of the minute scale on which the artist rendered the figures and objects that would be of assistance in a comparative analysis of Zotom's and Doanmoe's works. In addition, if the Pratt drawings are removed from consideration, comparatively few drawings are known to have been created by Doanmoe at Fort Marion. See Candace S. Greene, "Fort Marion and the Florida Boys: Rethinking the Named Indian Artist," in Colin F. Taylor and Hugh A. Dempsey, eds., *The People of the Buffalo: The Plains Indians of North America*, vol. 2, *The Silent Memorials: Artifacts as Cultural and Historical Documents* (Wyk auf Foehr, Germany: Tatanka Press, 2005). See also the brief discussion in Szabo, *Art from Fort Marion*, 179 n. 8.

20. Viola, *Warrior Artists*, 62–63.

21. Joyce M. Szabo, "Chief Killer and a New Reality: Narration and Description in Fort Marion Art," *American Indian Art* 19, no. 2 (1994).

22. Viola, *Warrior Artists*, 64.

23. Pratt, *Battlefield and Classroom*, 107–8.

24. Ibid., 109.

25. Ibid., 108.

26. Viola, *Warrior Artists*, 56–57.

27. Ibid.

28. Pratt, *Battlefield and Classroom*, 40–41.

29. Viola, *Warrior Artists*, 56–57.

30. Thomas C. Battey, *The Life and Adventures of a Quaker among the Indians* (1875; reprint, Williamstown, Mass.: Conner House, 1972), 124–26.

31. Berlo, *Plains Indian Drawings*, 164.

32. Fort Marion is built of coquina, a shell rock unique to the east coast of Florida.

Chapter 4. Cheyenne Artist as Ethnographer

1. The book is in the Richard Pratt Papers, Western Americana Collections of the Beinecke Rare Book and Manuscript Library, Yale University. The question of whether twenty or twenty-one artists contributed work to the book arises from two drawings that appear late in the book, following works identified as being by the Kiowa prisoner Zonekeuh. The two in question are unidentified by artist. Petersen attributed these to Zonekeuh as well, but they differ significantly from work by him that precedes them in the book, so they may be by another artist. This question is briefly explored in Szabo, "From General Souvenir to Personal Memento," 68–69 n. 22.

2. James Mooney, Field Notes 2531, V. Anthropological Archives, National Museum of Natural History, Smithsonian Institution, Washington, DC, 38a–38; Szabo, *Howling Wolf*, 157, 172, 179–80, 182–83.

3. Afton, Halaas, and Masich, *Cheyenne Dog Soldiers*, 188.

4. Grinnell, *Cheyenne Indians*, vol. 1, 336–40; Karl N. Llewellyn and E. Adamson Hoebel, *The Cheyenne Way: Conflict and Case Law in Primitive Jurisprudence* (Norman: University of Oklahoma Press, 1941), 78–79.

5. Grinnell, *Cheyenne Indians*, vol. 2, 12.

6. For a discussion of peace medals, see Francis Paul Prucha, *Indian Peace Medals in American History* (Madison: State Historical Society of Wisconsin, 1971).

7. Grinnell, *Cheyenne Indians*, vol. 1, 102, 112.

8. For excellent discussions of Navajo textiles, see Kathleen Whitaker, *Southwest Textiles: Weavings of the Navajo and Pueblo* (Seattle: University of Washington Press, 2002), and Kate Peck Kent, *Navajo Weaving: Three Centuries of Change* (Santa Fe, N.M.: School of American Research Press, 1985).

9. Earenfight, *Kiowa's Odyssey*, 22; Petersen, *Plains Indian Art*, 229.

10. This drawing is in a book now in the Richard H. Pratt Papers of the Western Americana Collections, Beinecke Rare Book and Manuscript Library, Yale University.

11. Hyde, *Life of George Bent*, 337–40; Llewellyn and Hoebel, *Cheyenne Way*, 167–68; George Bird Grinnell, *The Fighting Cheyennes* (Norman: University of Oklahoma Press, 1956), 310–18; Berthrong, *Southern Cheyennes*, 340–44.

12. For an example of such a cross, see Bates, Kahn, and Lanford, *Cheyenne/Arapaho Ledger Book*, 177, and additional drawings of men wearing crosses in plates 15 and 238 in that book.

13. Jeffrey Anderson, *The Four Hills of Life: Northern Arapaho Knowledge and Life Movement* (Lincoln: University of Nebraska Press, 2001), 144–47. Although Anderson's focus was the Northern Arapahos, the age-graded system is similar for the Southern Arapahos. Also see Loretta Fowler, *Wives and Husbands: Gender and Age in Southern Arapaho History* (Norman: University of Oklahoma Press, 2010).

14. Anderson, *Four Hills of Life*, 144–47. Mooney also wrote of this obligation in his *Ghost Dance Religion*, 987. For a drawing made by an Arapaho student who had returned to Indian Territory from Carlisle in 1881, illustrating the objects associated with the Tomahawk or Clubboard Lodge, see *American Pictographic Images*, drawing book 112–13. There the society is referred to as the Spear Society. The one club board with serrated edges appears in the center of the row of other spears and dog effigy sticks on the lower edge of page 112.

15. Anderson, *Four Hills of Life*, 147.

16. See, for example, Szabo, "Howling Wolf," 45. In many cases, different warrior societies on the plains had similar paraphernalia.

17. Grinnell, *Cheyenne Indians*, vol. 2, 79. Grinnell wrote that on occasion there might have been four Contraries but that this was doubtful.

18. Ibid., 81–82.

19. See the discussions of Cheyenne Contraries in Father Peter J. Powell, "Bearers of the Sacred Thunder Bow, Part 1," *American Indian Art* 27, no. 3 (2002), and "Bearers of the Sacred Thunder Bow, Part 2," *American Indian Art* 27, no. 4 (2002).

20. Powell, "Bearers of the Sacred Thunder Bow, Part 1," 70.

21. For examples, see the illustrations in both parts of Powell's "Bearers of the Sacred Thunder Bow," as well as drawings reproduced in his *People of the Sacred Mountain: A History of the Northern Cheyenne Chiefs and Warrior Societies 1830–1878, with an Epilogue 1969–1974* (San Francisco: Harper and Row, 1981), vol. 1, 144–49.

22. In the Oberlin ledger, Howling Wolf drew a representation of a Sun Dance, probably from the summer of 1874, the last such renewal ceremony in which he took part before the Fort Marion imprisonment. During that summer, the Bowstrings sponsored the Sun Dance. Their northern Crazy Dog colleagues had prominent places in the ceremony, as well as in Howling Wolf's drawing. See Szabo, "Howling Wolf," 54–55.

23. Grinnell, *Cheyenne Indians*, vol. 2, 57–58; Karen Daniels Petersen, "Cheyenne Soldier Societies," *Plains Anthropologist* 9 (1964): 159.

24. Cowdrey, *Arrow's Elk Society Ledger*, 20.

25. Margery Bedinger, *Indian Silver: Navajo and Pueblo Jewelers* (Albuquerque: University of New Mexico Press, 1973), 77.

26. Grinnell, *Cheyenne Indians*, vol. 2, 14.

27. George A. Dorsey, *The Cheyenne*, vol. 1, *Ceremonial Organization* (Chicago: Field Columbian Museum, 1905), 26.

28. Szabo, *Howling Wolf*, 90–91.

29. Grinnell, in *Cheyenne Indians*, discussed Cheyenne marriage customs at length, especially in vol. 1, 137–55.

30. See the discussion of the ways in which such concepts were suggested in ledger drawings in Candace S. Greene, "Structure and Meaning in Cheyenne Ledger Art," in Berlo, *Plains Indian Drawings*, 26–33.

31. See the discussion of the lance, and compare the drawings in Cowdrey, *Arrow's Elk Society Ledger*, 19–22, 61–62, and his plates 7, 27, and 163.

32. Compare most of the lances drawn by Howling Wolf in plate 41 and figure 62.

33. Grinnell, *Cheyenne Indians*, vol. 2, 51. The same responsibility was true for leaders of all Cheyenne warrior societies.

34. See the discussion in Cowdrey, *Arrow's Elk Society Ledger*, 53–56.

35. Ibid., 20–23.

36. See Viola, *Warrior Artists*, 120–21, for a two-page drawing by the Southern Cheyenne artist Making Medicine (misidentified as Zotom) that shows the prisoners providing such a demonstration of their skill for an audience at Fort Marion. The prisoner at bottom left on the left-hand page is passing his cap for donations, and the first seated man is placing a bill in it.

37. Compare the feathered lance pictured in plate 44.

38. See the discussions in John H. Moore, *The Cheyenne* (Oxford: Blackwell, 1996), 126–27, and Cowdrey, *Arrow's Elk Society Ledger*, 35–39. Even Contraries, although they did not make up an official warrior society, might lend the forked sticks associated with their thunder bows to other warriors. Grinnell, *Cheyenne Indians*, vol. 2, 82.

39. Szabo, *Howling Wolf*, 155, 160.

40. Grinnell, *Cheyenne Indians*, vol. 1, 308–11; John C. Ewers, *Plains Indian Sculpture: A Traditional Art from America's Heartland* (Washington, DC: Smithsonian Institution Press, 1986), 79.

41. Pratt, *Battlefield and Classroom*, 127.

42. John H. Moore, "Cheyenne Names and Cosmology," *American Ethnologist* 11, no. 2 (1984): 296–98.

43. Grinnell, *Cheyenne Indians*, vol. 2, 57. See also the discussion in Cowdrey, *Arrow's Elk Society Ledger*, 35–39.

44. Grinnell, *Cheyenne Indians*, vol. 2, 33–34; Grinnell, *By Cheyenne Campfires*, xxiii.

45. I thank Mary Beth Zundo for sharing her in-depth knowledge of horses with me.

46. Grinnell, *Cheyenne Indians*, vol. 2, 7.

47. George A. Dorsey, *The Cheyenne*, vol. 2, *The Sun Dance* (Chicago: Field Columbian Museum, 1905), 82, 108–19.

48. Szabo, *Howling Wolf*, 182.

49. Nora Bowers, Rick Bowers, and Kenn Kaufman, *Mammals of North America* (New York: Houghton Mifflin, 2004), 150–53, 156–57, 164–65.

Conclusion

1. Pratt, *Battlefield and Classroom*, 124.

2. Ibid., 124–25.

3. See Szabo, *Art from Fort Marion*, 97, fig. 75.

4. Alvin O. Turner, "Journey to Sainthood: David Pendleton Oakerhater's Better Way," *Chronicles of Oklahoma* 70, no. 2 (1992): 116.

5. Szabo, *Art from Fort Marion*, 90, 140, figs. 67 and 108.

6. The letter to Miss Ellerhausen, as well as photographs of her and of Buffalo Meat, are in the collections of the National Cowboy & Western Heritage Museum in Oklahoma City, Oklahoma. They are reproduced in Szabo, *Art from Fort Marion*, 155, fig. 120.

7. The book, which has suffered severe water damage, is in the collections of the Oklahoma Historical Society in Oklahoma City, Oklahoma. It was the gift of Marta Lesta Bertoia.

8. Pratt, *Battlefield and Classroom*, 147–53.

9. Michel Foucault, "The Subject and Power," in Paul Rabinow and Nikolas Rose, eds., *The Essential Foucault: Selections from the Essential Works of Foucault 1954–1984* (New York: New Press, 2003), 138.

10. William J. Diebold, *Word and Image: Introduction to Early Medieval Art* (Boulder, Colo.: Westview Press, 2000), 36.

11. See, for example, plates 50–52, 54, and 61.

12. See Szabo, *Howling Wolf*, 151, 156, 171.

References

Ackerman, Gerald M. *American Orientalists*. Courbevoie, France: ARC, 1994.

Afton, Jean, David Fridtjof Halaas, and Andrew E. Masich, with Richard N. Ellis. *Cheyenne Dog Soldiers: A Ledgerbook History of Coups and Combat*. Niwot: University Press of Colorado, 1997.

American Pictographic Images: Historical Works on Paper by the Plains Indians. New York: Alexander Gallery, and Santa Fe, N.M.: Morning Star Gallery, 1988.

Anderson, Jeffrey. *The Four Hills of Life: Northern Arapaho Knowledge and Life Movement*. Lincoln: University of Nebraska Press, 2001.

Appadurai, Arjun. *Modernist at Large: Cultural Dimensions of Globalization*. Minneapolis: University of Minnesota Press, 1996.

Applegate, Heidi. "A Traveler by Instinct." In *Hudson River School Visions: The Landscapes of Sanford R. Gifford*, edited by Kevin J. Avery and Franklin Kelly, pp. 53–73. New Haven, Conn.: Yale University Press, 2003.

Bates, Craig D., Bonnie B. Kahn, and Benson L. Lanford. *The Cheyenne/Arapaho Ledger Book from the Pamplin Collection*. Portland, Oreg.: Robert B. Pamplin Jr., 2003.

Battey, Thomas C. *The Life and Adventures of a Quaker among the Indians*. 1875. Reprint, Williamstown, Mass.: Conner House, 1972.

Bedinger, Margery. *Indian Silver: Navajo and Pueblo Jewelers*. Albuquerque: University of New Mexico Press, 1973.

Berlo, Janet Catherine. "A Kiowa's Odyssey: Etahdleuh Doanmoe, Transcultural Perspectives, and the Art of Fort Marion." In *A Kiowa's Odyssey: A Sketchbook from Fort Marion*, edited by Phillip Earenfight, pp. 171–97. Seattle: University of Washington Press, 2007.

———, ed. *Plains Indian Drawings 1865–1935: Pages from a Visual History*. New York: Abrams, 1996.

———. *Spirit Beings and Sun Dancers: Black Hawk's Vision of the Lakota World*. New York: George Braziller, 2000.

———, and Ruth B. Phillips. *Native North American Art*. Oxford: Oxford University Press, 1998.

Berthrong, Donald J. *The Southern Cheyennes*. Norman: University of Oklahoma Press, 1963.

Blish, Helen H. *A Pictographic History of the Oglala Sioux*. Lincoln: University of Nebraska Press, 1967.

Bolvig, Axel, and Phillip Lindley, eds. *History and Images: Towards a New Iconology*. Turnhout, Belgium: Brepols, 2003.

Bowers, Nora, Rick Bowers, and Kenn Kaufman. *Mammals of North America*. New York: Houghton Mifflin, 2004.

Boyd, Maurice. *Kiowa Voices: Ceremonial Dance, Ritual, and Song*. Fort Worth: Texas Christian University Press, 1983.

————. *Kiowa Voices: Myths, Legends and Folktales*. Fort Worth: Texas Christian University Press, 1983.

Brody, J. J. *Pueblo Indian Painting: Tradition and Modernism in New Mexico, 1900–1930*. Santa Fe: School of American Research Press, 1997.

Burke, Christina E. "Waniyetu Wówapi: An Introduction to the Lakota Winter Count Tradition." In *The Year the Stars Fell: Lakota Winter Counts at the Smithsonian*, edited by Candace S. Greene and Russell Thornton, pp. 1–11. Lincoln: University of Nebraska Press, 2007.

Burns, Sarah. *Inventing the Modern Artist: Art and Culture in Gilded America*. New Haven, Conn.: Yale University Press, 1996.

Chang, Heewon. *Autoethnography as Method*. Walnut Creek, Calif.: Left Coast Press, 2008.

Cowdrey, Mike. *Arrow's Elk Society Ledger: A Southern Cheyenne Record of the 1870s*. Santa Fe, N.M.: Morning Star Gallery, 1999.

Cruse, J. Brett. *Battles of the Red River War: Archaeological Perspectives on the Indian Campaign of 1874*. College Station: Texas A&M University Press, 2008.

Darrah, William C. *Cartes de Visite in Nineteenth Century Photography*. Gettysburg, Pa.: William C. Darrah, 1981.

Dempsey, L. James. *Blackfoot War Art: Pictographs of the Reservation Period, 1880–2000*. Norman: University of Oklahoma Press, 2007.

Diebold, William J. *Word and Image: Introduction to Early Medieval Art*. Boulder, Colo.: Westview Press, 2000.

Dini, Jane. "A Salon of Her Own: The Art Patronage of Eva Scott Fenyes." In *California Art Club, 91st Gold Medal Juried Exhibition*, pp. 7–13. Pasadena, Calif.: Pasadena Historical Society, 2001.

Divic, Michael Allen. "Eva Scott Fenyes: Windows to an Adobe Past." *Southwest Art* 23 (March 1994): 59–61.

Donnelley, Robert G., with contributions by Janet Catherine Berlo and Candace S. Greene. *Transforming Images: The Art of Silver Horn and His Successors*. Chicago: David and Alfred Smart Museum of Art, University of Chicago, 2000.

Dorsey, George A. *The Cheyenne*. 2 vols. Chicago: Field Columbian Museum, 1905. Reprint, Glorieta, N.M.: Rio Grande Press, 1971.

Dunn, Dorothy. *American Indian Painting of the Southwest and Plains Areas*. Albuquerque: University of New Mexico Press, 1968.

————. Introduction. In *1877: Plains Indian Sketch Books of Zo-Tom and Howling Wolf*, edited by Dorothy Dunn. Flagstaff, Ariz.: Northland Press, 1969.

Earenfight, Phillip, ed. *A Kiowa's Odyssey: A Sketchbook from Fort Marion*. Seattle: University of Washington Press, 2007.

Edwards, Holly. *Noble Dreams, Wicked Pleasures: Orientalism in America, 1870–1930*. Princeton, N.J.: Princeton University Press, 2000.

The Edwards Ledger Drawings: Folk Art by Arapaho Warriors. New York: David A. Schorsch, 1990.

Ellis, Carolyn, and Arthur P. Bochner. "Autoethnography, Personal Narrative, Reflexivity:

Researcher as Subject." In *Handbook of Qualitative Research*, 2nd ed., edited by Norman K. Denzin and Yvonna S. Lincoln, pp. 733–68. Thousand Oaks, Calif.: Sage, 2000.

Elmer, Robert P. *Target Archery, with a History of the Sport in America*. New York: Knopf, 1946.

Ewers, John C. "Hair Pipes in Plains Indian Adornment: A Study in Indian and White Ingenuity." *Bulletin of the Bureau of American Ethnology* 164: 31–85. Washington, DC: Government Printing Office, 1957.

———. Introduction. In *Howling Wolf: A Cheyenne Warrior's Graphic Interpretation of His People*, edited by Karen Daniels Petersen. Palo Alto, Calif.: American West, 1968.

———. *Murals in the Round: Painted Tipis of the Kiowa and Kiowa-Apache Indians*. Washington, DC: Smithsonian Institution Press, 1978.

———. "Plains Indian Artists and Anthropologists: A Fruitful Collaboration." *American Indian Art* 9, no. 1 (1983): 36–44.

———. *Plains Indian Painting: A Description of an Aboriginal American Art*. Palo Alto, Calif.: Stanford University Press, 1939.

———. *Plains Indian Sculpture: A Traditional Art from America's Heartland*. Washington, DC: Smithsonian Institution Press, 1986.

Feest, Christian F. *Native Arts of North America*. New York: Oxford University Press, 1980.

Foucault, Michel. "The Subject and Power." In *The Essential Foucault: Selections from the Essential Works of Foucault 1954–1984*, edited by Paul Rabinow and Nikolas Rose, pp. 126–45. New York: New Press, 2003.

Fowler, Loretta. *Wives and Husbands: Gender and Age in Southern Arapaho History*. Norman: University of Oklahoma Press, 2010.

Fry, D. Aaron. "What Was Wohaw Thinking? Double Consciousness and the Two Worlds Theory in Native American Art History." Paper presented at the 93rd Annual College Art Association Meeting, Atlanta, February 2005.

Greene, Candace S. "Exploring the Three 'Little Bluffs' of the Kiowa." *Plains Anthropologist* 41, no. 157 (1996): 221–42.

———. "Fort Marion and the Florida Boys: Rethinking the Named Indian Artist." In *The People of the Buffalo: The Plains Indians of North America*, vol. 2: *The Silent Memorials: Artifacts as Cultural and Historical Documents*, edited by Colin F. Taylor and Hugh A. Dempsey, pp. 36–42. Wyk auf Foehr, Germany: Tatanka Press, 2005.

———. *One Hundred Summers: A Kiowa Calendar Record*. Lincoln: University of Nebraska Press, 2009.

———. "Pictures of Home: Being Indian at Fort Marion." Paper presented at the symposium "A Kiowa's Odyssey: A Sketchbook from Fort Marion," Trout Gallery, Dickinson College, Carlisle, Pa., October 20, 2007.

———. *Silver Horn: Master Illustrator of the Kiowas*. Norman: University of Oklahoma Press, 2001.

———. "Southern Plains Graphic Art before the Reservation." *American Indian Art* 22, no. 3 (1997): 44–53.

———. "Structure and Meaning in Cheyenne Ledger Art." In *Plains Indian Drawings 1865–1935: Pages from a Visual History*, edited by Janet C. Berlo, pp. 26–33. New York: Abrams, 1996.

Gregg, Josiah. *The Commerce of the Prairies: Or the Journal of a Santa Fe Trader during Eight Expeditions across the Great Western Prairies and a Residence of Nearly Nine Years in Northern Mexico*. New York: Henry G. Langley, 1844. Reprint, Lincoln: University of Nebraska, 1967.

Grinnell, George Bird. *By Cheyenne Campfires*. New Haven, Conn.: Yale University Press, 1926. Reprint, Lincoln: University of Nebraska Press, 1962.

————. *The Cheyenne Indians: Their History and Ways of Life.* 2 vols. New Haven, Conn.: Yale University Press, 1923. Reprint, Lincoln: University of Nebraska Press, 1972.

————. *The Fighting Cheyennes.* New York: Charles Scribner's Sons, 1915. Reprint, Norman: University of Oklahoma Press, 1956.

Guilbaut, Serge. "Preface: The Relevance of Modernism." In *Modernism and Modernity*, edited by Benjamin Bulloch, Serge Guilbaut, and David Solkin, pp. x–xv. Halifax: Press of the Nova Scotia College of Art and Design, 1983.

Hardin, Jennifer. *The Lure of Egypt: Land of the Pharaohs Revisited.* St. Petersburg, Fla.: Museum of Fine Arts, 1966.

Harris, Moira F. *Between Two Cultures: Kiowa Art from Fort Marion.* St. Paul, Minn.: Pogo Press, 1989.

Hays, Robert G. *A Race at Bay: New York Times Editorials on the "Indian Problem," 1860–1900.* Carbondale: Southern Illinois University Press, 1997.

Hedrick, Joan D. *Harriet Beecher Stowe: A Life.* Oxford: Oxford University Press, 1994.

Hindman, Sandra, Michael Camille, Nina Rowe, and Rowan Watson. *Manuscript Illumination in the Modern Age: Recovery and Reconstruction.* Evanston, Ill.: Mary and Leigh Block Museum of Art, Northwestern University, 2001.

Hoebel, E. Adamson, and Karen Daniels Petersen. *A Cheyenne Sketchbook by Cohoe.* Norman: University of Oklahoma Press, 1964.

Howard, James H. "The Roach Headdress." *American Indian Hobbyist* 6, nos. 7–8 (1960): 89–94.

Hutchinson, Elizabeth. *The Indian Craze: Primitivism, Modernism, and Transculturation in American Art, 1890–1915.* Durham, N.C.: Duke University Press, 2009.

Hyde, George E. *Life of George Bent Written from His Letters.* Edited by Savoie Lottinville. Norman: University of Oklahoma Press, 1968.

Jantzer-White, Marilee. "Narrative and Landscape in the Drawings of Etahdleuh Doanmoe." In *Plains Indian Drawings 1865–1935: Pages from a Visual History*, edited by Janet Catherine Berlo, pp. 50–55. New York: Abrams, 1996.

Jennings, Vanessa. "Clothed in Valor: A Kiowa Dress with Battle Pictures." Paper presented at the Sixteenth Biennial Conference of the Native American Art Studies Association, Norman, Okla., October 22, 2009.

Jordan, Michael. "On Intellectual Property Rights and Historical Consciousness in Kiowa Society: An Overview." Paper presented at the Sixteenth Biennial Conference of the Native American Art Studies Association, Norman, Okla., October 22, 2009.

Kelly, Fanny. *Narrative of My Captivity among the Sioux Indians, with a Brief Account of General Sully's Indian Expedition in 1863, Bearing upon Events Occurring in My Captivity.* Cincinnati, Ohio: Wilstach, Baldwin, 1871. Reprint, New York: Corinth Books, 1990.

Kent, Kate Peck. *Navajo Weaving: Three Centuries of Change.* Santa Fe, N.M.: School of American Research Press, 1985.

Keyser, James D. *The Five Crows Ledger: Biographic Warrior Art of the Flathead Indians.* Salt Lake City: University of Utah Press, 2000.

Lindsey, Donal F. *Plains Indians at Hampton Institute, 1877–1923.* Urbana: University of Illinois Press, 1995.

Llewellyn, Karl N., and E. Adamson Hoebel. *The Cheyenne Way: Conflict and Case Law in Primitive Jurisprudence.* Norman: University of Oklahoma Press, 1941.

Lookingbill, Brad D. *War Dance at Fort Marion: Plains Indian War Prisoners.* Norman: University of Oklahoma Press, 2006.

Mallery, Garrick. *Pictographs of the North American Indians*. Fourth Annual Report of the Bureau of American Ethnology, 1882–1883, pp. 3–256. Washington, DC: Government Printing Office, 1886.

——. *Picture Writing of the American Indians*. Tenth Annual Report of the Bureau of American Ethnology, 1888–1889, pp. 5–882. Washington, DC: Government Printing Office, 1893.

Maurer, Evan M. *Visions of the People: A Pictorial History of Plains Indian Life*. Minneapolis, Minn.: Minneapolis Institute of Arts, 1992.

McChristian, Douglas C. *The U.S. Army in the West, 1870–1880: Uniforms, Weapons, and Equipment*. Norman: University of Oklahoma Press, 1995.

McCoy, Ronald. *Kiowa Memories: Images from Indian Territory, 1880*. Santa Fe, N.M.: Morning Star Gallery, 1987.

Meadows, William C. *Kiowa, Apache, and Comanche Military Societies*. Austin: University of Texas Press, 1999.

Merrill, William L., Marian Hansson, Candace Greene, and Frederick Reuss. *A Guide to the Kiowa Collections at the Smithsonian Institution*. Washington, DC: Smithsonian Institution Press, 1997.

Monahan, Forrest Dewey. "Trade Goods on the Prairie: The Kiowa Tribe and White Goods, 1794–1875." Ph.D. diss., University of Oklahoma, 1965.

Mooney, James. *Calendar History of the Kiowa Indians*. Seventeenth Annual Report of the Bureau of American Ethnology, Part 1. Washington, DC: Government Printing Office, 1898. Reprint, Washington, DC: Smithsonian Institution Press, 1978.

——. Field Notes, 2531, V. Anthropological Archives, National Museum of Natural History, Smithsonian Institution, Washington, DC.

——. *The Ghost Dance Religion and the Sioux Outbreak of 1890*. Fourteenth Annual Report of the Bureau of American Ethnology, 1892–1893, Part 2. Washington, DC: Government Printing Office, 1896.

——. "Kiowa Heraldry Notebook, 1891–1904: Descriptions of Kiowa Tipis and Shields." Manuscript 2531, Anthropological Archives, National Museum of Natural History, Smithsonian Institution, Washington, DC.

Moore, John H. *The Cheyenne*. Oxford: Blackwell, 1996.

——. "Cheyenne Names and Cosmology." *American Ethnologist* 11, no. 2 (1984): 291–312.

Mullin, Molly H. *Culture in the Marketplace: Gender, Art, and Value in the American Southwest*. Durham, N.C.: Duke University Press, 2001.

Murphy, Greta J. "Chief Blankets on the Middle Missouri: Navajo Artists and Their Patrons." In *Painters, Patrons and Identity: Essays in Native American Art to Honor J. J. Brody*, edited by Joyce M. Szabo, pp. 241–61. Albuquerque: University of New Mexico Press, 2001.

National Museum of the American Indian. *The Changing Presentation of the American Indian: Museums and Native Cultures*. Seattle: University of Washington Press, 2000.

Noll, Steven. "Steamboats, Cypress, and Tourism: An Ecological History of the Ocklawaha Valley in the Late Nineteenth Century." *Florida Historical Quarterly* 83, no. 1 (2004): 6–23.

Nye, Wilbur S. *Carbine and Lance: The Story of Old Fort Sill*. Norman: University of Oklahoma Press, 1937.

Ockenga, Starr. *On Women and Friendship: A Collection of Victorian Keepsakes and Traditions*. New York: Stewart, Tabori, and Chang, 1993.

Padilla, Carmella. *El Rancho de las Golondrinas: Living History in New Mexico's La Cienega Valley*. Santa Fe: Museum of New Mexico Press, 2009.

Palmer, Gus, Jr. *Telling Stories the Kiowa Way*. Tucson: University of Arizona Press, 2003.

Petersen, Karen Daniels. "Cheyenne Soldier Societies." *Plains Anthropologist* 9 (1964): 146–72.

———. *Howling Wolf: A Cheyenne Warrior's Graphic Interpretation of His People*. Palo Alto, Calif.: American West, 1968.

———. "Pictography: A Useful Folk Art." In *The Edwards Ledger Drawings: Folk Art by Arapaho Warriors*, edited by Karen Daniels Peterson, pp. xii–xxv. New York: David A. Schorsch, 1990.

———. *Plains Indian Art from Fort Marion*. Norman: University of Oklahoma Press, 1971.

Phillips, Ruth B. *Trading Identities: The Souvenir in Native North American Art from the Northeast, 1700–1900*. Seattle: University of Washington Press, Montreal: McGill-Queen's University Press, 1998.

Powell, Father Peter J. "Bearers of the Sacred Thunder Bow, Part 1." *American Indian Art* 27, no. 3 (2002): 62–72.

———. "Bearers of the Sacred Thunder Bow, Part 2." *American Indian Art* 27, no. 4 (2002): 56–65.

———. *People of the Sacred Mountain: A History of the Northern Cheyenne Chiefs and Warrior Societies 1830–1878, with an Epilogue 1969–1974*. 2 vols. San Francisco: Harper and Row, 1981.

Pratt, Richard Henry. *Battlefield and Classroom: Four Decades with the American Indian, 1867–1904*. Edited by Robert M. Utley. New Haven, Conn.: Yale University Press, 1964. Reprint, Lincoln: University of Nebraska Press, 1987.

Prucha, Francis Paul. *Indian Peace Medals in American History*. Madison: State Historical Society of Wisconsin, 1971.

Rinhart, Floyd, and Marion Rinhart. *Victorian Florida: America's Last Frontier*. Atlanta, Ga.: Peachtree, 1986.

Rodee, Howard D. "Stylistic Development of Plains Indian Painting and Its Relationship to Ledger Drawings." *Plains Anthropologist* 10, no. 30 (1965): 218–32.

Rubin, William, ed. *"Primitivism" in 20th Century Art*. 2 vols. New York: Museum of Modern Art, 1984.

Rudisill, Richard. *Mirror Image: The Influence of the Daguerreotype on American Society*. Albuquerque: University of New Mexico Press, 1971.

Rushing, W. Jackson. "Marketing the Affinity of the Primitive and the Modern: Rene d'Harnoncourt and Indian Art of the United States." In *The Early Years of Native American Art History: The Politics of Scholarship and Collecting*, edited by Janet Catherine Berlo, pp. 191–236. Seattle: University of Washington Press, 1992.

Said, Edward W. *Orientalism*. New York: Pantheon, 1978.

Scharff, Virginia, and Carolyn Brucken. "The House of Three Wise Women: A Family Legacy in the American Southwest." *California History* 86, no. 4 (2009): 44–59, 84–87.

Sunshine, Silvia. *Petals Plucked from Sunny Climes*. 1880. Reprint, Gainesville, Fla.: University Presses of Florida, 1976.

Supree, Burton, with Ann Ross. *Bear's Heart: Scenes from the Life of a Cheyenne Artist of One Hundred Years Ago with Pictures by Himself*. Philadelphia: J. B. Lippincott, 1977.

Szabo, Joyce M. *Art from Fort Marion: The Silberman Collection*. Norman: University of Oklahoma Press, 2007.

———. "Chief Killer and a New Reality: Narration and Description in Fort Marion Art." *American Indian Art* 19, no. 2 (1994): 50–57.

———. "Drawing Life's Changes: Late Nineteenth-Century Plains Drawings from Hampton Institute and Carlisle Indian School." *European Review of Native American Studies* 18, no. 1 (2004): 41–51.

———. "From General Souvenir to Personal Memento: Fort Marion Drawings and the Significance of Books." In *Painters, Patrons, and Identity: Essays in Native American Art to Honor J. J. Brody*, edited by Joyce M. Szabo, pp. 49–70. Albuquerque: University of New Mexico Press, 2001.

———. "Howling Wolf: An Autobiography of a Plains Warrior-Artist." *Allen Memorial Art Museum Bulletin* 46, no. 1 (1992): 4–87.

———. *Howling Wolf and the History of Ledger Art*. Albuquerque: University of New Mexico Press, 1994.

———. "Ledger Art in Transition: Late Nineteenth and Early Twentieth Century Drawing and Painting on the Plains, with an Analysis of the Work of Howling Wolf." Ph.D. diss., University of New Mexico, 1983.

———. "Medicine Lodge Treaty Remembered." *American Indian Art* 14, no. 4 (1989): 52–59, 87.

Szasz, Margaret Connell, ed. *Between Indian and White Worlds: The Cultural Broker*. Norman: University of Oklahoma Press, 1994.

Taylor, Robert. "The Journey of Howling Wolf." *Boston Globe Magazine*, April 11, 1993, pp. 10–17.

Thompson, Scott M. *I Will Tell My War Story: A Pictorial Account of the Nez Perce War*. Seattle: University of Washington Press, 2000.

Turner, Alvin O. "Journey to Sainthood: David Pendleton Oakerhater's Better Way." *Chronicles of Oklahoma* 70, no. 2 (1992): 116–43.

Viola, Herman J. *Warrior Artists: Historic Cheyenne and Kiowa Indian Ledger Art Drawn by Making Medicine and Zotom*. Washington, DC: National Geographic Society, 1998.

Wade, Edwin L., and Jacki Thompson Rand. "The Subtle Art of Resistance: Encounter and Accommodation in the Art of Fort Marion." In *Plains Indian Drawings 1865–1935, Pages from a Visual History*, edited by Janet Catherine Berlo, pp. 45–49. New York: Abrams, 1996.

Waggoner, Linda M. *Fire Light: The Life of Angel de Cora, Winnebago Artist*. Norman: University of Oklahoma Press, 2008.

Westermann, Mariet, ed. *Anthropologies of Art*. Williamstown, Mass.: Sterling and Francine Clark Art Institute, 2005.

Whitaker, Kathleen. *Southwest Textiles: Weavings of the Navajo and Pueblo*. Seattle: University of Washington Press, 2002.

Wied, Maximilian, Prince of. *Travels in the Interior of North America*. Vol. 23 of *Early Western Travels, 1748–1846*, edited by Reuben Gold Thwaites. Cleveland, Ohio: A. H. Clark, 1906.

Witmer, Linda F. *The Indian Industrial School, Carlisle, Pennsylvania, 1879–1918*. Carlisle, Pa.: Cumberland County Historical Society, 1993.

Wong, Hertha Dawn. *Sending My Heart Back across the Years: Tradition and Innovation in Native American Autobiography*. Oxford: Oxford University Press, 1992.

Index

Numbers printed in *italics* refer to illustrations.

Sun (Kiowa), 181n23

Sun Dance, 15, *30*, 30, *166–167*, 166–68, 177, 182n42, 194n22

"Surrender at Mount Scott. Troops meeting Indians" (Zotom), 98

Szabo, Joyce M., 179n1, 189n58, 192n19

Taylor, Frank Hamilton, 113

textiles: in drawings of Howling Wolf, 137, 139, 142, 144, 162; in drawings of Zotom, 83; and Navajo blankets, 124. *See also* clothing

thunder bows, 132–33, 134, 135, 194n38

Timber Hill Creek, Treaty of (1868), 4

Tohausan. *See* Little Bluff

Tomahawk Lodge, 128

tomahawks, 126

tourist art, Fort Marion drawings as, 20

trade: in drawings by Zotom, 80–82; networks of in Native North America, 136; and ornaments, 77; and textiles from Mexico, 162

transcultural, and ethnography, 56

treaties, between the U.S. and Plains Indian tribes, 4

"Two young Indians—and a Wigwam" (Howling Wolf), 141–42

Ulrich, Charles Frederic (Fényes 1882), *xi*

Utes, 4, 164

"Various Wild Animals" (Howling Wolf), 159–60

village, illustrations of Kiowa by Zotom, 69–70, 71, 83–84, 88

Viola, Herman J., 188n36

visual language, in Plains Indian art, 3, 170. *See also* name signs

Wade, Edwin, 27, 189n51

warfare. *See* battle imagery; bows and arrows; military; warrior societies

warrior societies, 55, 73, 74, 77, 95, 128, 140, 145. *See also* Black Leggings; Bowstring; Crazy Dog; Dog Soldiers; Elk societies

Waterton National Park, 21

Washita, battle of (1868), 4

"Wedding, Chief taking his bride to his Wig-wam" (Howling Wolf), 165–66

weddings, in drawings of Howling Wolf and Zotom, 58, 85–86, 165–66, 177. *See also* marriage

Western Americana Collections of Yale University, 140

Whipple, Benjamin, 65

White, Amelia Elizabeth & Martha, 186n6

White Bear (Arapaho), 29, 185n95

White Bear (Kiowa), 180n19

White Man (Kiowa-Apache), 70

Wichita Mountains (Oklahoma), 93, 98, 99

wigwam, Eva Scott's use of term, 82

"Wild Turkey-hunt" (Howling Wolf), 154–55

Wo-haw (Kiowa), *25*, 31, 185n102

Woman's Heart (Kiowa), 21

women: in drawings of Zotom, 88; interactions of Fort Marion prisoners with, 171–72; as prisoners at Fort Marion, 21. *See also* marriage

Women of the West Museum (Los Angeles), xii

Wong, Hertha Dawn, 185n102

Yellow Nose–Spotted Wolf book, 134

Young Mustang. *See* Gulhei

Zonekeuh (Kiowa), 192n1

Zotom (Kiowa), *62*: acquisition of works by Southwest Museum of the American Indian, xi, xiii; analysis of individual drawings by, 69–117; as bugler, 180n19; commissioning of drawings by Eva Scott, x–xi, 39–40, 47–51, 61–65, 171–77; drawings of as history, 3, 22, 25, 55, 117, 176; drawings of Howling Wolf compared to, 117; drawings of from other collections, xiv, 188n36, 192n19; and Kiowa calendrical system, 22, 176; and order of drawings in Fort Marion books, 27; problems in analysis of Fort Marion drawings by, 51–60

"ZoTom coming to Capt. Pratt with flag of truce in '71. On Otter Creek—S.W. part of Indian Territory" (Zotom), 105–106